Editor's Column

Throughout our short publishing life, two questions have been asked of us more than any: (1.) Why are you so negative? (2.) Why can't you be nice?

The answers, simply:

1. We're only negative to counteract the placating incestuousness that swamps all credible relationships in the art world.

2. We can't be nice when the people most closely associated with caretaking the beauty and legacy of great contemporary art abuse their roles for personal gain and/or glory.

The worst reactions to *Coagula* during my ten-issue tenure have been from people who at one time or another had originally supported this journal. They were cheering us on until we investigated something a little too close to them. The icy stares and canceled invitations followed. I have a wonderful thank-you note from a prominent Los Angeles galleriste, handwritten in expensive boarding-school script, thanking us for "our continuous support" after two positive reviews of the gallery's artists. Yet after one small item discussing the personal habits of one of the stable's more obnoxious junior artists, it was as if we had aimed a cannon at the space's fledgling legacy. It was made perfectly clear that we were no longer in the "club" (or, with this gallery's increasing demand for obedience, the CULT). Luckily and happily, we at *Coagula* are not interested in belonging to the elitist cliques that so permeate the art-world landscape as thoroughly as Jack Ruby haunting every JFK assassination theory. If we can unnerve just one trust-fund kid's grasp on taste and sentiment we will have done our job. Face it, art world—*Coagula* has published ten issues of thumbtacks in your pretty little over-rated ass. Just be ready for more than ten more. We are here to stay.

—Mat Gleason

Issue 10, December 1993

most art sucks

FIVE YEARS OF COAGULA

SMART ART PRESS, SANTA MONICA

Smart Art Press
Bergamot Station
2525 Michigan Avenue, Building C1
Santa Monica, California 90404
310-264-4678 (tel)
310-264-4682 (fax)
www.smartartpress.com

Smart Art Press
Volume IV, no. 36

Editor: Tom Patchett
Associate Editor: Susan Martin
Design: Steve Samiof, Brains
Copy Editor: Sherri Schottlaender

Distributed by D.A.P.
155 Avenue of the Americas
New York, NY 10013
1-800-338-BOOK

TABLE OF CONTENTIOUSNESS

Secrets Of the Art World, ReVealed

I smell a rat.
—Patrick Henry

Are you ready for a little celebrity-bashing, art-world style? You've come to the right place! No one dishes the dirt better than *Coagula*.

Oh, lots of art critics can be mean. New York art-lovers, for instance, cherish the weekly tongue-lashings administered by Hilton Kramer in the *New York Observer*, for liberties taken with tradition, and Roberta Smith in the *New York Times*, for liberties not taken with tradition. And who can forget the time that Peter Schjeldahl compared Mark Tansey's paint surface to pond scum?

As P. David Marshall elaborates in *Celebrity and Power* (1997), in our society of raging consumer capitalism, celebrity is the very emblem of success and achievement and freedom. But at the same time, "the celebrity is ridiculed and derided because it represents the center of false value." Everybody knows that celebrities don't actually work, they don't actually produce anything useful. And they like to refer to themselves as artists!

With *Coagula*, the insults have a higher purpose. The Futurist F. T. Marinetti spelled it out in *The Pleasure of Being Booed* (1911–15): "We especially teach a horror of the immediate success that normally crowns dull and mediocre works." Would you care for some examples?

The California critic and artist Jeremy Gilbert-Rolfe is a "stuffy boretician." American Fine Arts proprietor "Colin DeLand's doppelgänger is Huckleberry Hound." Neoexpressionist painter Susan Rothenberg is reported to be out on her New Mexico ranch "diligently studying the daily roadkill." Byron Kim's paintings,

which apply the motifs of formalist abstraction to a taxonomy of skin color, prove that "sticking a little body hair on an otherwise monochrome panel can take you way beyond P.S. 122."

These are more than wisecracks; they're capsule analyses!

There's more. Regarding outsider art: "I just wish people would put it outside!" Of Haim Steinbach: "How pathetic. Fifty years old and still shopping for a bargain." About Jeff Koons: "Too bad they don't have cosmetic surgery for talent!" And a reminder that Alexis Rockman's first big success was a painting of a raccoon screwing a hen.

This is writing, as the journalist Arthur Pegler characterized his competition back at the beginning of the century, which "sounds like a screaming woman running down the street with her throat cut."

> Coagula *gets everyone so mad. I like it.*
> —Karen Finley

But *Coagula* ain't all bon mots, by any means. By January 1998 the magazine had published thirty-one issues, the most recent numbering seventy-two newsprint pages. There are anecdotes, reviews, and commentary. There are serious pieces on cutting-edge artists like Ron Athey, Karen Finley, and Bob Flanagan, and interviews with the likes of MoMA curator Robert Storr, *Newsweek* critic Peter Plagens, and Dada expert Francis Naumann. And there are the ever-popular reader-service features like "Reader's Poll," "The Good, the Bad and the Ugly," and "The Collegiate Top Ten."

Coagula champions underdogs and originals—for instance, once-little-known artists like Kim Dingle, Max Estenger, Manuel Ocampo, China Adams, and galleries like American Fine Arts, the now-closed Fawbush, the all-but-forgotten Muranushi Lederman. It editorializes, seriously, that the universally loved Metropolitan Museum director Philippe de Montebello should be fired for showing "British hacks" like R. B. Kitaj and Howard Hodgkin while allowing the Philadelphia

Museum's Cézanne show and the National Gallery's Vermeer exhibition to bypass New York.

This package is largely the work of two men, Mat Gleason in Los Angeles and Charlie Finch in New York, who didn't meet until two years into their collaboration and who, once they had met, didn't find each other's company that agreeable. Their attitude towards the art world's fools and knaves is remarkably consistent. "I drop the piano on someone," says New York editor Charlie Finch, "and if they squawk I drop the piano again."

> *Great artists are a bit crack-brained.*
> —Diderot (1763)

As art historians Rudolf and Margot Wittkower point out in *Born Under Saturn* (1963), the ancient Greeks favored poets and musicians (the rock stars of the day) but found artists interesting largely for their eccentricities. Early episodes of Western art history begin with what we would call gossip, though Pliny called it *Natural History*: The sculptor Apollodoros was a short-tempered perfectionist who smashed his own work and was called a nut. Protogenes, "the story runs," would become so obsessed with working that he would stop to eat only bitter lupines soaked in water. The painter Zeuxis, who became celebrated and quite rich from his art, was a conceited blowhard. Sound familiar?

The point is that this kind of confidential material is the raw stuff of history.

Will we ever tire of celebrating the dark side of genius? "Obscene and excretory acts and organs," North Carolina Senator Jesse Helms called the stuff, inspired by Robert Mapplethorpe's scandalous photographs. As for *Coagula*, it has steadily chronicled what it calls "the anus bandwagon," as "the fecal end of the art spectrum" continues to be popular, not just with the crack-brained artists, but with crack-brained collectors as well.

Witness just a few of 1997's auction records. Kiki Smith's *Pee Body*, a wax statue of a squatting woman "peeing" a rather long string of yellow beads, was bought

for $233,500 (and promptly unloaded on Harvard's Fogg Art Museum). Robert Gober's life-size sculpture of a naked child's torso, upended and truncated in more ways than one, was bought for $167,500. Jeff Koons's giant photograph of himself making love to his wife—an Italian porn star and member of Italy's parliament—set a record for a "painting" by the artist (it is actually a photograph printed on canvas) when it sold for $158,500. Cindy Sherman's lurid self-portrait pin-up, her body augmented by prosthetic private parts, went for $55,200. Rachel Whiteread's cast of a mattress sold for $167,500, and Mike Kelley's collection of sixty photos of forlorn cast-off dolls for $96,000.

If, as Balzac remarked, behind every great fortune stands a great crime, what strange millennial inversion have we here?

> It was the secrets of heaven and earth that I desired to learn.
> —Baron Frankenstein

In his famous speculation on Leonardo, Freud observed that the first course of business for small children is the "great question of where babies came from and what the father has to do with their origin." The great craving for knowledge, the compulsion to investigate, derives from violent Oedipal curiosity. Leonardo "began to brood on this riddle with special intensity," Freud hypothesized, "and so at a tender age became a researcher." *Coagula* shares this mad drive to uncover the hidden. Of course, Freud also had in mind the notion that Leonardo was homosexual and that the Mona Lisa represented his mother.

Only *Coagula* gives a true picture of the art world, rooted in the social. "Thumbtacks for the art world's pretty little ass," it promised early on. Where else do we learn that the Getty Center is constructed on the same hill that was the former site of the Los Angeles city dump? This is the kind of revelation that, even if not exactly true, deserves to be made up.

Here is what T. J. Clark had to say in his *Image of the People* (1973) regarding the huge number of writers—forty-five—who discussed Courbet in the Salon of 1851: "What interests us, if we want to discover the meaning of this mass of criticism,

are the points at which the rational monotone of the critic breaks, fails, falters; we are interested in the phenomena of obsessive repetition, repeated irrelevance, anger suddenly discharged . . ."

The best writing is born out of anger. *Coagula* says what we really think about Gogo, the Schnab, and the rest of the art-world annointed. Besides, that is what's interesting! Everything else is just the ABCs or hot air!

> *For God shall bring every work into judgment, with every secret thing, whether it be good, or whether it be evil.*
> —Ecclesiastes 12:13

The bottom line is the question of judgment. And a critic's opinion has weight to the degree of the critic's celebrity and power. Caesar's pronouncements are the ones that count at the Coliseum; who cares if a beginner votes yea or nay after a tour of the art shows?

The business of refining one's aesthetic judgments is, in the end, a poor pastime for grown men and women. Do not such "tender feelings," as Freud put it, have "primitive sexual feelings at their source?"

Better to consider, simply, what kind of labor is required to produce the work. Can it be more revealing to note that while the typical sculptor bangs away at a rock with a hammer, the artist Matthew Barney in *Cremaster 5* gets to kiss Ursula Andress and make up nude girls with ersatz male genitalia?

In this regard, a parting thought, taken from Richard Brinsley Sheridan's comic play *The Critic* (1779). A character named Sir Fretful is speaking: "The newspapers! Sir, they are the most villainous—licentious—abominable—infernal—Not that I ever read them . . . "

—Walter Robinson
New York, January 1998

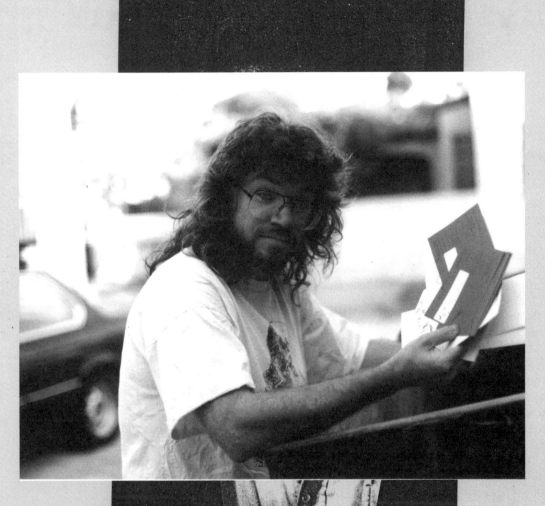

Coagula's esteemed editor, rummaging for art-gallery trash.

BOMBS AWAY!
BITTER BLASTS FROM THE BIG APPLE

Arnie and Morley: The Art World's Most Wanted

Like an arrogant caudillo, Arne (or is that Arnie?) Glimcher roosted on the cover of the *New York Times Magazine* with eleven aging White Male Artists (but mercifully, not Julian Schnabel).

What other dealer but Dim Glimcher could turn Robert Ryman into a hack and Donald Judd into an aging hippie? Allan Schwartzman's rim-job of an article paused occasionally to question Arnie's taste, but generally gave the impression that Arne is to artists what Alexiente was to coffee.

By the way, you don't think the puffery over "Glamcher" has anything to do with his threat to pull advertising from the *Times* last spring, do you? Most laughable was Mary Boone's quote: "Inevitably the artists are choosing between the same three dealers—Arne, Larry and me." Hey, Mary, you went into the showers back in the seventh inning! Do you think Larry Go-Go is panting after Roni Horn or that Arne Glim-Glam is afraid of a dealer who can't even hold on to Sherrie Levine?!?

The glum Glimcher piece highlighted what can only be called the Peronist phase of New York art-world history. Cultural philistine Morley Safer found easy pickin's in his September *60 Minutes* art-bashing piece. Collector Elaine Dannheisser fell on her sword trying to explain a Ryman painting and Morley got to mock a Franz Kline. What a man! Hey Morley, why don't you go mock "The Degenerate Art Show," you dumb asshole.
Issue 9, Winter 1993

Idiot Wind

Anyone who doubts that David Ross is the biggest moron in the history of the New York art world should check out the Whitmeister's communications with President Clinton. Last December, vapid David wrote Clinton that because the two of them had achieved generational positions of leadership, "Powerlessness is no longer in the equation . . . like the dog who finally catches the car he's long been chasing, we are now confronted with the question 'What Next?'"

Ross went on to ask Clinton rainmaker Ronald Feldman to insert a reference to the Whitney's highly suspicious Seoul Biennial annex into one of the President's mid-July Asian speeches.

With encouragement like this from what Clinton considers the art-world elite, the NEA

may soon be funding hog-calling contests at halftime of the Alabama-Arkansas football game.

Issue 8, Autumn 1993

Pay the Toll

I recently discovered a new twist to the old joke about Carnegie Hall. You know the one, where a tourist asks a New Yorker, "How do you get to Carnegie Hall?" and the New Yorker responds, "Practice, practice, practice!" Well, it seems as if the young neo–Abstract Expressionist painter Suzanne McClelland has given us an art-world version of that old show-biz saw. How do you get a show at the Whitney Museum? If you are McClelland, your family reportedly donates thousands of dollars (and thousands and thousands until you hit seven figures) during 1992 and you end up with a big solo show at the Philip Morris branch of the Whitney and then in 1993 you make the Whitney Biennial. Pretty good for a painter whose dealer is Stephanie Theodore.

Issue 6, April 1993

Jasper Johns: The Accidental King

Staring out, with coy vapidity, through a white Lifesaver on the cover of September's *Artforum*, the young Jasper Johns appears as fey and antiquated as the young Buster Keaton in *Steamboat Bill Jr.* Under the mesmerizing arch of his eagle eyebrows, Johns invites us back to a fragile past, where thin specimens of rough trade fucked each other on studio floors while a pretty young coed went out for beer and cigarettes. Johns was, and is, an icon of private art thrills, champion of what's left unsaid while his sleek hand caresses your nuts.

Contrary to Rosalind Krauss' post-menopausal bleatings in *Artforum*, Robert Hughes was right when he wrote in 1977 that Johns' career had produced few masterpieces, and none since 1965. Johns would argue that this is precisely the point, for he has taken Duchamp's jokey indifference to artistic output and made it the *raison d'être* for his own neurotically casual production.

When Johns comments that he can't draw or he's ripping off other artists, words that befuddle the woolly-headed Krauss, old Jap (as his friends call him) is being nothing but honest. Since the long-ago structural grandeur of *Green Target* or *Flag*, making spatial sense of the picture plane has become a constant irritant for Johns, the pearl in the oyster.

The famous hatches and erased hatches of the seventies and beyond testify to the artist's torture in filling space. Nothing could be further from the world joy of creation than the push-pull of Jasper Johns in the studio. Yet, as with Duchamp, this is precisely what so wildly endears the art establishment to everything Jasper. Let him steal from his inferiors, James Rosenquist, Larry Rivers, and Philip Guston; cough up millions for redundant self-imitations like *Highway*; reproduce *Flag* on shopping bags, towels, and coffee cups: you can't escape a nauseating antiquity fibrillating with existential horror.

Jill Johnston has offered up the stunning proposition that parental sexual abuse permeates Johns' iconography. To Johnston, Johns embodies an Oedipal longing similar to W. H. Auden's famous desire to be fucked by his father. The hypothesis hit home as Johns brutalized Johnston on the record in the September *Vanity Fair*, hinting that she had father-fucking problems of her own (so's your old man!!).

It's a safe bet that the future will have little use for Johns and his scraggly corpus. After all, we don't look at silent films now much, either. Johns' oft-repeated wish to have all his work on permanent display in museums only speaks to his own insecurity on this score.

Yet Johns' approach has been wholly justified, in a way Duchamp especially would appreciate: he got it while it mattered, while it happened, when he was alive—and fucked us all, but good, in the process.

Issue 25, January 1997

Reconsidering Rauschenberg

"No Good Deed Goes Unpunished." Such is the epitaph of Robert Rauschenberg's long, colorful career. Rauschenberg's political involvement, personal advocacy, and physical machismo have made him a figure as colorful as Manet or Caravaggio, and a distinct object of ridicule like Whistler or Thomas Hart Benton. The oh-so-chi-chi types, whom Rauschenberg used to have in his hip pocket, now whisper that Bob has spread himself too thin or, as one museum curator put it indelicately, "Jasper was always top man on Bob."

To be sure, Rauschenberg has always been his own worst enemy, throwing great parties, drinking too much Jack, getting in a messy palimony spat with longtime assistant Terry Van Brunt, socking Robert Scull in the gut, and daring twenty-five years ago to ask, like Oliver Twist in the orphanage, for modest artists' commissions on resales.

Yet even a close perusal of Bobby's aesthetic excesses easily shows that Rapid Rausch was ALWAYS ahead of the curve. Fifteen years ago Rauschenberg emptied his studio into the over-the-top "Smiles of Art" exhibition at the Met. Donald Lipski and Chris Burden, among hundreds, have since ripped off this bit, while an aging Jason Rhoades has based his entire career on this gesture. Rauschenberg's much-ridiculed R.O.C.I. Project, in which he collaborates on projects with indigenous peoples from China to Brazil, seems the single credible inspiration of hack schmoozer Rirkrit Tiravanija.

Of course, Bad Bob's combines have become the basic building blocks of the new sculpture, and Rauschenberg was the pioneer of minimal conceptualism with the spare flags, his monochromes, erased de Kooning, the white-on-white series, all influential reductive machines that he produced in the early fifties.

Ileana Sonnabend owns and exhibits much of this excellent work. Neglected stuff like Bobby's black-and-white photograms from the sixties (which were tastefully shown at Brooke Alexander last year) presage the inferior work of Lorna Simpson or David Salle. After dipping precipitously in the late eighties, Rauschenberg's market value is soaring, which is, of course, the primary reason for this fall's double retro at the Guggenheims Up and Down. Yet the sense that Rauchy is less than an art giant has already produced some passive/aggressive behavior from the Goog's boss, old Thom Krens. According to the *New York Observer*, when Rauschenberg signed a much-mocked deal to design ties for Hugo Boss, the Goog's staff strenuously denied having anything to do with cutting the deal. Then on June 30, the *Observer*'s Art Diary reported that Hugo Boss had announced that Rauschenberg would be dressing windows instead, heaping further humiliation on the now clean-'n-sober seventy-one-year-old legend. After thoroughly dragging his reputation through the mud, the *Observer* reported in late July that a Rauschenberg spokesman told them that the artist never even considered any of the reported arrangements.

A sad consequence of the contemporary art world's commercial lust is that even our greatest artists get trampled under by the Thom Krenses and the David Rosses, people who have never done the kind of unconditionally generous acts that Bob Rauschenberg commits every day. While his classic work sells for millions, corporate dicks allege that Bobby has to whore himself once again to fund a show.

How Rauschenbergian!!

Issue 29, October 1997

Boze Update

Jack Tilton, John McEnroe, and Eric Fischl were right on the scene as Armenian artist Zeke Zadikian wrote *Tony is a Boze* on Tony Shafrazi's gallery windows one bright spring morning. *Boze* is Armenian for whore.

Proving that sleazeballs come home to roost, Zadikian hurled a brick through Shafrazi's window the next day for good measure, as innocent artist Diana Balton cringed inside the gallery.

Inquiring minds smelled a put-up job when Shafrazi declined to press charges, and further odors ensued because Zadikian's work was being exhibited at boss thug Baghoomian's new gallery (!!!!) in the old Shafrazi space on Mercer Street.

Bags' space has all the charm of a mob clubhouse on Mulberry Street and the goons to match, by the way.

Shame, shame, shame on *Artforum* for taking an ad from this guy.

Issue 17, May 1995

This column breathlessly tries to keep up with Mary Boone's love life, but it's hard work, though not as hard as Ron Warren's!! Mary's newest cupidly conquest? Longtime Kent director Doug Walla, which inspires this Mary Boone cheer:

Walla, Walla Walla! Mary wanna holla!!

When he starts to spoon her,

Walla, Walla Booner!!

No wonder Jim Corcoran got married!!

Issue 20, Spring 1996

Weirdly enough, it's time to ponder the 1997 Whitney Biennial (it's only a year away). Egomaniacal curatrix Lisa Phillips has a long track record at the Whitney and a very mixed reputation in New York. Bringing in Louise Neri (editor of *Parkett*, the snobbiest of all art magazines) assures an elegant rim-job of a show.

Expect Phony Phillips to heavily aggrandize herself (this *is* the woman who announced her wedding in the *New York Times* one week after Klaus Kertess got hammered for the last Biennial).

Phillips is a real starfucker, no matter how worn and has-been the stars, so expect Eric Fischl, David Salle, Kenny Scharf, Ross Bleckner, Dennis Hopper, and Julian Schnabel in the survey show.

She's also extremely ambivalent about other women à la Mary Boone, tending to prefer those she can suck up to, such as Jennifer Bartlett, Sherrie Levine, Jenny Holzer, and Elizabeth Murray.

Based on her "Beat Generation" show,

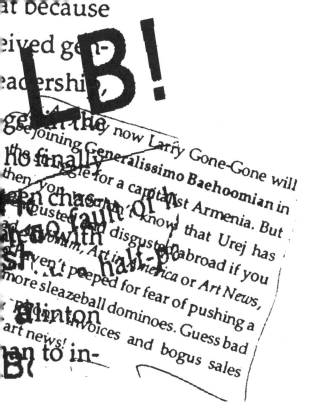

at because
eived gen-
eadership,
LB!
L.A. now Larry Gone-Gone will
go joining Generalissimo Baehoomian in
the finally able for a capitalist Armenia. But
then you chasing "Or know that Urej has
Houster disgust abroad if you
down, Art in America or Art News,
ven't peeped for fear of pushing a
more sleazeball dominoes. Guess bad
Klinton invoices and bogus sales
art news!
an to in-

Phillips might be expected to seduce L.A. in a big way, but she'll probably recruit old males like Wayne Thiebaud, Mike Kelley, and Ed Moses.

Look for Phillips to avoid Kertess' mistakes by de-emphasizing painting, not elevating unknown younger artists, and disregarding critics like Roberta Smith and Jerry Saltz. She'll make sure that the accent will definitely be on *Showtime*!!!

Other artists to expect from Leering Lisa:

Nam June Paik, David Bates, Judy Pfaff, Carroll Dunham, Jasper Johns, Alex Katz, Roy Lichtenstein, Alexis Rockman, Ellsworth Kelly, Jeff Koons, Meyer Vaisman, the Starn Twins, and Vija Celmins.

Suggested Title for Biennial '97:

K-Tel Curations Presents the Eighties' Greatest Hits.

Issue 21, Spring 1996

Whenever we hit them extra hard, the boy-toys at *Artforum* turn Coagulesque for an issue or two before returning to their standard sycophancy. Case in point: the September *Artforum*, with its expanded review section. David Rimanelli rips into the slipshod disorder of Damien Hirst at Gagosian, for example. Lane Relyea claims that Lari Pittman's work is grandiose and overreaching. There's a long-overdue attack on hack Brit Leon Kossoff, and brit crit James Hall, reviewing a Jasper Johns show at Leeds University, asserts that when Johns abandoned sculpture in 1961, his work went to hell. Featurewise, however, *Artforum* still sucks hard. Even publisher Knight Landesman told us at the Anna Kustera opening that Christopher Knight's incomprehensible piece on Johns was "an absolute failure."
Issue 24, Mid-August 1996

An angry Jeffrey Deitch shouted over the phone to an unidentified client, "Anthony d'Offay is trying to manipulate the market!"

The subject: Kiki Smith's signature sculpture *Pee Body*, a plaster sculpture of a woman urinating, which d'Offay wrested from Deitch in furious bidding for $285,000 at Sotheby's spring sales (way, way over its $60,000–80,000 estimate). Deitch continued, "d'Offay is so distrusted that Barbara Gladstone won't consign any Matthew Barney photos to him!"

But did d'Offay really get such a good deal? According to Richard Polsky's *1997 Art Market Guide*, Smith "doesn't have much talent . . . she knows neither how to draw or sculpt a figure. When Pace signed up Smith, it raised a few eyebrows in the art world. Arne Glimcher certainly has a good-enough eye to know the difference between his immensely talented stable

of artists and a minor talent like Smith. But Glimcher is not immune to art-world pressures to be politically correct. . . Collectors will perceive this to be a ground-floor opportunity. It's not."

Thank you, Mr. Polsky, although, in Smith's defense, anything Richard writes has to be taken with the warning that his 1997 guide actually recommends buying Chuck Arnoldi.
Issue 28, Summer 1997

Any day now Larry Gone-Gone will be joining Generalissimo Baghoomian in the struggle for a capitalist Armenia. But then you wouldn't know that Vrej has been busted and disgusted abroad if you read *Artforum, Art in America,* or *Art News,* who haven't peeped for fear of pushing a few more sleazeball dominoes. Guess bad loans, phony invoices, and bogus sales aren't art news!
Issue 3, August 1992

He's at it again!! A January evening found Vrej "Scum" Baghoomian flying the coop. His name has been quickly painted out on scumbag's Mercer Street space, and no one knew Vroom Vrej's whereabouts. Bags didn't pay for his full page ad in *Artforum,* of course, and left a barndoor-size clue by not listing an address or phone number in the ad! Hey, Frank Stella, that solo show at Baghoomian last fall really boosted your career, didn't it?!?!
Issue 20, Spring 1996

For once, this column agrees with Josh "Shrinkin" Baer: Pepe Karamel is an idiot. Reviewing the mouthwatering show of Duchamp ephemera, "Documenting Marcel," at Reinhold-Brown Gallery, Karamel carped that Duchamp's famous chess game with a nude

babe at the Pasadena Art Museum was "one of those embarrassing pieces where avant-garde intersects with the *Playboy* philosophy."

Let's spell it out for Pepe le Pew: much of Duchamp's work oozes sex, *Bride Stripped Bare* was the gangsta rap of its day, and maybe, just maybe, Marcel was using chess ironically, okay Pepster? Anyway, hasn't the steady stream of Duchamp shows been a joy?!?
Issue 22, Summer 1996

Anyone who doubts that **David Ross** is the biggest moron in the

wrote Roberta Smith, t

own, hit an alltime

review of ha

JAN

Keaton in *Steamboat Bill*. Under the mesmerizing arch of his eagle eyebrows, Johns invites us back to a frag specimens of rough trade fucked each other on studio floors, while a pretty young co-ed went o

Lisa Phill

Johns was, and is, an icon of private art thrills, champion of what's left unsaid while his sleek hand caresses your nuts.

ambivalent

Contrary to Rosalind Krauss' postmenopausal bleatings in *Artforum*, Robert Hughes was right when he wrote in 1977 that Johns' career had produced few masterpieces, and none since 1965. Johns would argue that this is precisely the point, for he has taken Duchamp's jokey indiffer-

Art-world bigshots met on the midway, Damien Hirst's oddball freak show at Gagosian. Hirst's crack installation crew was still struggling at 3 P.M. the afternoon of the opening, trying to arrange a giant ashtray full of butts, a sectioned hog, eight pieces of cow in formaldehyde, and two huge wheels on the wall.

The unsatisfying result didn't deter those on the list: David Bowie (his face is now pierced from tip to top), actress Debbie Mazar, *Vogue* editrix Anna Wintour palefaced in a faux-leopard suit, a scummed-up Julian Schnabel, Ivor Bracker (who purchased the hog), and an exuberant Roy Lichtenstein.

After telling the *Times* that he would take $20 million from Chanel for his Soho space, Larry Gagosian split the party early for Pravda, that pretentious vodka-and-cigar emporium, where guys like Go-Go can always go-go in search of a quick lay.

Issue 22, Summer 1996

Big-dealer-in-his-own-mind Daniel Templon begged and begged Jay Jopling to consign him a Damien Hirst spin painting, alleging that he had a buyer for it. Joppa the Whoppa finally relented.

When Jaybird arrived at the Chicago Art Fair, however, the Spinner dominated Templon's booth!

Issue 23, September 1996

Appearing on *The Charlie Rose Show* with David Bowie to plug his ego-trip *Basquiat*, human douchebag Julian Schnabel opined that "Andy Warhol was one of the most misunderstood people since Hitler."

Charlie Rose: "Hitler was misunderstood?"

Schnab the Slob: "Well, maybe he wasn't."

What level of idiocy, bombast, ignorance, and incompetence will Schnabel have to reach before he permanently disappears from the radar screen?

Issue 23, September 1996

Ron Athey, the late Bob Flanagan, and sado-masochists everywhere are under attack at the European Commonwealth court in Strasbourg, Austria. A dozen Brit Sex 'n' Suffer artistes are appealing their 1991 convictions in English

courts. Their crime? Inflicting consensual harm on each other as art. Citing copious examples of performance video from Ron and Flan, the convicted claim artistic freedom—always a dicey defense in relativistic, Machiavellian Europe. We'll keep our victims posted . . .
Issue 24, Mid-August 1996

A-list billionaire collector Eugene Thaw desires one thing, and one thing only, that he doesn't have—an appointment to the board of the Frick Museum.

To that end, Generous Gene donated a priceless Bernini to the museum—but there's just one problem. The Frick reportedly has a reputation for anti-Semitism. Good luck on cracking that ceiling, Gene.
Issue 26, March 1997

That was transgressive vet Richard Prince outside Armani's SoHo store cursing the sky, while his wife and daughter shopped inside. "I shouldn't be at Armani," Prince prattled, "Armani is the enemy!!!" It seems that the Princeling is suing Armani, with justification, for allegedly appropriating one of his images without permission or acknowledgment. Nan Goldin and Jack Pierson are in the same boat. (Let's also forget that Der Princester invented the appropriation game twenty-five years ago!!!)
Issue 30, December 1997

No humiliation meted out to Larry Gagosian in this column could match the hammering from *New York Magazine*, which featured Gaga in a piece on "walkers," the men who escort the ladies who lunch. *New York* added a dimply snapshot of Larry Lothario to its list of noited fruits like Bill Blass, Barry Diller, and the late Jerry Zipkin. Seems that the Armenian gigolo has been spotted with one too many merry widows—get thee to a nunnery, Larry!!!
Issue 21, Spring 1996

Janet Preston, aka Charlie Finch

THE GAGOSIAC ERA: A LARRODY

by Janet Preston

1992

- Leaves Chelsea years before anyone else gets there.

- Hires Robert "Pinky" Pincus-Witten, who curates Max Beckmann portrait show.

- Starts seriously sucking up to Leo Castelli, who is, at first, flattered.

- Steals Peter Halley from Ileana Sonnabend.

- Buys a Porsche and moves into his oceanfront Hamptons manse.

- Starts practice of presenting master shows where only one work is for sale; lenders provide works just to go to Gaga's parties.

- Commissions "Yves Klein Blue"–style bust of himself.

The LowDown on High Art

COAGULA

(Ko-WAG-yoo-luh) ART JOURNAL • MAY, 1997 • FREE

Larry GAGOSIAN asks

...buddy, Can you $pare a Million?

our 5th anniversary edition

moolahraptor

#27

- Moves into David Geffen's 69th Street double town-house, near the Sculpture Center.

- Opens cavernous SoHo space.

- Regularly picks up chicks in the poolroom at Rex.

- Exhibits Chris Burden's giant LAPD uniforms.

- Hires socialite curator Susan Forrestal, who is immediately profiled in the <u>New York Observer</u>.

- Guarantees David Salle a reported $3 million advance against sales.

- S. I. Newhouse tells the <u>New York Times</u> on the record, "I have never been a financial backer of Larry Gagosian."

- Hooks up with Planet Hollywood czar Keith Barish.

- David Geffen allegedly gives Gagosian a $40 million fund to buy art.

- Shows Jackson Pollock's "Black Enamel" paintings,

uptown New York.

- **Starts short-lived co-gallery with Leo Castelli at SoHo's GS Thompson Street.**

- **Battles with Bruno Bischofberger over consigned Philip Taaffes.**

- **Starts dating Detroit supermodel Veronica Webb.**

- **Forgets to tell Peter Halley that his solo show has been canceled in favor of Cy Twombly until the ads come out—Halley departs.**

- **Withholds stipend payments from David Salle.**

- **Hires former Khouri Wingate partner Ealan Wingate.**

- **Begins lucrative arrangement with Warhol Foundation, leading to numerous solo shows.**

- **Castelli cools.**

- **Hires Francesco Clemente crony and Huntman Press founder Raymond Foye.**

• **Larry in London: Looks at spaces with prospective partner Charles Saatchi while dating Jay Jopling assistant Honey Duart.**

• **Larry in Switzerland: Visits legendary Picasso dealer Jan Kruger, but returns sans Pablos.**

• **L.A. gallery strip wars commence with Arne "The Suit" Glimcher.**

• **Allegedly starts sending chauffeured limousines, unbidden, to a wealthy New York female gallerista.**

• **Hires longtime Richard Bellamy sculpture curator Barbara Flynn.**

• **Tells L.A. real-estate mogul Eli Broad "Go fuck yourself!!" in public.**

• **Hires Spencer Tomkins, son of legendary <u>New Yorker</u> critic Calvin Tomkins.**

• **Gaga factotum Robert Pincus-Witten and Ealan Wingate play judge and counselor in a <u>New York</u> magazine fashion spread.**

- Tells Bob Colacello in <u>Vanity Fair</u> about "the Havermeyers" (sic), famous Met Museum benefactors. (It's "HAVEMEYERS," Gaga!!!)

- David Geffen allegedly asks for his money back, gets Philip Taaffe's instead.

- Signs sculptor Elyn Zimmerman, wife of MoMA painting and sculpture chief Kirk Varnedoe.

- Only gets B-list crowd at his Venice Biennale bash at Harry Cipriani, the same night Shanghai collector David Tang throws a bash for Princess Diana at the Palazzo Grassi—Larry furious at being upstaged.

1996

- Organizes L.A. tribute show to Leo Castelli— Castelli unmoved.

- Dumped by Veronica Webb, allegedly over fidelity issues.

- Featured in <u>New York</u> magazine article on "walkers"—men who escort wealthy women to parties.

- Hires Nadine Johnson, spouse of "Page Six" legend Richard Johnson, to do publicity.

- Damien Hirst show opens in SoHo to mixed reviews.

- Gianni Versace, who bought a lot of the Taaffes from Gaga, "borrows" Taaffe's designs for his frocks. Taaffe upset.

- Robert Pincus-Witten leaves for C&M Arts, allegedly because he's asked to work just on commission. "It's a good move for Robert," Gaga tells the press.

- Starts withholding rent on his uptown space from landlord Ralph Lauren, for unspecified reasons.

- Gets multimillion line of credit from Bank Negera, former State Bank of Indonesia.

- More relaxed Larry starts manning the front desk at his own openings.

- Philip Taaffe finally leaves Gagosian, has a show at Peter Blum.

- **Tells fellow diners at Odeon that "Jackson Pollock is the greatest American artist."**

- **Nightly regular with the chicks at SoHo's Balthazar.**

- **Gagosian staffers put pressure on <u>Art Newspaper</u> editor Anne Summerscop to report that Taaffe is leaving.**

- **Pattern of stiffing small Los Angeles vendors, like limo companies, allegedly emerges.**

- **IRS review withdraws $13 million bill to Gagosian—should have gone to defunct tax shelter.**

- **Appears to back off regular compulsive womanizing.**

L.A. SCENe: Straight Shots from the City of Angles

by Mat Gleason

Censorship of Filipino Art Goes to the Dogs

NOTE: If you read coverage of this story in the L.A. Times, *you missed the ending.*

LOS ANGELES–When Adolfo Nodal, head of the Los Angeles Cultural Affairs Department, backed down from his censorship of the Filipino Grupo de los Gagos show at City Hall, many people remarked how rare it was to see him eat crow. Few realized that he probably ate some dog, too!

An incident of artistic freedom versus government enforcement of antistereotyping came to a head this spring at Los Angeles City Hall. The Grupo de los Gagos (Group of Fools, an association of Filipino artists) exhibited work that was at times sexually explicit in the City Hall rotunda, to the consternation of prudish City Hall employees. But it was a banner announcing the show and featuring a drawing of a mutt being roasted on a spit that Nodal chose to cleanse from the exhibit.

"He made it seem like he wasn't the bad guy, that he was under pressure," GDLG member Freddy Agriam told *Coagula*, "but he was really vague on exactly who was offended and by what."

In walking one of the finest PC tightropes ever, Nodal reportedly alleged that Filipino city employees considered the banner to be an illustration of a negative cultural stereotype and had asked for its removal. Nodal insisted to GDLG members that since the banner was only an announcement, it was not actually "art," therefore, he was not actually a "censor."

When they didn't buy this bullshit, Nodal gave them his utmost assurances that he would try to work out a compromise amenable to both parties; translated, this means he was going to sit on his ass and do nothing (and get paid for it) since the show was less than a month from closing. Group members then threatened to pull the entire show, citing censorship. Even though the *L.A. Times* regularly kisses Adolfo's butt, he

LOS ANGELES
Cultural Affairs?

circa 1970s

PG. 13 HALF-TONE
NO. RIAC

decided at the eleventh hour to avoid any potential bad publicity and work out a compromise. The Group agreed to keep up the show if Nodal would rehang the banner and arrange a meeting between them and the "offended" parties.

But the group had a trick up its sleeve—they brought a little appetizer of their own to the meeting. Somewhere within driving distance of L.A., a little old Filipino man raises dogs to be sold as food. Group members selected a dog and, just like visiting the butcher shop, waited as the man prepared the meat for them to take home—except they took it to City Hall!

Among a table of "appetizers," GDLG members placed a plate of delicious Filipino eggrolls, doggie-style. The Filipino-American civil servants in attendance decried the group's imagery of certain aspects of their culture (eating dog) which are offensive to Middle America. Many in attendance did this while eating (eggrolled) dog!

One City Hall insider close to *Coagula* noted that in addition to looking well-fed, Nodal really shouldn't be feared by artists who want to take a stand. "His bark is worse than his bite," she said.

Issue 8, Fall 1993

It Seems . . .

Hot painter Manuel Ocampo couldn't wait to see *Beverly Hills Cop 3*—so he called the B.H. police to meet him at Fred Hoffman's Rodeo Drive gallery space to assist in the retrieval of paintings that Pit-Bull Fred was balking on returning. Hoffy had told Ocampo that it was too late in the day to load up artwork the artist wanted back from the notorious dealer. Ocampo and entourage showed up anyway, just in time to see the movers carrying out a large canvas. The men in blue

Brady Westwater bewildering Manuel Ocampo.

were quickly summoned and Hot-Head Fred was forced to relinquish the two pieces (each valued at around $20,000) in his possession. Ocampo's camp alleges there are more. The

Hoffmeister isn't talking and is currently dealing out of his garage. Don't forget to take out the trash, Fred.

Issue 13, Summer 1994

Editor's Column

It was the most forgettable show of the entire Bergamot Station complex preview, yet *L.A. Times* scribe David Pagel said it transformed the gallery into a "pirate's cove."

It was the least-inspired blend of kitsch and art history since Warhol's *Last Supper* scams, yet Kristine McKenna gave it a major Calendar spread as if it were the second coming of an Andy or Christ or some combination thereof.

Its articulations of pop culture were so backwardly uncouth it made Trivial Pursuit seem profound, yet the normally sane David Greene was found drooling throughout his previously unreliable *L.A. Reader* column.

IT? A solo show by Joel Otterson at the Shoshana Wayne Gallery at Bergamot Station. The reason for such hype: a ludicrous assertion that blending skeletons, ceramic thrift-store tchotchkes, jukeboxes, and Guns & Roses references qualifies as a practice remotely similar to the making of art.

The show's real secret was its Schnabelesque hetero penchant for bombastic presentation of a queer aesthetic . . . and it looks like it fooled a lot of dweebs.

Issue 15, November 1994

Call her delusional, call her borderline, but one late-fortyish gallerist cornered me in her space and rambled on and on, STARK RAVING MAD (now, we're not talking letting off a little steam, we are talking bipolar, near-schizo, flashing-lights-and-sirens Meltdown) about the fact that the murder of Nicole Simpson and Ron Goldman happened the day after one of her gallery's openings and took all of the potential press and word-of-mouth she should have gotten away and how she hasn't been able to recover from the tragedy of having her big moment dwarfed in the headlines by the infamous murder and how can she ever hope to get the attention of the L.A. art scene that she damn well deserves, could I do something for her? Yes. I can do something for you as soon as the Pope okays euthanasia in hopeless situations.

Issue 18, Fall 1995

If right place, right time were ever used to describe the career of one artist, it is certainly L.A.'s Victor Estrada. While someone as talent-free as Mr. E. might labor years in obscurity, grade-school teacher Estrada had the good fortune of picking a studio near Mike Kelley and working his way into that infamous UCLA clique that revolutionized the way art-world schmoozing was done.

So it is no surprise that Kelley-champion Christopher Knight also roots for Estrada's blip-on-the-screen career. Knight raved about Estrada's contribution to MOCA's "Helter Skelter" show (when he was universally agreed to be the show's weakest link) while disparaging Manuel Ocampo (recently awarded the Prix de Roma).

Estrada's synchronous karma hits again: his show at the Santa Monica Museum (reminiscent of piñatas designed by drunks) is in tandem with Hannah Wilke's dramatic documentation of her ultimately fatal struggle with lymphoma. Enter Knight, poison pen in hand. Wilke is (1.) a woman, (2.) not gay, and (3.) greatly assisted by her capitalist art dealer Ronald Feldman. Three strikes and Estrada gets a glowing review.
Issue 19, Winter 1995

Calling Oprah . . .

Most everyone has heard that L.A. County Museum curator of twentieth-century art Maurice Tuchman was recently demoted to curator of twentieth-century drawings. Many have since heard audible sighs of relief from many women in the local arts community who held the "Mighty Tuck" in the same esteem as Clarence Thomas and Senator Bob Packwood. As a county employee and civil servant, though, he is appealing the reassignment.
Issue 7, Summer 1993

Los Angeles Scene

You're Richard Koshalek. You run L.A. MOCA, a world-class museum. You boost

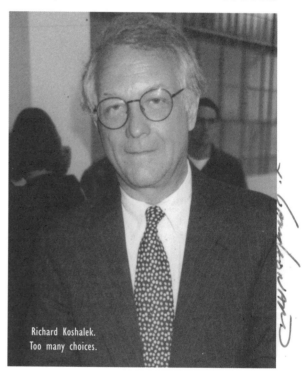

Richard Koshalek.
Too many choices.

emerging careers, revive sagging ones, and help write the art history of this century.

And yet when it comes to those momentous decisions, the advice of a close friend is always the most trusted. So we're very glad you called in Frank Gehry to choose the color to repaint your office. It takes a real man to admit when he's in over his head.

Issue 12, Spring 1994

When a young MOCA employee was fired from his job at the bookstore in 1992 for not bathing, nobody knew then that the building he worked in would later be named after David Geffen, nor that David Geffen's record label would sign the quiet kid to a million-dollar record deal, launching a major music career. The unbathed singer/bookstore clerk was also the grandson of the late Fluxus artist Al Hansen. . . . He's now known to Generation X simply as Beck.

Issue 23, September 1996

Editor's Column

Earth to Christopher . . . Come in, space cadet number one . . . Sound familiar? It was the reaction of many to *L.A. Times* Art and Entertainment honcho Christopher Knight and his pompous December 19 Calendar editorial about the state of art in L.A. entitled "It's Not About Money." In it, Sister Mary Knight disciplined us all for blaming rich people for cutting off the money supply known as the 1980s. He then pointed his smelly little finger at Al Nodal and L.A. Cultural Affairs (mirroring the Rush Limbaugh school of thought that government programs are always easy targets. What's next, fag-bashing?); he pointed it at everyone for not having a John McLaughlin retrospective (I've got a soft spot for John, and Lorser Feitelson as well, but I don't blame a cynical scene on the lack of their visibility). While pointing at us all, Lil' Chrissie went on to whine that charity begins at home and that we should support alternative spaces but not private dealers working out of their homes!

The problem isn't money, I will agree. So what *is* the problem? The problem is *L.A. Times* art critics writing rave reviews of shows by their friends—shows that actually suck. The problem is *L.A. Times* art critics reviewing galleries they have (past and present) relationships with. The problem is *L.A. Times* art critics reviewing artists whose work they own (or shall we say, have invested in). The problem is *L.A. Times* art critics trumpeting condescension-specialist Mike Kelley as if he were our post punk savior. The problem is *L.A. Times* patriarchal art critics reviewing shows of questionable worth in turgid prose while simultaneously axing columns (by women writers) covering the L.A. art scene (was it sexism or just the lack of advertising revenue?).

This is a one-paper town. The *L.A. Times* is a public trust when it comes to offering opinion. Knight and his twisted visions run amok, unchecked by the apathy of a publisher whose desire to have a world-class paper

means only that art reviews be printed, not that they be subject to even feeble scrutiny.

Knight-man and his youthful ward Davey Pagel should find a Metropolis that doesn't mind having its art scene directed by the whims of two pretentious versions of "Regular Dudes."

It's not about money—it's about Christopher Knight's amazingly myopic visions for the cultural life of Los Angeles. *Issue 11, Spring 1994*

No Daylight for Knight

On August 21, the *Los Angeles Times* published an essay by Christopher Knight that established a benchmark for hissyfit misogyny. In it he accused L.A. gallerist Sue Spaid of being in a conflict of interest over her curation of art shows for some local non-profit spaces.

Knight's attack might have had some weight *IF*

1. Sue currently had a storefront.

2. L.A. nonprofit spaces didn't specialize in tchotchke shows.

3. We were certain Knight was above conflict of interest.

The *Times* Calendar section ran rebuttals by dealer Paul Kopeikin and art activist Fred Dewey but reportedly turned down more than twenty other essays. Was one of them yours? Send it in—*Coagula* wants to run excerpts from them. Apparently, Knight

wrote some responses to some of you. Send them too. Following is the essay I submitted to the *Times* (it was never printed, nor did it garner a response from CK).

In response to Christopher Knight's "Nonprofit Groups' Credibility on Line with Dealer Shows," *L.A. Times*, **Saturday, August 21:**

Sir Knight.

Christopher Knight made some ridiculous assertions in questioning the enlistment of an art-gallery owner for curatorial duties by local nonprofit art venues.

Knight was disingenuous from the start, labeling LACE as an artist-run space; it may

have been originally, but lately it seems to be steered by a group of arts professionals whose only artistic vision has been in writing grant proposals. But LACE and other non-profit institutions should be applauded for seeking out interesting curatorial visions. They should not be lambasted for failing to comply with Mr. Knight's outdated constructs of the sacrosanct public organization being untouchable by the best and brightest of the private sector. If these venues don't take chances at established ways of organizing shows, what credibility could they possibly have?

He sunk pretty low by consistently referring to local gallerist Sue Spaid as an art dealer, a label better suited to commercial peddlers of Dalí prints and Picasso posters. A gallerist develops emerging talent. A dealer puts whatever is selling on the walls. Sue Spaid is a gallerist in an art world desperately in need of quality. In running a gallery and curating interesting shows, her commitment to the local art scene has been nearly without equal in L.A.

Mr. Knight works for an entity of the public sector (Times-Mirror, Inc.) and reviews many exhibitions at major (nonprofit) museums. While he feels free to question the integrity of such commingling by others, no one has questioned his relationships or those of other *Times* art critics to these institutions and the artists they show. Perhaps they should. If Mr. Knight feels comfortable to point the finger,

perhaps he and the other critics at the *Times* could reveal the artists whose works they and their spouses/life-partners choose to collect. Are any *Times* critics receiving art from private-sector galleries which ends up in public-sector museum shows? If the *Times* art critics really want to stand on the bully pulpit of public moralizing, isn't the onus of responsibility on them to first be beyond reproach? Shouldn't full disclosure of their past and present holdings be a nominal first step before they stray away from art criticism into the testy waters of unbiased investigative journalism?

Issue 18, Fall 1995

BICoASTAL BARBS: THE BEST OF THE WuRST

Readers' List of the Most Obnoxious People in the Art World

First off, the bozo who tried to stuff the ballot box by mailing lists with nearly identical listings should have tried harder—pal, why not at least type one list out of the twenty you sent? You made your twos and fives the same way every time you wrote them. Second, please remember that all quotation marks indicate our readers' opinions.

Five Who Were Mentioned on Lists from Both Coasts:

Christo
"What you get when the aesthetics of bad planning go homicidal."

Jeff Koons
"Still trying to prove that he isn't gay."

Robert Hughes
"You're nobody until (and unless) he hates you."

Hal Foster
"'Anti-Aesthetic' was the Anti-Climax of his career."

Ashley Bickerton
"The coolest ex-surfer, postcommodity, hippie, beatnik, green environmentalist, multiculturalist. NOT!"

Some Honorable Mentions We Just Couldn't Leave Out:

Matthew Weinstein
"Has his butt grown as big as his head?"

Robert Mahoney
"Why doesn't he finish his novel?"

Stefano Basilico
"Beware after Thursday-evening shrink sessions."

Anthony Haden-Guest
"Takes his accent for everything it's worth."

Five Most Obnoxious People in the Art World on the West Coast:

Robert Berman
Mentioned on nearly every L.A. list
"He 'discovered' everyone."

William Wilson
The L.A. Times art critic
"If Wally Cox had been senile and aloof, he'd be William Wilson."

Separated at birth? Robert and Cheech Berman.

Eric Orr
"Rehashed Rothko without the soul."

Frank Romero
"Get some new ideas, already."

Richard Duardo
"Does he count as a member of the 'art world?'"

Five Most Obnoxious People in the Art World on the East Coast:

Daniel Weinberg
"And the women in his gallery . . ."

Pruitt-Early
"Trying to be black, but only succeeding in having brown noses."

David Diao
"A dedicated follower of fashion."

Barbara Schwartz
"The nightmare continues!"

Alain Kirulli
"A man who simply hates women."

The editors were surprised that former bad boy Julian Schnabel was not mentioned on any lists. "Proof," one staffperson said, "of what I felt about him all along. The man is utterly inconsequential."

Issue 2, July 1992

The BRIT Crits are coming

How, in an art world dominated by American art for fifty+ years, did the media personages of the art world become so distinctly British?

Coagula presents this guide to the three most visible art world authorities of the Nineties.

Suffice to say that, poses aside, not a one of these limeys would ever want mum to read them denegrating a Queen or supporting Irish self-determination.

Royal Subject:	Sister WENDY Beckett	Robert Hughes	Anthony Hayden-Guest
colony of origin	South Africa	Australia	ENGLAND
opus	*The Story of Painting*	*American Visions*	True Colors
scope of opus	12,000 years in 5 hours	300 YEARS IN 8 HOURS	25 years in 200 pages
opus starts with…	French Caves	Plymouth Rock	Spiral Jetty
opus ends with…	Lucian Freud	James Turrell	Ashley Bickerton
network	BBC	PBS	VH1
day job	Nun	Writer	keeper of the rolodex
would rather be…	*Praying for sinners like us*	Fly-Fishing	in the House of Lords
prominent physical attribute	Habit	Gut	Jaggeresque Lips
prominent physical defect	Teeth	Nostrils	BREATH
ya gotta wonder…	HOW LONG her canonization will TAKE	*if Ted Turner takes his calls.*	*Was Horace Harris a good kisser?*
On Warhol:	suspiscion	Contempt	ENVY
Critical Position best summarized as	The Status Quo has acheived masterful depictions of beauty and triumphs of the human spirit, blah blah blah…	If the picture illustrates a political or moral concept that I happen to endorse, then, by golly mate, it is ART!	This is important art if it will get me invited to the party, on the guest list or provide all the Guinness I can guzzle!

The Most Overrated Artists of the Twentieth Century as Voted by the Readers of *Coagula*

1. Julian Schnabel (153 points)
The insufferable bombast, the infernal posing, the pseudoliterate pretension; is he really *over*rated?

2. Joan Miró (139 points)
The best advertisement against modernism.

3. Keith Haring (125 points)
Basing a career on appropriating kindergarten stick figures may land you in a few collections, but taste catches up with everyone, eventually.

4. Georgia O'Keeffe (118 points)
Her commission to paint the ladies' powder room of the Rockefeller Center epitomizes the true appropriateness of her art.

5. Frank Stella (117 points)
Like Dylan, should've died in 1966.

6. David Hockney (111 points)
Refer to Matisse (#9) sans all but the trash compactor.

7. Robert Motherwell (108 points)
Elegy to a big American ego.

8. Helen Frankenthaler (102 points)
Better remembered as the mother of tie-dye.

(Tie) 9. Henri Matisse (99 points)
Three floors of MoMA could have been condensed into two galleries and one trash compactor.

(Tie) 9. Pablo Picasso (99 points)
A big dick.

11. James Rosenquist (91 points)
He was doing bad David Salle twenty years before Salle!

12. Jeff Koons (85 points)
Too bad they don't have cosmetic surgery for talent!

(Tie) 13. Marc Chagall (78 points)
They'll give anyone a retrospective . . .

(Tie) 13. Salvador Dalí (78 points)
The persistence of pedestrian concepts . . .

(Tie) 13. Donald Sultan (78 points)
As appealing to the eyes as his tarred lemons would be to the palate.

16. Jim Dine (70 points)
See Rosenquist comment above (#11) and merely substitute Schnabel for Salle.

17. Wassily Kandinsky (67 points)
Just because you're a pioneer doesn't mean that you're great.

18. Francesco Clemente (62 points)
#18 on the overrated list, arguably #1 on the worst list.

(Tie) 19. Frank Gehry (55 points)
Commissioned by Disney—case closed.

He's no LeRoy Neiman.

(Tie) 19. Hans Hofmann (55 points)
The Ab-Exer's Richard Simmons.

Runners-up

50–54 Points:
Joseph Kosuth, Andy Warhol, Robert Longo, LeRoy Neiman

40–49 Points:
René Magritte, David Salle, Henry Moore, John Baldessari, Eric Fischl, Anselm Kiefer, David Smith, Claes Oldenburg, Ed Moses, Alexis Rockman, Christo, Red Grooms

30–39 Points:
Karel Appel, Richard Diebenkorn, Richard Serra, Marcel Duchamp, Andrew Wyeth, Carl Andre, Franz Kline, Paul Klee, Sherri Levine, Roy Lichtenstein, Robert Rauschenberg, Gerhard Richter, Tim Rollins, Ed Ruscha, Cindy Sherman

20–29 Points:
Georg Baselitz, Jean-Michel Basquiat, Dan Flavin, Sam Francis, Adolph Gottlieb, Madonna, Kenneth Noland, Mike Kelley, Joel Shapiro, Haim Steinbach, Jonathan Borofsky, Willem de Kooning, Jackson Pollock

10–20 Points:
Ernst Ludwig Kirchner, Clyfford Still, Philip Taaffe, Paul Jenkins, John Chamberlain, Jasper Johns, Mark Lere, Robert Morris, Jacqueline Humphries

Issue 5, Winter 1993

1st runner-up: Martin "Red Roof" Mull.

Coagula
Art Journal
#16

Does The Art World Care About OJ?

Answer Inside

Bookstore/Newstand
Price: $1.00

7-20-80 HOLLYWOOD. CA.

Readers' Poll Featured List: The 25 Most Obnoxious People in the Art World

This list was compiled by our staff from reader responses received in the past few months. Final tallies were determined by number of ballot appearances. Multiple mentions on the same list were not counted (like the ballot that had Fred Hoffman listed #1–10 and as an honorable mention!). These lists are solely for use as entertainment. The opinions and comments expressed here were selected from reader responses for their wit and brevity by the editors of this paper but do not necessarily reflect the opinions or beliefs of anyone involved in the publication of this journal.

Los Angeles

1. Paul Schimmel (35 ballots)
Curator, Los Angeles MOCA.
Curated "Helter Skelter" group show.
"His pathetic attempts at shocking the public are the art-world equivalent of a prepubescent bedwetter."

2. Mike Kelley (30 ballots)
Old artist.
"When he points a finger and says 'Pathetic,' three fingers—along with intelligent people—point back at him."

3. Fred Hoffman (27 ballots)
Art dealer.
"The Pit Bull of West Hollywood."

4. David Pagel (21 ballots)
L.A. Times art critic.
"Greenberg Lite."

5. Gary Kornblau (19 ballots)
Editor, Art Issues newsletter.
"The vanity of Morrissey without the

Any publicity is better than none.

46

style meets the condescension of Christopher Knight sans good looks."

6. Randall Scott (15 ballots)
Former director TBA gallery.
"TBA—*T*alk, *B*ut no *A*ction."

7. Gregg Gibbs (12 ballots)
Glad-handing scenester.
"Makes Keith Boadwee seem house-broken."

8. Al Nodal (11 ballots)
Bureaucrat.
"He can't censor Mayor Riordan's upcoming performance piece, *Budget Axe at Cultural Affairs.*"

9. Steve Hurd (5 ballots)
Appropriator.
"Three words—take a bath."

10. Rachel Lachowicz (4 ballots)
Artist.
"Appropriating dead white male artists ain't feminism, honey."

New York

1. Barbara Schwartz (44 ballots)
Collector, dealer, decorator.
"Not only can money not buy taste, but in the case of Mrs. Schwartz it can't even buy good art."

2. Larry Gagosian (41 ballots)
Art dealer.
"The jury is out—would he make a better pimp or used-car salesman?"

3. Hilton Kramer (39 ballots)
Right-wing art critic.
"Wonder when that stick will ever come out of his ass—forty-three years is a long, long time."

4. David Ross (38 ballots)
Director, Whitney Museum.
Oversaw this year's disastrous Biennial.
"I can't imagine ever wanting to be a boring old white loser."

5. Mark Kostabi (37 ballots)
Celebrity.
"Go back to Fullerton."

6. Kim Levin (30 ballots)
Art critic, *Village Voice*.
"Won't somebody just tell her that
Stalin died in 1953?"

7. Liz & Val (29 ballots)
Artists.
"Gotham's very own disembowelers
of Dada."

8. Ross Bleckner (25 ballots)
Artist.
"The embodiment of hissyfit."

9. Ashley Bickerton (22 ballots)
Old artist.
"He hasn't mattered in four years
and he's *still* an irksome pest."

10. Tim Nye (20 ballots)
Rich kid.
"A fourth-rate aesthete lounging
around a third-rate space with some
second-rate bimbos."

11. Hudson (14 ballots)
Dealer, Feature Gallery.
"Perhaps his gallery's proximity to
the Holland Tunnel has produced
enough carcinogens in his lungs to
soon rid us of him."

(Tie) 12. Christian Leigh (10 ballots)
Independent curator.
"Portrait of a gay midget sumo
wrestler as unethical art huckster."

(Tie) 12. Paul Kasmin (10 ballots)
Art dealer.
"His favorite artist is Bottom Line."

14. Tony Shafrazi (7 ballots)
Dealer, "Sleazebag."
"You think he'd take a hint from
Jean-Michel and Keith, i.e., go die!"

15. Laura Westby (6 ballots)
Makes artists' stretcher bars.
"The worst wood, the biggest knots,
the wrong sizes, but always the best
excuses."

420 420 420 42) 420 420

Issue 8, Fall 1993

The Disembowelers: Liz & Val. (Liz on the left.)

Bicoastal Honorable Mention>

Art World Scavenger Hunt!

Are you willing to scavenge the trenches of the L.A. and NYC art worlds in search of the following items (some of which may not even exist)?

You should at least consider it, because this is a real contest and one winner will win the GRAND PRIZE—A free subscription to Coagula! Contestants may request anonymity, that is, if you don't want your name in the paper (but you may).

All submissions become the property of Coagula.

Find and deliver to this publication as many of the following items by March 24, 1994 (and remember, stealing is a sin).

1. Porn photo of **Ilona Staller** with any man *but* **Jeff Koons**.
2. Photograph of **Kim Light** dining with Black people at Denny's.
3. **David Salle**'s movie script.
4. Photo of **Julian Schnabel** with **Michael Ovitz**.
5. Photo of **Bob Flanagan**'s pre-pierced penis.
6. An issue of a publication with "Art" in its title that features an artist on its cover—but has no advertising from any gallery representing that artist in that issue.
7. **Fred Hoffmann**'s fingerprints.
8. **Karen Finley**'s panties.
9. **Raymond Pettibone**'s syringe.
10. Any "art" by **Morley Safer**.
11. **Margo Levin**'s TRW report.
12. **Frank Stella**'s speeding ticket.
13. **Tim Nye**'s report card.
14. Mug-shot of **Tony Shafrazzi**.
15. **Sue Spaid**'s bus pass.
16. **Steve Hurd**'s bath sponge.
17. A lock of **Rory Devine**'s hair.
18. **Doug Christmas**' tax return.

19. **Starn Twins**' birth certificate.

20. Handwritten note from **Jenny Holzer**.

21. Jockstrap signed by **Matthew Barney**.

22. **Peter Halley**'s wedding invitation.

23. Personal check from **Thomas Krens**.

24. Photo of **Leo Castelli** in Bell Bottoms.

25. Photo of **Mary Boone** in a bathing suit.

26. Nude photo of **Jacqueline Humphries**.

27. **David Ross**' resignation letter.

28. Childhood snapshot of **Ross Bleckner**.

29. Dollar bill signed by **David Geffen**.

30. hoto of **Jasper Johns** in a dress.

31. Tube of Clearasil autographed by **Mike Kelley.**

32. Original work of art by **Mark Kostabi.**

33. **Kim Levin's** Communist Party membership card.

34. A Finger-Painting by **Donald Judd.**

35. **Christopher Grimes**' cigar butt.

36. Tampon autographed by **Rachel Lachowicz**.

37. Any book co-authored by **Vrej Baghoomian**.

38. Photograph of **Robert Berman** eating a Sloppy-Joe.

39. Nude photo of **Candyass**.

40. Photograph of **Christopher Knight** kissing **Mike Kelley's** butt.

41. Demo tape of **Laura Howe's** "Too Much Girl" band.

42. Photo of **David Pagel** while employed at any So. Cal. gallery.

43. Business card from **Larry Gagosian's** old L.A. poster store.

44. **Christian Leigh's** discarded weight-loss books.

45. Ticket stub from NFC runner-up San Francisco 49ers signed by **Richard Koshalek**.

46. High school yearbook photo of an art world personality.

47. The two **Clive Barker** T-Shirts the **Bess Cutler** gallery promised us at the LA Art Fair.

Pete Townsend

Seminal figure in postwar music history

Born three months before Hiroshima

Use of power chord as simultaneous source of melody and power transformed Rock music and influenced countless future guitarists.

Tall and lanky Brit

Willingness to go beyond convention and stage a rock opera (*Tommy*) was generally successful but paved the way for a generation of pompous, overproduced Progressive Rock losers (*ELP, Styx*).

Works in London, but lives on an estate where he likes to spend time riding horses with his wife.

Historical impact has only been lessened by the completeness of his influence.

Smashing guitar during performance brought a loud, disconcerting and violent edge to performances.

Often useless appendage: Roger Daltrey

Synthesized the innovations of Chuck Berry with the voice of alienated British youth.

Probably best known for *Pinball Wizard*.

Peaked critically in early 1970s

Trademark: Guitar Windmill

Capitalist? Every third album by The Who seemed to be a *Greatest Hits* collection

Historically, may wind up playing second fiddle to Keith Richards.

Bruce Nauman

Seminal figure in postwar art history.

Born one day before Pearl Harbor

Use of language as simultaneous illustrative and conceptual medium transformed art and influenced countless future artists.

Tall and lanky Yank

Willingness to use unconventional media and installation was generally successful but paved the way for a generation of pompous, overhyped, anti-object losers (*Paul McCarthy, Mike Kelley*).

Shows in NYC, but lives on a ranch where he likes to spend time looking at paintings of horses by his wife.

Historical impact has only been lessened by the completeness of his influence.

Tortured clown videos brought a loud, disconcerting and violent edge to his retrospective.

Often useless appendage: Susan Rothenberg

Synthesized the innovations of Joseph Beuys with American love of TV and gadgetry.

Probably best known for neon crotch-kick

Peaked critically in early 1970s

Trademark: Cowboy Hat

Capitalist? Every piece he makes seems to have a series of prints like it available.

Historically, may wind up playing second fiddle to John Baldessari.

Best & Worst of '94 New York

Best Solo Show

Charles Spurrier

Best Group Show

"Mapping" at MoMA

Best Gallery

American Fine Arts Co.

Best Openings

Brooke Alexander

Best Museum Show

"Mapping" at MoMA

Best Emerging Artist

Jonathan Tucker

Best Trend of '94

Lower prices

Biggest Surprise

Art world still exists

Next Big Thing

Abstract Expressionism

Best Art Writer

Schjeldahl

Best-looking Artist

Les Ayre

Best Publication

Art in America

Best Hangout

Jerry's

Best 1994 Event

Artforum party at Markuhm

Worst Solo Show

Twombly

Worst Group Show

"Family Ties" at PPOW

Worst Gallery

Leo Castelli

Worst Museum Show

Twombly

Worst Curator

Thelma Goldin

Worst Trend of '94

Rich get richer

Worst Art Writer

Joshua Decter

Worst Publication

Parkett

Stupidest Artist

Ross Bleckner

Obnoxious Gallery Attendant

Ron Warren

Overrated Living Artist

Frank Stella

Superbowl Prediction

Dallas

Coagula should go after . . .

Galleries laundering money

Coagula should lighten up on . . .

Nobody

*Readers' Poll Conducted
November 1994–January 1995
Issue 16, January 1995*

Chris Burden	Jerry Garcia
• Overweight Art Star	• Overweight Rock Star
• Early critical success as the "angry young artist" led to career of making art about being the "angry young artist"	• Early popular success as the "drugged-out guitarist" led to career of making music about being the "drugged-out guitarist"
• Bloated reputation	• Bloated everything
• Famous for being shot in a gallery as part of a performance	• Famous for shooting-up backstage after a performance
• Wife in the Whitney	• Wife on acid
• Big ego kept in check by bigger gut	• Big beard kept in check by bigger gut
• Noted contribution to culture: *Medusa's Head*	• Noted contribution to culture: *Truckin'*
• Very influential wherever 22 yr.-old grad students gather	• Very influential wherever 50 yr.-old potheads gather
• Ungrateful	• Grateful
• Earned critical raves by combining the American hunger for spectacle with the European admonition for detatchment	• Earned critical raves by combining the American hunger for simplistic music with the overriding power of pure LSD
• Currently teaching art at a college in Southern California	• Currently resting in peace at a cemetery in Northern California

Jackson Pollock | Mickey Mantle

Jackson Pollock	Mickey Mantle
• **Trailblazing Artist**	• **Trailblazing Athlete**
• **Born in Wyoming, made it big in New York**	• **Born in Oklahoma, made it big in New York**
• **The defining artist of the 1950s, with the possible exception of Robert Rauschenberg**	• **The defining baseball player of the 1950s, with the exception of Willie Mays**
• **Heavy drinker, smoked tobacco**	• **Heavy drinker, chewed tobacco**
• **Brute force + precision = paintings**	• **Brute force + precision = pennants**
• **Surpassed his mentor, Thomas Hart Benton**	• **Surpassed his mentor, Joe DiMaggio**
• **In his whole career, he never made as much money as some current art stars get paid for a single work of art**	• **In his whole career, he never made as much money as some current sports stars get paid for a single season**
• **Went out drinking with Willem De Kooning**	• **Went out drinking with Billy Martin**
• **In 1956, he died in a car crash**	• **In 1956, he won the triple crown**
• **His poured paintings reflect both the possibilities inherent in art & painting, AND the transcendence of the American Post-war era**	• **His ability to hit for both average and power led to more pennants than ANY sports team of the American Post-war era**
• **Got real fat just before he died**	• **Got real skinny just before he died**

Coagula Art Journal

Your Guide to the Galleries of Bergamot Station

It opened last September to much skepticism—but is now the undisputed center of the Southern California art gallery scene. With hindsight boosterism for Bloodless Bergamot Station reaching even the *L.A. Times* (one Summer Sunday *Calendar* cover story brought puff pieces to a new level of unsophistication), it has fallen on *Coagula* to burst the bubble of the art mall that is swallowing all.

Gallery	Disneyland equivalent	Predominant style of art	Best artist in stable	Worst artist in stable	Gallery employees
Robert Berman	Ticket Booths	If it smells like art...	May Sun	Frank Romero	Claremont Graduates
Boritzer Gray Hamano	Captain Hook	Disco decor	Richard Ankrum	Answering machine girl	Used-Car Salesmen
Patricia Correia	Small World	Celebrity Glass	Richard Godfrey	Celebrity spouses	Sassy Shana
Patricia Faure	Steamboat Willie	Couch Paintings	John Miller	All of the others	Old People
Rosamund Felsen	Cruella DeVille	*Art Issues* table of contents	Tim Ebner	Jim Shaw	Dullards
Sherry Frumkin	Snow White	...if it looks like art...	Corey Stein	Most of the others	Barbizon Graduates
Gallery of Functional Art	Outdated Tommorowland	No art here	No artists here	Customers	Ikea Graduates
Bobbie Greenfield	Mickey, Donald, Goofy	Blue Chip	Call your art consultant	Pick one	K-Mart Graduates
Peter Fetterman	Disneyland Hotel Lobby	B&W Photos	Most of the dead ones	All of the living ones	Are there any?
Shoshana Wayne	Souvenir Stand	...it must be art!	...has left the building	Joel Otterson	Bored interns
Burnett Miller	Monorail	Minimalesque	Karin Sander	Sigmar Polke	Ice Queen
Track 16	Main Street USA	L.A. Kitsch	Vernon Kiln	Alf	MTV VJ Rejects
Ernie Wolfe	Adventureland	Continental Cuisine	Unnamed African sculptor	Unnamed African sculptor	Stereo Salesmen
Bergamot Cafe	Tommorowland Cafe	Java	Espresso machine	Whoever made that salad	Caffeinated
Parking Lot	Parking Lot Tram	Concrete jungle	N/A	Double parkers	Orange Parking Cones

Facts about Bergamot Station:

- One public toilet per 2,134 visitors at *L.A. International* opening

- The best place in L.A. to pick up a wealthy divorcée

- Fine for parking illegally at David Ash's 2341 Michigan Avenue Parking Lot when Bergamot lot is full: $85.00 including tow

Pre-Bergamot Track Record	Customers drive...	Best tactic to get a show	Hipness on a 1-10 scale
Spawning ground of Julie Rico AND Jeff Poe!	Volvos	Get a gimmick or get on your knees	4
From a broom closet on Colorado Blvd. to Paradise!	Cadillacs	Learn to correctly pronounce Mr. Boritzer's first name	5
Seeking the fine-art path out of the family glass biz	Harleys	Blow, glass that is	6
Predates the Sam Yorty administration	Jaguars	Be a has-been, a senior citizen or, preferably, both	5
Strictly flavor-of-the-month	Mercedes	Hire her boyfriend to photograph your building	3
Very commercial SaMo space survived the lean years	Ferraris	Resumè should include a stint at Chippendales	5
Noveau-riche nirvana	U-Hauls	Make junk you can sit in or set stuff on	-1
Status quo since day one	Rolls	Be a famous has-been with an assembly line studio	0
Did not stoop to showing Linda McCartney	Hondas	Take Civil War photos	2
Has had the *L.A. Times* in her back pocket for years	Buicks	Hire former employee David Pagel as your agent	2
L.A.'s longtime home to monochrome	BMWs	Speak w/ German accent or paint in less than one color	8
Money talks	Corvairs	Utilize local thrift stores as art supply stores	7
An admirable lack of pretension	Jeeps	Box of your slides should be postmarked in Lesotho	6
Yikes—three owners in three months	All of the above	Walk in and start hanging your stuff on the walls	4
Used to allow trucks	No Trucks	Show up and start acting like every other snob	9

yo - list

You know you're an Art Loser when...

Galleries

Collectors routinely pay you to take back work

Your receptionist is so snobby, she won't even talk to YOU!

Aryan Nation requests you change color of gallery walls, calls them insult to Whiteys everywhere

Liz & Val refuse to show with you

Collectors

Nobody will do your portrait

Even the Metropolitan Museum won't accept a donation

Everyone keeps trying to sell you their Eric Fischl

Jasper Johns pays for lavish Hawaiian vacations that begin at the crack of Sotheby's gavel

Grad Students give you attitude

Jack Tilton doesn't return your calls

Artists

A museum curator schedules a studio visit with you, saying he "needs a good laugh."

Robert Hughes positively compares your work to an artist from another century that nobody alive has ever heard of

NEA offers to pay you to NOT make art

People say your work reminds them of a young Peter Halley

Judy Chicago begs you to make work that debases and objectifies women

Count Panza buys twelve pieces: the dozen blank canvases in your studio

You don't include a self-adressed stamped envelope with your slides, and they get returned U.P.S. Next Day Air!

Art supply stores just can't part with their paint

You've shown with every gallery in town—Akron!

Critics

You trash an entire group show and get more thank-you notes than all the birthday presents you've ever received

Kim Levin quotes you

You champion an artist, and he sues for defamation

Your latest review gets turned down for publication by *Coagula*!

Curators

You get stuck doing the architecture shows

The biggest artistic egos are suddenly "not ready for an institutional setting..."

You name a show *Pure Beauty*

A Whitney Biennial credits your "unique vision..."

You are given four pristine walls—but no door!

Someone's gotta give Frank Stella that ninth retrospective

Nickname: Spock Varnedoe

he Next Basquiat

Hollywood loves a good story only a little less than it loves a good story that returns a 300% profit. With the commercial success of Julian Schnabel's

squiat, as well as this Summer's sleeper *I Shot Andy Warhol*, it seems inevitable that options will be taken on the life of anyone who r went to art school or rented a loft—provided that the Basquiat formula can be fit into the slew of ripoffs that are certain to be ning your way (except for Jeremy Gilbert-Rolfe, who doesn't attend movies).

So, knowing that the beast is lurking out there, we can only surmise that Hollywood will be having a field day over the next year ng to fit square artist pegs into the even squarer Basquiat hole.

Selling the screenplay:

Most film industry people are complete ots, so you must learn to take complex ory lines and turn them into three and four ntence summaries.

Example: Basquiat—Boy makes art, y gets famous, boy gets high, boy dies.

So, purchase the options to these art- s' lives and try it yourself!

Andy Warhol—Boy lives with mom, boy arties with meth fiends, boy gets shot.

Eric Fischl—Boy goes to Cal Arts, boy vives conservative figuration, boy & Mary oone laugh all the way to bank.

Barbara Kruger—Girl feels political, girl nakes art, girl preaches to converted.

Jenny Holzer—Girl feels political, girl nakes art, girl preaches to converted but as a tolerable hairstyle.

Julian Schnabel—Universe revolves around boy, boy makes art, boy gets fat, oy makes movie.

Keith Haring—Boy makes art, boy gets sick, boy continues to cruise Spanish Harlem, boy and many lovers die.

Jackson Pollock—Boy makes art, boy gets drunk, boy fucks a college co-ed while the wife is in Europe, boy dies.

Morris Louis—Boy inhales, boy dies.

Jasper Johns—Boy makes art, boy re- fuses to grant an interview, boy gets a ret- rospective.

Robert Rauschenberg—Boy makes art, boy gets drunk, boy lives off legacy.

Agnes Pelton—Girl likes girls, girl makes bad art, girl championed posthu- mously by deperate same-sexers.

Felix Gonzalez-Torres—Boy doesn't make art, boy dies.

Helen Frankenthaler—Girl makes art, girl curries favor with Clem Greenberg, girl marries Robert Motherwell, girl actually survives these harrowing adventures!

Robert Ryman—Boy moves to big city, boy makes art, boy chooses risky career strategy of wearing polyester suits, boy's art is so good nobody mentions the threads.

Laurie Anderson—Girl wants to be art star, girl performs, girl becomes a rock star!

Ed Moses—Boy makes art, boy smokes pot, boy makes more art, boy smokes more pot (repeat endlessly).

Chris Burden—Boy gets shot, boy gets famous, boy gets fat.

Lari Pittman—Boy gets shot, boy makes art, boy gets famous, boy's fifteen minutes are up!

Frank Stella—Boy makes art, boy gets retrospective, boy makes bad art, boy gets another retrospective, boy makes even shittier art, museum curator retires.

Catherine Opie—Girl takes snapshots, girl exhibits photos, museum trustees go out and get pierced and tattooed.

Publicist Patter:

Film publicists are the only people in the industry with any brains whatsoever. Their jobs? Turn entire movies into TWO-WORD summaries. Using the Basquiat movie as a model allows them to use creative license for your art-bio film:

Andy Warhol/ Brillo Basquiat

Marcel Duchamp/ Bare Bride Basquiat

Edgar Degas/ Ballet Basquiat

Jasper Johns/ Ballantine Basquiat

Robert Rauschenberg/ Bourbon Basquiat

Damien Hirst/ Beastly Basquiat

Pablo Picasso/ Basque Basquiat

Jeff Koons/ Banal Basquiat

Matthew Barney/ Bashful Basquiat

Kim Dingle/ Batty Basquiat

Julian Schnabel/ Bellyful Basquiat

Keith Boadwee/ Buttfuck Basquiat

Christopher Knight—Boy trashes *Star Wars*, boy switches to art reviewing.

Mike Kelley—Boy makes art, boy grows ponytail, boy proven to be conceptual con- servative he was all along.

Larry Gagosian—God expells Lucifer from Heaven, Lucifer opens a poster shop in Los Angeles…

Match the Schtick!

By Janet Preston

It's Quiz Time.

It's a material world, as every artist knows—but these days, it's not what you make, it's what you make it *with*—so try to match artist and medium, five points for each correct answer.

Artist	Schtick
A. Meg Webster	1. Tampons
B. Fischli & Weiss	2. Shit
C. John Peterson	3. Beads
D. Tod Alden	4. Turkeys
E. Lauren Szold	5. Urinal blocks
F. Carolee Schneemann	6. Bed sheets
G. Beth Haggart	7. Vaseline
H. Damien Hirst	8. Shit buckets
I. Karen Finley	9. Toast

J. Meyer Vaisman

K. Charles Spurrier

L. Nari Ward

M. Janine Antoni

N. Chen Zhen

O. Mark Dion

P. Charles Ledray

Q. Matthew Barney

R. Lisa Hein

S. Liza Lou

T. Alana Herzog

10. Stinky groceries

11. Spilled gunk

12. Garbage

13. Dead animals, tarred

14. Natural gas

15. Sand

16. Bubblegum

17. Chocolate

18. Shopping carts

19. Dead animals in water

20. Smeared objects

Scoring 15 points: Hilton Kramer 30 points: Kim Levin
45 points: Budding formalist 60 points: Date with Bill Arning
75 points: Manage a nonprofit space 90 points: Write for *Artforum*

Answers: A-10, B-20, C-9, D-2, E-11, F-1, G-12, H-19, I-15, J-4,
K-16, L-18, M-17, N-8, O-13, P-5, Q-7, R-14, S-3, T-6

Issue 23, September 1996

Match this!

Guide to TrenDy Theory

By Mat Gleason

With so many artists immersing themselves in trendy art theory and so many theories out there, you never know who exactly is booksmart or full of shit. This handy guide will hopefully help cut through the crap.

Poststructuralism: Language is everything but it means nothing. **Marxism:** If you build a wall, they will stay. **Deconstruction:** Pretentious description of the act of analyzing. **Semiotics:** Every picture tells a story. **Derrida:** A smart Frenchman. **Foucault:** A smart Frenchman who didn't use a condom. **Baudrillard:** A smart Frenchman who likes Las Vegas. **Lacan:** A smart Frenchman who hates Freud. **Formalism:** A boring new innovation is better than exciting rehash. **Essentialism:** The space between your legs is more important than the one between your ears. **Sociology:** People live and ritualize in different ways and for different reasons. **Psychology:** If you caught your parents

fucking, you're fucked. **Modernism:** History ended not with a bang, but with a white cube. **Postmodernism:** Monochrome paintings are boring. **Pop Art:** Cartoons are never boring. **Kitsch:** Not only are cartoons never boring, they're collectible! **Signifier:** Adjective. **Signified:** Noun. **Quality**: Taste. **Activism:** Desire to relive the 1960s. **Nihilism**: Desire to relive the 1970s. **Narcissism:** The desire of the talentless to have the fact ignored. **Historicism:** Trust the art, not the artist. **Romanticism:** Trust the artist, not the bad painting they leave behind. **Elitism:** Trust-fund kids are the best judges of what matters. **Hickeyism:** Overweight chain-smokers are the best judges of beauty. **Academicism:** Tenured professors are the best judges of what you need to know. **Multiculturalism:** Give me some of that wall space, white boy. **Classicism:** Give dead Greeks all of the shelf space. **Spiritualism:** Aesthetics without taste. **Sublime:** The term atheists use for spiritualism. **Cronyism:** When successful people hire complete losers. **Late Capitalism:** What the sore losers insist on labeling the current era. **Capitalism:** The economic system that made the Cézanne CD-ROM possible. **Young Collectors**: Do not exist.

Issue 23, September 1996

Coagula's 1996 Art World Best & Worst

Los Angeles Best

Best Solo Show
Dennis Hollingsworth at Blum & Poe

Best Museum Show
Sexual Politics at UCLA-Hammer

Best College/Alternative Gallery Show
Lavialle Campbell at CSUN
(see page 44)

Best Non-Profit Gallery Show
Roland Reiss at L.A. Artcore
(see page 54)

Best Alternative Space
Spanish Kitchen

Best Non-Bergamot Gallery
Ellen Murphy
(formerly LASCA, see pgs. 42, 66, 68)

Best gallery front desk-person
Janée at Patricia Correia

New York Best

Best Solo Show
Manuel Ocampo at Anina Nosei
(see pgs. 66, 68)

Best Museum Show
Making Mischief: Dada in New York
at the Whitney (see pg. 30)

Best College/Alternative Gallery Show
Native American Drawings
at Drawing Center

Best Non-Profit Gallery Show
Brookworld
(see Coagula #24)

Best Alternative Space
The Drawing Center

Best Non-Soho Gallery
Paula Cooper

Best gallery front desk-person
Sarah Watson at Deitch Projects

Los Angeles Worst

Worst Solo Show
Monique Prieto at ACME

Worst Museum Show
Just Past at MOCA

Wost Group Show
anything at Shoshana Wayne

Worst Art Writing
Christopher Knight in the L.A. Times

Worst Non-Bergamot Gallery
Margo Leavin

Worst gallery front desk-person
The Yuppie Lady at Regen Projects

New York Worst

Worst Solo Show
Teresita Fernandez at Deitch

Worst Museum Show
Jasper Johns at MOMA

Worst Group Show
Minimal Sculpture at Gagosian

Worst Writing
Homi Bhaba in ArtForum

Worst Non-Soho Gallery
Mary Boone

Worst gallery front desk-person
The Brundage Sisters at Castelli

Coagula

Art Journal #17

In This Issue:

MoMA's Controversial young Curator Robert Storr

Francis Naumann on Duchamp's Legacy

Backstage with Ron Athey

Whitney Biennial Reviews

Art Gossip

Kay Eskay on Dean DeCocker

Mammagerie

Coagula

September '94 Art Journal Issue #14

Bob Flanagan

SERIOUS STUFF: CRITICAL WRITING AND PONTIFICATION

Backstage with Ron Athey

By Constance Monaghan
A Coagula Exclusive

In the reductive world of Congressional thinking, teenage welfare mothers represent nothing more than wasted lives, Robert Mapplethorpe was the guy who photographed a bullwhip stuck up another guy's ass, and Ron Athey is the anti-Jesus freak who just about gave an entire audience AIDS. These people, the logic goes, have nothing to offer the common good and therefore no perceivable value—they oughtta be cut off at the pockets. *Cut off.*

And Congress did cut off the NEA budget two percent last year, in part because of $150 NEA dollars that indirectly supported Ron's *Four Scenes in a Harsh Life* when it was seen at Minneapolis's Walker Arts Center. The audience, critics said, could have been exposed to HIV during the scene in which Ron (who's HIV-positive) makes cuts on the back of Darryl Carlton (who's not), blots the design, and runs the prints out on a clothesline stretched above the seats.

There's a sign in a tattoo-and-piercing shop on Hollywood Boulevard, put up for tourists who unwittingly wander in, which asks, "Please don't judge what you don't understand."

But a few tourists to Ron's world can't help but attack what is admittedly difficult, sometimes near impossible to understand. Vincent Carroll of Denver's *Rocky Mountain News*, for instance, in a full-page op-ed piece, described *Four Scenes in a Harsh Life* as "a sick spectacle" of "bad art"–admitting to me months later that he never saw Ron perform and that he based his opinion solely on what others said.

The *New York Times* tried hard to understand, noting that "for Mr. Athey, such rituals are a means of transcendence," yet, unable to simply absorb and examine the experience, couldn't help but cough up that old hairball, "Is it art?"

Discussion of what is art is exactly what's been missing from the bombast and hoopla. Ron Athey doesn't make art that's about gayness, sickness, or victimhood, though elements of all of those can be found in *Four Scenes in a Harsh Life.* It's a bigger story than its parts, just as his life adds up to more than the severe circumstances that molded it. But a true delving into the content and meaning of Ron's work could only be antithetical to the right's agenda–as a survivor of religious fundamentalism, Ron is a threat–a true poster boy for Christian Boyhood Gone Berserk. Under the tattooed skin, he's one of them. To understand his life would be to risk compassion, which for some would mean a condemning self-evaluation.

fa
ca

Le
is
ar
m
loo
lik
a h
no
she
hav
day
of

Beyond the full-body and facial tattoos that demand attention and just as neatly scare it off is Ron: unnervingly perceptive and sweet to the core, an ego-driven diva eager for approbation from those he respects and swiftly dismissive of those who don't understand; beyond *Four Scenes'* blood is the twisted story of Ron's life. And behind the curtain, as *Four Scenes in a Harsh Life* unfolds in a small theater in Manchester, England, is where I am. In the interests of presenting a fuller (though incomplete) picture of Ron Athey and his work, this is my diary of what happened during two nights of performance (condensed for brevity's sake to seem like one).

An early March afternoon: Manchester is clear, windy, and near-freezing; snow now and then whips between imposing turn-of-the-century red-brick buildings. Inside the Green Room, half performance space, half cafe, a blowsy young waitress practices attitude on the troupe of tattooed and pierced outsiders: of the six women and five men, all but two are self-proclaimed "daggers" (butch dykes) or queers. And these performers have bigger problems than bad help: when thay arrived yesterday from two successful shows in Glasgow, the Green Room's management and tech crew weren't prepared, and because of it the dress rehearsal scheduled for yesterday is happening late today. Props are missing, as well as necessary backstage items such as a clean bucket in which to sterilize the nylon filament that will, tonight, be sewn into performers' skins. The dressing rooms and bathrooms are dirty. No one's quite happy—even the accommodations in a cheap hotel connected to a bathhouse are lowly—but there's still the opening-night buzz of nerves, the suspense of seeing how the audience will react. Ron's never performed here before.

Co-director with Ron is performer Julie Tolentino, a tiny woman with dark, shaved hair, large eyes, and a frenetic energy. It's she who deals with seemingly endless hassles of work permits and immigration as well as tech problems. She huddles with Bush, the theater manager, faxes forms, makes calls, gives orders.

6:00 Backstage: Leezan, a stocky British "boy dyke," darts around with her mouth sewn shut, looking unnervingly like a character from a haunted house. It's not for the show—she just wanted to have it done for the day. Though the idea of being unable to speak for six hours is appealing, getting my lips literally threaded together is more than I can comprehend. I try to get it, and I don't. The others kid Leezan and try to make her laugh.

In the smallest of two dressing rooms, Alex Binney, one of two straight men in the troupe, sits stoically, his thin legs spread, as Ron inserts a needle into his scrotum. It's attached to an IV that drips saline to engorge his testicles for a scene memorializing a friend of Ron's who died of AIDS. The others pop in to look and joke.

I am the interloper/voyeur, and though most of the group are tremendously nice, still I make myself as small as possible. I'm envious of the obvious closeness they all seem to share: there are hugs and kisses, the tragicomic moments born of entangled histories, and the current intimate mission of putting on the show.

From the hall, I listen to their voices: Overheard from Brian, the prettiest of the cast: "Actually, I heard that when you pierce right through the testicle, you don't feel it." Woman's voice from the bathroom, "You look like an angel with its wings ripped off."

The troupe takes turns sewing loops of filament through one another's backs in preparation for the final scene. It's done methodically and caringly, latex gloves on for everyone.

Ron wanders to the stage area and back with a saunter worthy of a plantation owner. "I've gotta be a little more present tonight," he says to no one in particular.

Darryl Carlton, a large black man who does his own performances in Los Angeles under the name Divinity Fudge, announces, "Well, it's time for me to get beautiful." He's got line patterns of scars on his back and arms from previous shows in which Ron used him for the now-infamous "human printing press." Getting beautiful means putting on a skimpy red g-string outfit, blue eyeshadow, and huge lashes.

Ron stands in the hall playing with the rings through Garreth's nipples. Garreth's a wild young English guy who says he "loves girls, boys, getting pierced, and dancing."

Alex's balls swell. "Is this all right?" he calls to Ron, who goes in to take a look. "I mean, I don't wanna be the first man to die from . . ." It's the only quiver in the Brit's stiff upper lip. Ron assures him that "nobody's ever died from having their balls infused."

Howls are heard from the larger dressing room, where Brian, a professional piercer, is creating a "crown of thorns" around Pigpen's head by inserting long needles in an X pattern. "Before you, like, jam, I'll feel the pinch and I'll tell you," Pigpen says. She's intense and boyish, with crosses tattooed over her back, geometric designs down one arm, and a monkey on her neck. The sides of her head are shaved, leaving a thatch of thick brown hair at the top.

Ron, walking the hall, says to Donna, the no-nonsense New York chef here as a stagehand, "What happened last night? As soon as I stood up, three limes fell off." He's talking about the ritual at the end in which they all dance, near-naked, with limes, figs, and bells wired onto the filament through their bodies. She agrees that tonight those'll have to be tied on more securely.

The feeling is one of a traveling circus family, with Ron the big daddy ringmaster and Julie the lion tamer. Though I sense mostly good feelings among them, Ron mentions later, in his talk to the audience, separating the girls from the boys "when things get too intense" backstage. Shortly before curtain much of the group is in the small dressing room with Alex, whose balls are grapefruit-size and getting bigger. They talk matter-of-factly about catching an early train to London in the morning to attend the funeral of a friend who died last week of an overdose. At the moment it is a matter of logistics, though, not sadness—and the mood is high. In the other room, Brian admires his handiwork, "this one is so beautiful." Pigpen laughs hoarsely, "I've been a vocal girl tonight."

7:25 Onstage: Ron is laced into a black leather corset under a flowing white dress, a parody of evangelist Aimee Semple McPherson, standing poised in a spotlight amid rolling stage fog. To his left, Pigpen leans naked on a crutch, one wrist hanging from a rope that goes to the rafters. Besides the "crown of thorns" that glistens in the light, feather-tipped needles pierce her side, arm, and thigh. She shakes in the chill as the audience files in to the sounds of a solemn, religious-sounding gong.

In a calm, friendly voice, Ron relates the story of his Aunt Vena, who had a vision when Rom was young that he was called to be a preacher. He tells about the time they went out to the desert to see a woman who claimed to have stigmata, and how, when he was little, he sliced his sister's fingers with a razor, and then his own to ease her fear. Brian, as an altar boy in a white shirt and black pants, leads audience members down a path lined with crutches to Ron, who anoints them. But this turns out to be a reluctant crowd, difficult to coax out of their seats.

Backstage: Alex ties balloons to Darryl's red thong.

Onstage: Ron, the beatific evangelist, pulls the arrows from Pigpen's flesh, carries her to a downstage tub. As he removes the crown, needle by needle, Pigpen bleeds. He washes her face in the blood, pours water over her, washes her again, kneads her shoulders.

Backstage: Darryl, who's been standing in the hall-

way holding a large pair of black patent pumps, peels his socks off. The music changes to metallic strip-raunch. Pigpen runs back to change, followed by Ron, who strips out of the dress, bra, and corset, sucking in his gut to have Julie unfasten the last hooks. He's pulling on a pair of coveralls as he dashes to the stage-left entrance to narrate *Working Class Hell*, a scene in which the daggers, dressed as workmen, attack Darryl as he struts the runway.

Because it's illegal to cut someone onstage in England, the *Human Printing Press* segment is seen on video as Ron and Darryl mime it. It's thought later that the audience didn't understand what was happening. The repulsive effect of watching blood ooze from flesh is missing; so is the wonder of seeing the odd fresh prints hanging on the clotheslines like down-home washing; and the consequent Gordian knot of contradictions: pain equals pleasure, life equals blood equals death equals art, the master does the bidding of the slave.

Backstage: Garreth ties bells onto the filament in Lizette's back. The boys walk around in jockstraps and boots, their full back, ass, and thigh tattoos stunning.

Onstage: In the scene called *Suicide/Tattoo Salvation* Ron lies on a bed in his underwear, writing as an echoey taped narrative relates his hellish descent into drugs and suicide attempts. Sitting up, he ties off and deftly inserts a herringbone pattern of twenty syringes into his arm. The story tells of a dream in which Ron saw himself tattooed. Naked, he climbs a metal ladder and swings back and forth, now in the light, now in the dimness. The music is eerie: "In that dream, my tattoos were complete," his voice reverberates. It's the moment of redemption, of his turn toward a new life, and though the story has been wrenchingly sad, this moment of hope is transcendent. And here is Ron, in the flesh, proving that that hope wasn't in vain.

For the next scene, *Leather Daddy Bootshine*, Alex hobbles onstage, pulling the IV stand with him. He wears a shirt but no pants and his giant balls hang grotesquely. Julie tells the story of Ron's friend Butch, whose fetish

was motorcycle boots. When he died of AIDS there were thirty pairs in the closet, some worn out, we hear, some never worn. The story is a strange mix of pathos and absurdity, death and passion, told in the tone of one who understands and even admires the fixation.

Backstage: It's near-chaos as the performers rush to have the limes, bells, and figs tied onto them for the last scene.

Onstage: Ron, standing high on a podium in a brown suit and glasses, is a preacher now. "There's so many ways to say Hallelujah!" he shouts. "Lemme hear you say it! Hallelujah!" As he demonstrates the different ways, he takes his clothes off until he's naked but for a furry jockstrap and steps onto the lower platform where Julie, Pigpen, and Crystal Cross are wrapped in yards of white tulle. It's the *Dagger Wedding*. "Where are we to draw new traditions from?" Ron asks, unveiling them. Bells are heard as the women shake slightly. They wear only red loincloths. They hold hands. One by one Ron pierces their cheeks, and as the drumming starts from either side of the stage, they all dance wildly, bells flying, limes dropping. The frenzy increases, and blood colors their backs. Even Alex, who can barely walk, dances on his knees and beats his hands against the floor. It seems to go on for a very long time until the energy is spent; they're panting, exhilarated and bleeding.

Watching from backstage, I'm overcome with emotion, irrational, unexplainable, coming from depths and memories I'm not conscious of. It's something I've rarely felt, but it hits me again a few days later, in Westminster Abbey, as I listen to pipe-organ music echo up to the vaulted ceiling.

In Manchester, I had a dream of which I remember only Ron's presence, and the word **Christerious**. It's meaningless until I look back later and see how it connects Ron's theater and the church: two not-so-different places where God and life are celebrated through the flesh and the spirit and the blood. And it's all very good. Amen.

Issue 17, May 1995

The NEA and Candidates: An Editorial

By Javier C. Barcelo

In a recent televised debate on C-Span, Jerry Brown, the maverick Democrat running for his party's nomination, dared to bring up the issue of art and culture in response to a question concerning education. Brown stated, "During the Revolutionary War, John Adams wrote a letter to his wife Abigail explaining that he was engaged in matters of war so that one day their children could engage in matters of commerce and his children's children could engage in matters of art and music." He then commented, "Thirteen generations later, we haven't advanced much further than matters of war."

It was a startling statement particularly in light of the reactionary assault on the whole notion of artistic freedom posited by George Bush and Patrick Buchanan in the Republican primaries. What Brown said was that he didn't simply want a nation of robotic workers happily competing with the Japanese. Brown's vision is of a productive nation that is also interested in a quality of life apart from material goods. Unlike conventional politicians, however, he did not link this desire with a pitch for the values of that old-time religion. Brown represents a kind of post-Enlightenment, post-Humanist humanist who incorporates a decidedly non-Western discipline throughout his coagula. His candidacy is a direct challenge and threat to the American establishment (corporations, Washington, big media), and thus the unprecedented bias against him from the organs of American power (e.g., the *New York Times*) has been enormous.

And yet his makeshift campaign lives on (at this late date he remains the only alternative to Bill Clinton after Paul Tsongas' surprise withdrawal). As an African-American with a loyal following, Jesse Jackson seemed threatening to many because of his race, and it was precisely because of his race that he was unelectable, thus only presenting a marginal threat to the status quo. He may well be as unelectable as Jackson (though stranger things have happened), but his threat goes deeper into the American psyche—Jerry Brown is challenging the power of money. Jackson's core was a campaign to be included in the democratic process and redistribute the resources of the federal government. The irony is that Brown is more conservative than the movement he is unleashing—his is the angry rhetoric of radical reform. This demonstrates how far the political spectrum has swung to the right. Brown is seen by the pros as a freak and most people in this country are afraid of change (no matter how dire their own personal circumstances). He has the intellect, charisma, and life experience to articulate an authentic alternative to the politics/business as usual of American elites. The really interesting question will be where he and his supporters go if he doesn't get the

Democratic nomination.

On the Republican side, there rests a party where interest in the arts has never been too strong, especially in recent decades (remember Nixon's love of Andrew Wyeth and, much worse and lowbrow than even that, Reagan's worshipping of Old West painter Frederick Remington; at least Nelson Rockefeller had taste but then many would argue that he wasn't a Republican anyway). Patrick Buchanan's ugly and proud fascism is colliding with George Bush's kinder and gentler fascism and the biggest loser so far has turned out to be the NEA's John Frohnmayer (besides, of course, Buchanan's poor electoral showing, which the media hyped to great heights following his artificially strong showing in the New Hampshire primaries—held in a state that boasts some of the most wicked and wretched citizens in this nation). As everyone knows by now, Frohnmayer became the sacrificial lamb offered up to the ultra-Right by the Bush Administration just before the Georgia primary. Frohnmayer, who was savaged by both Right and Left for his middle-of-the-road approach, ultimately came around to believing in the independence of artists and the NEA but became the obsession of former Bush chief of staff John Sununu—a mean-spirited and petty little man who has turned his White House incompetence into a cushy big-paying position as the conservative voice on CNN's *Crossfire*. Only in America.

Buchanan, commenting recently on the NEA, said, "If I become President I would shut it down, padlock it, and fumigate it." The naked fascism is there for all to see, complete with "brownshirts" imagery. Even the "fumigating" remark recalls the darkest days of the thirties and forties. Of course, Bush thinks the same way but is simply smarter, having much more decorum than to utter it publicly. The ultra-Right is now the most powerful force in American life—one need only look at the unholy alliance of Christian fundamentalists and the Catholic Right to see its effects on advertisers, network executives, and record-store chains. The Ayatollah lives!

The probable alternative to Bush/Quayle will be Bill Clinton, not exactly the favorite of progressives and those who see a need for real fundamental change, but Clinton will offer a symbolic alternative to Bush nonetheless (it would be nice to see all of those right-wing assholes lose in any case). His position on the NEA is to support its independence and increase its budget slightly. He does not strike me as someone who has spent much time hanging around museums (except perhaps if there were a good Rubens retrospective).

The racism, sexism, and homophobia that is at the heart of the American system and its house organs is an expression of the feelings of a majority in this country. It will not be until these hearts are changed that any kind of electoral blows can be struck for freedom and diversity. In which case one can only hope that the economy remains in recession just a little bit longer.

Issue 1, May 1992

To Loot and Die in L.A.

By Mat Gleason

Cruising through downtown L.A. after curfew on Looting Thursday (ahead of the National Guard), I had to see for myself how the art situation was faring. We drove the only car on the road, a Daihatsu carrying three drunken men (probably the only people in Los Angeles who had paid for their case of beer that day). Performance artist Alex Nam drove and Chicano artist Tragic Danny crouched in the back seat. It was pretty shrewd of him to let me sit up front. As a reporter, it was necessary to at least check on the status of one museum, and L.A.'s Museum of Contemporary Art was closest. My mind was already making plans to sell MOCA's Pollock on the black market if the looters had hit the building and not realized the value of the walls.

We had watched the city burn on television all day. So many fires, so much chaos, plenty of thoughts race through your mind. Alex worried about the status of Hollywood's sex shops. Would Club Fuck have to find a new location? Danny drank and cheered on the revolution from his armchair. I drank and thought of that Pollock on my wall (say all you want about high vs. low art—it would look great next to my Sex Pistols poster). I kept wishing MOCA's Rothkos were small enough to be carried away nonchalantly and cursed the fact that they really didn't have any great Rymans.

Of course, that conscience of mine reminded me that museums are for everyone and that even the greediest scum art collectors share their treasures with the masses. I remembered that Marcia Weisman only donated her Jasper Johns map painting two days before new and stricter donation-tax-deduction laws came into effect.

Fortunately (for all future patrons), it got the better of me. I realized that if MOCA were burned, looted, or damaged, the government's priorities would be far from giving it a dime, or a damn. One imbecile who had seen the Joker's museum scene in Tim Burton's *Batman* could set the status of Los Angeles further back than Santa Fe's. And even if Tom Bradley made overtures to fund some sort of museum resurrection plan, he would be crucified on both sides; the Left would say poor communities needed the assistance more and the Right would hype big brother spending your tax dollars on splashes of paint that a third-grader could do. An American museum reduced to rubble in 1992 would most likely get boarded up and sit, or worse, be sold to some private ego who would sell off those works not in keeping with the taste or whims of his/her collection (if you haven't thought of Norton Simon yet, you don't know the tragic history of Southern California art).

With the need to know only superseded by intense cabin fever, we went by MOCA to report on any potential ruins. There the guardians of postwar art stood, two twentysomething security guards with scared looks on their faces and nervous reactions in their hands. "Howzit goin', dudes? Any looters?" They were stuttering negative responses to us while walking backwards. Quickly walking backwards. All the lights were off in the courtyard and they began to fade. These dudes would've helped us load a Franz Kline into the Daihatsu if we had asked with a bit of authority in our voices. Hell, these dudes would've helped us load their mothers into the car if we had asked them. It was only when I saw those nervous hands holding their holsters that I told Alex to step on it. When you clearly hear the echoes of a four-cylinder engine off of skyscrapers, you know your town is under siege.

How many TV sets could you buy with the sale of one primo Rauschenberg combine painting? Just think of the L.A.

Ideas don't burn.

County Museum's Diebenkorn and imagine every unscrupulous billionaire's mouth water. Not to mention every Bozo with an extra hundred-grand who could conceivably finance the theft of Armand Hammer's van Goghs. The *Los Angeles Times* reported that the city's cultural institutions were unscathed. That when looters, arsonists, and vandals approached the arts, they were scolded by onlookers and retreated, compliantly, almost reverently, en masse. If these looters were so uncivilized, as the media has portrayed them, how could even the most uncontrollable mob mentality avoid buildings that housed the most obvious amount of wealth? How could these people, described by L.A. newsman and dork Harold Greene as "cockroaches who scurry when you turn on the light," how could they comprehend what most of Washington and all of middle America seem to miss: that culture is one of the few things that bind any of us together, and in times of incendiary separation, we need it more than ever. The thousands of Angeleno looters may never visit MOCA, but they did more for it, and all of Southern California's cultural institutions, than an elected official ever did. And, unfortunately, more than any probably ever will.

One last potshot. I had scheduled that Thursday to review Alexis Smith's midcareer retrospective. If we had remembered it was up, we would have checked out the L.A. County Museum instead, since there was nothing of cultural value at MOCA.

Issue 2, July 1992

Did Karen Finley Cancel Dennis Miller?

By Mat Gleason

An inside source involved in the production of the *Dennis Miller Show* has informed *Coagula* that the decision not to air an episode of the show featuring a performance by artist Karen Finley was the final straw leading to Tribune Broadcasting's (the show's Chicago-based distributor) decision to cancel the program.

Finley submitted her intended text, along with a video of herself performing, to the show's producers well before the scheduled air date of July 14.

It was at the afternoon rehearsal that some higher-ups became worried. According to our source, Miller, who is also one of the show's producers, rarely made it to afternoon rehearsals, and therefore was completely unaware of the content or the delivery of the piece. As our source observed, had he been there for the rehearsal, he "might have been able to figure out that her piece was controversial and maybe interview her a little (on the show) before he let her perform. Instead he just introduced her like he would any band or comedian and the audience was definitely not prepared for it at all." Finley's piece was described as the delivery of an impassioned, forceful, confrontational sermon from memory concerning women's issues.

The text, according to the *L.A. Times*, was part of her current installation at the Los Angeles Museum of Contemporary Art entitled "Memento Mori." Our source continued, "When it was finished, the audience barely clapped. Most of them were stunned. A lot of the clapping was from the crew who had seen her rehearse and knew what to expect and were into it."

Miller allegedly chided the audience for their ignorance and lambasted Midwestern viewers for being incapable and unwilling to understand material like Finley's. His mood turned after the taping when he met with the show's other producers and chided them for not warning him about Finley's performance. When reminded that the show was already in hot water, Miller himself reportedly decided to axe the episode in hopes that less controversy might prolong the life of his show.

Not only was it impossible for our source to acquire a copy of the July 14 episode, Tribune was diligently at work removing everything before the final taping. "Karen Finley was the last straw. Tribune wanted Dennis to at least take a pay cut,

seeing as he got paid as the host, as a writer, and as a producer, but he flatly refused. When this performance thing happened, Tribune just said forget it and pulled the plug."

Once the decision was made, the movers came. Top priority: securing the Finley performance before it could be leaked to the press or public. Tribune Broadcasting was apparently successful.

Issue 3, August 1992

An Abstract Main Event
Puryear vs. Diebenkorn in L.A.

By Mat Gleason

The Los Angeles Museum of Contemporary Art had it right for almost a month. From September thirteenth until October fourth, two retrospectives of modern masters were being shown simultaneously. Unlike the SoHo Whitney, the works of each artist were displayed separately.

Consider the context of two retrospectives competing like two professional boxers (note that most museums *are* pay-per-view). Like a match that goes the distance, the classic pairings would be between the champion and a contender. Although in the same class, different styles, strategies, and tempos would clash until the end, when a close decision was announced. The closer the decision, the more it would be argued over the years.

This was not Frazier–Ali or Leonard–Hagler. If you live in Southern California, you've probably read reviews of Martin Puryear (July 26–October 4) and Richard Diebenkorn (September 13–November 1) at MOCA. The overlapping weeks were like a preview of the main event: "Puryear vs. Diebenkorn:

Going Loca at MOCA!"

The press sided with the champion (Diebenkorn), especially since his trisectional career was so easy to synopsize (and his pictures are more colorful to reproduce). The challenger (Puryear) was unknown to some scribes who were then forced to discuss the effect his ethnicity had on his ability to compete (*now* this is *really* beginning to sound like sports reporting).

Diebenkorn's light and airy style was recounted in tale after tale while Puryear's earthier groundings were helplessly woven into ramblings about alchemy. Anyone following the match in the press could have surmised it as: Fleet Feet vs. Rock Solid.

Richard Diebenkorn. A high place in contemporary American art he has earned and deserves. Like The Who in rock, Diebenkorn is not the number one of all time but is popular and legitimate enough to be included in nearly everyone's top ten. His retrospective highlights a career of three distinct phases, like an all-star pitcher who has won big with three separate teams. Swimming through an orgy of *Ocean Parks* was good enough for me, while his realistic period still towers over the legions of pseudo-Hoppers who continue to teach life drawing in our colleges today. Saddest commentary: the large percentage of old fogies (yuppies, some of 'em, time does go on . . .) attending on the first Sunday (at the behest of lavish *L.A. Times* Sunday Calendar coverage). I've always thought that the Dieb was a bit hipper than that.

Martin Puryear. I had always mentally placed him in the ranks of Jene Highstein, a similar minimal-minded organic nonobjective sculptor. Yet Puryear's abandonment of stone and steel are central to what distinguishes him from the crowd. His materials are more likely to be seen in a museum of natural history than in one of contemporary art. Viewing the MOCA show was like walking through a three-dimensional Motherwell

painting: organic yet composed, chaotic but not threatening. He combines classic modernist sculptural tradition with a fresh (and sorely needed) lack of strangling, scholastic pretension. The materials have a zest, a life, that a certain plastic/metal/concrete tradition sorely lacks. Some critics have made a big deal about his ancestry. Some lowlifes have hinted that he got a show of this stature because of it. Fuck all of you, Puryear is a sculptural giant, an approachable Judd, a decipherable McCracken, a LeWitt with a sense of humor.

Decision: Diebenkorn by a nod, but take Puryear in the rematch.

Issue 4, October 1992

National Affairs
Slick Willie: After Crushing the 700 Club, What's Next?

By Javier Barcelo

As the election returns began to come in last month, most in this country were relieved that such an emphatic rejection of twelve years of neglect, deception, and stupidity had been issued by the electorate.

Bill Clinton is the most conservative Democrat to run for President since JFK, yet he won with only a 5 percent margin, proving that even when the ticket is young, moderate, telegenic, and Baptist, many Americans were scared enough to vote Bush/Quayle (even though they despised them) or Ross Perot (who, in the course of six months, proved himself as vulgar as most would have pictured a Texas billionaire to be). Yet thank God for those nineteen million rednecks who voted for Ross Perot.

For all their pandering to the white suburban vote (along with the Reagan Democrats), Clinton/Gore did not carry the white vote nationally. If it were not for the huge support of blacks, Latinos, and Jews, they would not have carried the popular vote. I wish the new President all the best, because if things fail to go well, the backlash will make Reagan/Bush look kinder and gentler by comparison.

Slick Willie must begin by boldly acting on a progressive social agenda that will require him to do nothing more than sign a few executive orders. Among these items: repealing the gag rule on abortion, ending the ban on homosexuals in the military, and lifting the ban on fetal tissue research and RU-486, all very significant changes that signal a decisive break with the decade-long stranglehold on Washington by the fanatical religious right. Clinton must also demonstrate that he is willing to open up more positions to women and racial minorities through appointments to cabinet-level and senior-staff positions. The federal judiciary and Supreme Court will no doubt get a respite from Robert Bork clones who have been filling up vacancies for years. If Clinton forgets the groups that elected him, he will do so at his own peril, because no president elected with 43 percent of the vote can afford to lose any part of his constituency or his administration will be doomed from the outset. Take away California and New York from Bill's electoral map and his wife might be filing for divorce instead of buying a ballgown.

Yet with an impressive victory over an incumbent, Clinton is already retreating from his position on gays in the military because of conservative opposition within his own ranks. The former Reagan/Bush Joint Chief flunkie Admiral William Crowe and that despicable hillbilly warmonger, the honorable senator from Georgia Sam Nunn, lead this charge. The military is America's most racist, sexist, and above all homophobic public institution. It is the most vicious killing machine in recorded history. Why anyone would want to "serve" their country through this vehicle is beyond me (but it should be everyone's right).

The President-elect now wants to "study" the Issue. He has stated that there is no timetable for implementing this change. The issue of same-sexers in the military has caused a

nationwide uproar, bringing out all of the warmhearted American homophobes in droves; the rhetoric has been utterly contemptible and ignorant, yet bigotry has been made "respectable" as just another opinion (homophobia goes hand-in-hand with racism–but a scumbag like Colin Powell doesn't remember the days when he was referred to as "negro" since he is too busy licking all of those white asses). Europeans are much more enlightened than Americans (once again) on this issue. They simply don't give a fuck who their soldiers fuck. (The UK, ever more backwards than even the USA, is the one exception).

Everyone should also expect some more-enlightened appointments to the National Endowment for the Arts, along with greater funding–not just for the arts–for ARTISTS. They are the ones who make things HAPPEN, not some bureaucratic theater group in Orange County which does Neil Simon plays. Clinton should consult Jerry Brown's platform on the arts. It not only calls for more money but supports artist-only granting committees as well as making HIGH national culture a priority (painting, sculpture, new medias, music, theater, and dance). Perhaps under Clinton we will see the return of blue-chip contemporary artists to the White House (Kennedy invited Mark Rothko to his inauguration).

Clinton would do well to also take a look at the reform of government–the most important message from the Brown and Perot movements. I don't expect Clinton and the Democratic congress to adopt the Brown humility agenda, which would reverse the midnight pay raise of a few years ago and cut or eliminate many of the perks that Washington loves (limousines, bloated staffs, etc.). The obscenity of lobbying by former government officials for foreign and domestic concerns must be curtailed and regulated. Finally, a real reform of election financing must be considered (but don't hold your breath). So much depends on who Clinton appoints to his administration–one can only hope that he finds and supports some competent new faces and not just Carter-administration retreads.

Who can be optimistic on U.S. foreign policy? The bluff is now being called on those who always said that the Soviet threat alone justified an incredibly large military budget. Calling this bluff are those of us who suggested that perhaps the reason for our presence was to enforce the dominance of multinational corporations (by providing them with expensive security guards).

Will Bill Clinton bow to business interests at the expense of the environment and workers? During the campaign, he never hid the fact that under his guidance, a move away from the Wild West entrepreneurialism and towards a more cooperative government and business partnership (as in Germany and Japan) would take place. American free enterprise has long been a myth in the era of collusion between the corporate and government sectors. How do you think Ross Perot made his billions?

This was a fascinating election year, one that demonstrated that the system is not as stable as some think. One hopes that the visionary campaign of Jerry Brown's We the People movement continues towards being a viable third party–one that genuinely *is* grassroots à la Brown's 800 number. Grassroots campaigns are NOT dependent on the big money of someone like Perot. Jerry Brown was the only candidate to ask what kind of nation the United States wanted to be in the next century. Hopefully, Clinton heard a little of what Brown was saying during the campaign. Hope springs . . .

Issue 5, Winter 1993

Biennial Is Travesty: PC Meets Grunge
By Marily Fishkind

The Whitney Biennial is on every New Yorker's mind and, as expected, the Whitney has managed to make this the most political Biennial in history. It should prove to be like tuning

into a politically correct version of C-Span. Let the neo-teach-in begin and may a thousand flowers bloom. What some may resent in all of this is the suffocating one-party line that will be emanating from the Whit. There is absolutely no pluralism here, only the familiar mantra of mind- and eye-numbing pseudo-outrage and infantile emotions-on-the-sleeve—whether it is the neo-Surrealist/realist sculptures of superstar Kiki Smith (whose work looks too much like Antony Gormley's) or the psycho-subjective adolescent regressions of Jack Pierson. But hey, it's someone else's turn now, and that's what this show is all about. Of course, most of this stuff has been around for years. It is the institutional art of the so-called "alternative spaces" in New York (Artist's Space, Art in General, P.S. 122, Exit Art), but the invasion of the Whitney is the kind of institutional triumph that tends to doom all kinds of movements. The recent full-scale national rejection of the right wing may also have robbed this stuff of some of its urgency.

What exactly is this movement, if it is a movement at all? This kind of work has been in abundance since the sixties (remember Carolee Schneemann?), but what is different now is that it is THE mainstream. The *Village Voice*'s Kim Levin has recently attempted to create a trendy link between it and the so-called grunge movement in rock and fashion. I hardly think that the concerns of Pearl Jam are in any way related to those of, say, Sue Williams. Levin's deterministic obsession with cross-cultural affinities is looking in all the wrong places. If old Ma' Levin really had a clue, she would see someone like drag queen Ru-Paul, whose ungrungelike "Supermodel" is racing up the charts and is far more related to some of the concerns of this recent art that she so admires.

Levin's predictable glossing on anything "smart" (re:

I CAN'T IMAGINE EVER WANTING TO BE DANIEL MARTINEZ

Minimal/Conceptual in lineage) reared its ugly head again in a recent review of Damian Hirst's "Pharmacy" installation at the Cohen Gallery uptown. Levin argued that Hirst's clean, restrained, and ironic "European" aesthetic was hopelessly out of touch with the brave new world of grunge being forged by America's sensitive, informal multicultural aesthetes. Levin wondered how anyone could make any art that even smacked of formal sophistication in the age of AIDS. Of course, the old windbag felt the same way about art before AIDS and now she is trying to erect some kind of theoretical apologia for this zeitgeist.

What is most unfortunate is that hack journalists masquerading as critics have turned art into an extension of mainstream pop culture and capitalism. There is no criticality and no resistance in the new criticism: Jackson Pollock equals Ernie Kovacs equals Roni Horn equals Michael Jackson, etc.

The new *Artforum* magazine with its glossy referencing of advertising and fashion has become the norm—the Warholian triumph is now complete.

That dealers put up no resistance and give people what they want is not surprising. That collectors snap up stuff that reminds them of their suburban postwar TV-saturated household is not surprising either. But where are the critics? Their capitulation is the most embarrassing of all: simply consider the fact that they're not even making any money!

The only criteria that should matter is how a given work of art is either morphologically or conceptually different than what has come before. If an artist or critic cannot answer how he/she differs from other art/artists, then that given person is a failure. "What is your work doing that no one else has done in quite the same way?" This is an

objective question easily verifiable by pointing to the work of other artists. It is still the primary task of the best artists to take us to visual and intellectual terrain that we have never been to before. Anyone can make good, competent art, but very few ever make truly original art. It can still be done, it is just harder today than at any time in history.

For contemporary art to matter it must be formally innovative unless the issues that it raises are of such profundity, novelty, and relevance to society that its formal conservativeness can be forgiven. The latter is rare. Few artists manage to pull off both of these, Felix Gonzalez-Torres being the best example. Too much of what is celebrated today is more bad expressionism (Sue Williams), more bad decorative abstraction (Jacqueline Humphries), or the countless SoHo hordes of Mike Kelley imitators jumping on the "pathetic" art bandwagon. Let's all agree that no matter how well-intentioned the sociopolitical sentiments of a particular work are, those sentiments are totally and ultimately irrelevant in deciding whether that work of art is significant or not. Unfortunately, this is news to a lot of people.

Critics must also come up with new methodologies to understand and explain contemporary works of art. All of the great twentieth-century critics have done this—Ortega y Gasset, Greenberg, Fried, Steinberg, Krauss, the picture theorists, and most recently Yve-Alain Bois. But there are no theorists for Levin's "grunge art" because it is all, by and large, unoriginal and intellectually weak. It is art that wears its diapers proudly. We are being assaulted with the art-world equivalent of the whining self-indulgence of Oprah, Sally-Jesse, Geraldo, Montel, et al.

But this too shall pass. However, let all the empty decorative formalists beware: when the grunge/PC trend ebbs, its alternative will NOT be a return to your shabby Poons/Bleckner

world. If it doesn't, we'll have an art world dominated by two reactionary tendencies—one represented by Ma' Levin and the other by Hilton Kramer and Robert Hughes. They are two sides of the same coin and both sides are hostile to anything that smacks of a formally progressive and intellectually liberating art. Getting beyond these two factions is the challenge for the next Biennial cycle.

As recent art reflects our collective dirty laundry being aired (that's ALL this shit is), perhaps the real brave new world looms just around the corner, carrying a new high-tech art ready to emerge. Soon, new materials, technologies, and unique modes of thought could be making today's hand-obsessed, crafty crybabies look quite feeble. Wake up! It is time to put the garbage where it belongs—in the trashcan.
Issue 6, April 1993

After 60 Minutes: Should the Art World Reassess Its Pace?

By Mat Gleason

The art world's unanimous outcry over a mid-September *60 Minutes* cheap-shot analysis of contemporary art has been heard in Manhattan for over a month now. The broadcast featured Morley Safer, a sycophant to power and money if there ever was one, commenting on postwar art with one thumb up his ass and two feet in his mouth. Seen in over seventeen million homes, it was epitomized by a shot of Moron Morley asking a group of school-children if they could paint better than a particular artist (here it was Basquiat). Yes, you sir, an aging mouthpiece for whoever is advertising on CBS, have been reduced to confronting

the visual arts through the mouths of babes. Safer is the reason some cultures make their old people float away on icebergs–and those cultures claim to respect their elders. Who could possibly respect the biased tactics of McCarthyesque Safer?

Safer attacked Cy Twombly and Robert Ryman without ever allowing them to defend themselves on camera. He did allow Jeff Koons (who besides Safer is still interested in that Cicciolina-less, flat-assed has-been?) to do his usual indecipherable pontificating. Robert Ryman is a nerd with a bad haircut,* Morley, he might have been a shittier interview than Koons. Who knows? Since you lied to the viewing audience that Koons' artspeak was indicative of contemporary artists, we will never know if Twombly or Ryman can defend themselves against your juvenile attacks. It is this dishonesty that exposes the true status quo mission of *60 Minutes*. You aren't really there to give both sides of the story; you are there to give an opinion. You are as biased as the *National Enquirer*–and at least they are honest enough to admit the fact that unbiased news is an unachievable dream at best or a status quo dupe at worst.

The right wing had its anti-art moment with the whole Helms–Mapplethorpe–NEA debacle. The left has its ongoing politically correct campaign stretching from reassessing Picasso because he fucked two women in the same day to complete condemnation of paint on canvas for the crime of being a Euro-patriarchal exercise in oppression. Now the status quo has had its moment in the anti-art spotlight, with Mister Middlebrow, Morley "safe for the sponsors" Safer speaking the mind of Joe Six-Pack today as efficiently as the Paris tabloids railed against Manet for Joe Absinthe a century ago. In its heyday, Impressionism was ridiculed by the masses and lampooned by the media. Housewives today (and Safe-ass Safer himself) engage in weekend attempts at recreating Impressionistic styles. This evolution from avant-garde to household word took roughly three quarters of a century. Hypothesis: once the decrying stops and the how-to books

start, a movement's vitality and significance have transferred from street to suburb. Since Old Man Safer put quite a bit of focus on Twombly and Ryman, the conventional art-world wisdom that abstraction and painting are debunked, debased, and defaulted as mediums would be suspect by the fact that the mass media is still harping on these artists. Losers like Mike Kelley and Meyer Vaisman (who have staked careers on the premise that smart people buy dumb art) lose out if the avant-garde of 1953 has yet to be advanced in 1993. If the attacks aired in much *au courant* theory and art (that nonobjective art is insincere, elitist, and outdated) are simultaneously eloquated by the peanut gallery, what separates the likes of Kelley and Vaisman from Brownshirt Safer? The cocky art celebrities are sent out to pasture to join in the mantralike chant of the conservative status quo's age-old reactionary message: "Hey! A third-grader could do that art and rich people buy it and dammit, I'm too fuckin' ignorant to do anything but get pissed off and ridicule the whole god-darned thang!" Add an amateur caricature and this quote would be a Mike Kelley drawing. Add a racist slur or two and it's an Archie Bunker diatribe!

Some other points brought up by Safewad's whining masturbatory exercise in close-minded snobbery were legitimate–most humorously when he recited the turgid texts of recent art criticism (if you thought that reading that crap was boring, try listening to it)–but Safer's full-frontal assault on the art world really garnered merit when the *New York Times Magazine* printed a cover star-fuck of Pace Gallery Führer Arnold Glimcher in early October. How ironic that *60 Minutes* would publish a letter condemning Safer's critique from one of Glimcher's children, which decried the program for being "anti-intellectual." Did this putz, this yuppie spawn, read the unintelligent article about his old man? Allan Schwartzman's piece made the art world look like a cutthroat game of Monopoly played by self-absorbed middle-agers whose goal in life is to suck off Michael Ovitz while picking his pocket without their breast-implanted wives finding out. The article mentioned money twice as often as it did art or artists and mentioned

Ovitz more often than any single artist. As far as I can see, based on the profile of this lanky vulgarian, Glimcher is little more than an art-world toxin who has stolen some great artists and specialized in selling the vicarious thrill of being cultured to like-minded Hollywood pimps. While the *Times* featured shocked editorials on the Safer piece by Michael Kimmelman and Carol Vogel in the weeks following the broadcast, its Sunday *Magazine* was confirming many of Safer's premises: that the art of the deal is the only contemporary masterpiece worthy of a cover story. The glamorization of a whore of Glimcher's stature renders the *Times* totally neutered as a force or voice in the art world.

Coagula's suggestion to every artist who reads this essay: make an anti–Morley Safer piece of art for posterity, and if you see Morley on the street, spit in his face and tell him that your lugi is art. If you see one of his housewife Impressionistic pictures anywhere, deface the outdated piece of shit. Above all else, don't name your kid Morley.

** Editor's note: I think Robert Ryman is a truly great artist and any attack here on his personal appearance is not meant to detract from his art, career, or legacy.*
Issue 9, Winter 1993

Obituary
Charles Bukowski,
1920-1994

By Mat Gleason

On August 16, 1920, Cleveland Indian shortstop Ray Chapman was killed at bat when an inside fastball hit him in the temple. The national pasttime was forever tainted with this sad, unnerving footnote stuck among its glorious anecdotes. That day also marked the birth of writer Charles Bukowski.

Hank, as he called himself, ended up providing American literature with thousands of poignant tragedies to match the anecdotal heroics smearing this century's pages. He sang as sweet a song of bitterness and sad truths as anyone before him. His

Charles Bukowski, Mary Ann Swissler and Mat Gleason, November 1990.

wisdom came hard from the bottle and the streets, yet landed on the page almost too easily. His simple style was deceiving, for revealing the truth in so few simple words (as he did so often, in novels like *Post Office* and *Factorum*, and poetry collections like *The Roominghouse Madrigals* and *Love IS a Dog from Hell*) was more difficult than most iambic-pentameter

conglomerations undertaken.

He was buried in San Pedro in a Buddhist ceremony arranged by his wife of fourteen years, the former Linda Beighle. Sean Penn was one of the pallbearers. Bukowski once told me a story about Sean and then-wife Madonna. Penn had taken his new love to visit the obscure writer he was so enraptured by. It was obvious she was obliging, but throughout the evening seemed to be miffed at his fascination with this old pockmarked geezer and his young, cute wife. The four went to dinner at a little local seafood restaurant where Hank and Linda were regulars.

The locals were shocked to see the two stars at the height of their celebrity there, let alone with these two regulars, of all people. As dinner went on it became apparent that the waiter wanted an autograph from the grande dame. He waited for an opportune moment, slinked up with a menu, and began a quiet plea. Madonna, in star gear for the first time that evening, grabbed the menu, scribbled what passed for an M and some lines, and threw it back to him while shielding her view of the commoner. He gripped it guiltily and was about to slink off with what was left of his ego when Hank let out a scream. He loudly berated her, told her that this was a nice place, that these people were his friends, that he and his wife had to come back here. She shrunk in her chair and later apologized, weakly blaming the pressures of fame. She and Penn divorced soon afterward.

The day after their dinner date, Bukowski was backing out of the driveway, on his way to the horse races, when the little girl next door stopped him with a question.

"Hank," she said, "I heard that Madonna came to visit you yesterday."

"Yes, Stephanie, she did."

"Hank, why would Madonna want to come see you?"

"Beats me, Stephanie. I'll never know."

But he knew. They wanted to see the truth. And, as in his writing, he delivered it, hard.

Issue 12, Spring 1994

World-Class Fine-Art Printmaker Gunned Down: Ken Farley Traded Art-world Peak for Underbelly Lifestyle and Death

By Mat Gleason
A Coagula Exclusive

Ken Farley, one of the top printmaking technicians in the world, a master etcher and printmaking assistant to a who's who of contemporary artists for more than a decade, was shot to death on the morning of August 29 in his downtown L.A. studio space. The Los Angeles County Coroner's office reported that he died from multiple gunshot wounds to the body and one to the head. Catherine Geary, a female companion of Farley's, was also shot to death.

For ten years at West L.A.'s Gemini G.E.L., Farley had worked with nearly every major artist who walked through the legendary printer's doors. Without even needing to look up a list, Sid Felsen, president of Gemini, was able to recite an enviable roster of contemporary art giants who had been assisted by Farley: Robert Rauschenberg, Roy Lichtenstein, Ellsworth Kelly, Richard Serra, Jonathan Borofsky, Claes Oldenburg, Vija Celmins, Ken Price, Ed Ruscha, and Malcolm Morley.

Felsen spoke to us by phone only days after Farley's tragic death. "Kenny was a master. He was a great asset to Gemini." Felsen indicated that Farley had left his job about two years ago after more than ten years with Gemini G.E.L.

A graduate of the University of Wisconsin at Madison, Farley was a prodigy at lithography and had mastered the difficulties of the photogravure process. His printmaking skills

were put to use first for Petersburg Press before he was wooed away by Gemini in the early 1980s.

A suspect in the murder was apprehended later that day. Andrei Belei, a white twenty-four-year-old resident of L.A., is also the chief suspect in two more murders occurring that day—the death of a homeless man near Farley's residence just hours before the double murder, and the killing of a cabdriver in Hollywood around noon, this according to Los Angeles Police Department homicide detective Troy Bybee.

Since ending his tenure at Gemini, Farley's efforts to start his own fine-art printshop were hampered by the sluggish economy and his worsening addiction to cocaine. His drug dependency problem became so severe that in January he moved from East Hollywood to the downtown L.A. Loft District to clean out.

Boasting a crime rate one-tenth that of Hollywood and relatively little narcotic activity with hundreds of working artists living nearby, the Loft District was perfect for Ken to clean out and start his life over again and still keep one foot in the art community. Sadly, it wasn't meant to be.

While Ken was in the process of setting up a photogravure studio Downtown, he slowly slipped back into the depths of cocaine addiction. By late spring, Farley had reportedly begun selling crack to street transients from behind his studio space's iron security gate in order to support his escalating habit. Farley's best customer was reported to have been local homeless activist Fred "Wyatt Earp" Caruthers. Caruthers was spotted at the scene of the crime minutes before and after the shooting. Although not a suspect, Loft District residents report often seeing him leaving Ken's studio/crackhouse with locked briefcases that he stashed in a shopping cart and delivered up to local hoodlums under the First Street bridge, one-half mile away.

Many residents of the Loft District neighborhood had voiced complaints about Farley's crackhouse for months, to little avail. "As sad as this is," said one neighbor who wished to remain anonymous, "once he had started selling crack, all of a sudden burglaries and disturbances were going on everywhere." The Loft District prides itself as a place where a woman can walk alone at 3 A.M. Farley's crackhouse threw the neighborhood out of equilibrium.

While clueless councilperson Rita Walters has always been a disappointment to Downtown neighborhood complaints (despite the growing number of paint-soaked angry residents registering to vote, some residents wondered out loud if she even knew that she represents the Loft District), the real irony was that Ken's very public center of commerce did business all summer sitting in an unimpeded sightline of the Federal Building's penthouse HQ of the Drug Enforcement Administration!

Farley left no next of kin. According to LAPD spokesman Al Gonzalez, there were artist's printing equipment and numerous fine-art prints at the murder scene. When suspect Belei was arrested, seven grams of crack were found on the 6'4" suspect. He was high on crack when taken into custody.

Unnamed sources have speculated that a homeless man with a reputation for drug addiction and criminal behavior, known locally only as J. R., had been trying to gain access to Farley's crackhouse. After breaking a few windows on a Saturday, Farley apparently enlisted Belei's help in getting rid of the "problem." By all reports, Farley was very gun-shy and most likely not involved in Belei's alleged shooting of J. R. (whose real name police have yet to release, pending notification of next of kin).

After allegedly murdering J. R., Belei reportedly went to Farley seeking payment. Speculation is that Farley balked at paying for a hit and was subsequently gunned down along with companion Geary, who was pregnant. Belei is suspected of combing through Farley's studio and finding a large quantity of crack cocaine. Detective Gonzalez reported that no drugs were recovered from the murder scene.

In the hours following Farley's murder, Belei is suspected of smoking major quantities of crack. It is alleged that he picked up a taxi at Little Tokyo's New Otani Hotel just before

noon and reportedly shot its driver to death somewhere in Hollywood. Belei's reported crack-induced paranoia was evident when his alibi about being carjacked didn't explain his leather jacket on a 90-degree day. He then implicated himself in the Farley murders. A .38 revolver and spent shells were found in bushes near the cabdriver's murder.

While the Loft District spent the week assessing the impact, one thing was certain–the shopping-cart traffic coming and going by Farley's place on East Third Street had ceased. Things were returning to the mellower abnormal chaos artists work best–and safest–in.

Issue 14, September 1994

The Tragic Masochist Comes to Manhattan

One of the most captivating artists in America today is coming to New York City this September. Bob Flanagan has transformed his battle with cystic fibrosis into a profound metaphor of survival and individuality. His use of physicality as both subject matter and medium puts most recent "body" art to shame, while his subtle manipulation of sickness and depravity surpasses all profundities of "pathetic" art. His Visiting Hours show will run at the New Museum from September 23 through December 31. –Janet Preston

The Shock of the Normal
By Jessica Pompei

Bob Flanagan, former "traffic cop" of the Beyond Baroque Wednesday Night Poetry Workshop, would never be so conceited as to refer to himself as "teacher." Bob looked like a junkie, or an anorexic ex-addict. He was pale, dressed in black jeans and T-shirt. He had an awful smoker's hack. And his hair was sticking up all over. His job, as facilitator, was to be the only nice one in the workshop. So I was stunned when I finally heard about the nipple rings. There was other stuff, something about Bob jumping on any chance to get naked, that he was a masochist. It was like a child hearing the word "Fuck" for the first time. I needed to know more, but felt stupid asking, "Hey, word is you're into some weird shit, would you mind telling me about it?"

As my rapture for Bob's style of poetry workshop blossomed, so did my quest for extracurricular education. Imagine Diane Arbus stalking huge game, with a video-camera rifle. S&M . . . cystic fibrosis . . . so much ripe territory. I wanted the full poop and went to Mark Robin, the workshop "deputy." My first fiction makeover: Bob was no Marlboro Man. All the hacking during workshop, where he had to excuse himself, was

not about lighting up in the bathroom. It's the cystic fibrosis that's threatening to make a dead duck of him at any time. The last rites were read to him at the age of nine. His sister died from the disease at twenty-one. Bob is one of the oldest CF survivors in the world. Cystic fibrosis is a single-gene disorder that lies smack in the middle of chromosome seven. The havoc appears in the first ten years of life and affects the pancreas and lungs. Its major by-product is mucus that forms delightful plugs that clog breathing, resulting in the sensation of drowning without the benefit of water. Oh yeah, and big problems with digestion, necessitating tons of drugs, but not good ones.

How has he survived? Read on.

Bob's had this same Mistress for fifteen years, who tells him what to do (they have it going on great, most couples don't make it past three months). Sheree Rose doesn't fit the image of an evil, iron-prodding, whip-toting dominatrix. Bob and Sheree collaborate artistically as a team.

A perfect opportunity for discreet inquiry presented itself with Bob's *Visiting Hours* show last December at the Santa Monica Museum. It was going to be an installation, a hospital room, where Bob would be in bed with cystic fibrosis. He wouldn't be installing paintings—he really had this genetic disease. He would be on site during museum hours, so it wasn't some Chris Burden thing where you weren't allowed to see him. Besides, Bob, the pragmatist, would never do a painful endurance gig that wouldn't give him an erection at some point . . .

Opening night of *Visiting Hours* was carnival to the gills, with a major procession of high-fashion fetishists. It was interactive without the CD-ROM. Visitors brought candies, cards, a record, a thorny rose switch without the flowers, balloons, plants, and useless flowers. Background noises included whips cracking. Folks collected in the waiting room to share or read *Parents Magazine* and *Highlights*, replete with photos of bondage sex acts. Camera chat was in full gear, from a *National Geographic* photographer to everyone and his sister bumping into one another's lenses.

Bob lay serenely in state—hospital-bedded, examination gown—until his *Ascension*. Sheree, behind the scenes, hoisted flim-flam Flanagan, feet first, by ropes, naked, into the museum's wood-beamed ceiling. With arms extended, Bob appeared the upside-down Jesus, floating. Instead of a loincloth, his penis had numerous earrings on. Nothing gaudy, just simple silver studs that seemed to pushpin his weenie up against the corkboard of his balls.

A few neck-craners from below had questions for Bob:
"Do you have a match?"
"How long have you been up?"
"Is this the piñata portion of the party?"
"What time is it?"
Naked and suspended, Bob was wearing his watch.

On his way down, back into bed, while struggling to return to his hospital-issue open-air smock, he did a spread-eagle removal of his ankle harness. Hanging from his perineum (between butthole and testicles), a sterling silver, elegantly understated hoop.

After resting up a bit—water, inhalant, mugging for the cameras, and coughing—Bob kibitzed with the guests. People who couldn't manage to sardine themselves into the hospital-room area stood outside the door, by a wall of collaged black-and-white pictures of Bob. Written in the background, in those nice black letters you get at Office Depot, around the perimeter walls, was the background history of how and why he got into SM . . .

". . . because of my genes; because of my doctors and nurses; because they tied me to the crib so I wouldn't hurt myself; because I had time to think; because I had time to hold my penis; because I had awful stomachaches and holding my penis made it feel better; because I felt like I was going to die; because it makes me feel invincible; because it makes me feel triumphant . . ."

It was a Disney World of Bob's manifold theme attractions. A consumer favorite was the wall of pain, a video-scaffolding view ride with at least seven monitors, stacked, featuring dif-

ferent video loops. Each monitor was in charge of a different body part. Feet were tied. Hands were paddled. Ouch! Fun with enemas. The Werewolf faded in from Bob's head. Interlaced with goofy violent cartoons (wacky sound and all) was vintage video of Bob getting his dick nailed and different horror shriek tracks. One contented customer rushed from the scaffold screaming, "There must be Satanists in high places."

If you ducked around the corner to vomit or recoup your composure, you would find yourself confronted by a wall of clouds containing a large photograph: Bob as the caped crusader Supermasochist, hinting at the machismo involved in taking so much pain (and I had thought he was so humble). A barbell hangs from Supermasochist's penis and breast rings. Bob sports a powder-blue oxygen mask and matching Playtex gloves. He stares you straight in the eye. He floats, up in the air, taking it all in stride, hands on his hips, ready for more action.

The *CF/SM Alphabet Blockwall* guided the way to the kitchen area. A mini table-and-chairs playroom featured an educational clear-skinned anatomy statue. Green vomit, phlegm, and cum dripped out of him creating a gross-out puddle on the table and rug. Inside scoop: it was really White Rain shampoo and Maalox. In close proximity to the fake barf, a play doctor's kit and stethoscope if you felt the need to pretend-operate or just cheese it up for pictures.

The Cage, an iron, tiger-sized circus enclosure, was commissioned by Sheree, as a gift for Bob's fortieth birthday. Locked inside, a crystal baby bottle and infant blanket. Unlike the lions and tigers, Bob has enjoyed being locked in it, less now than a few years ago, as he is much sicker. Sheree's job is getting usurped by the meaner mistress, CF. He can't come out and play as much.

At least Bob shares his toys with John Q. Public, who came out in record numbers to play. Tourists to the SM Museum photographed themselves trying out different personas, saddling up to their favorite plaything d'art, peeking their heads through as if behind a Wild West cardboard set.

"Get one of me over here, by the *Gurney of Nails*."
"Smile."

The *Gurney* was new to the repertoire, specifically fabricated for the show. On closing night, Bob got on the bed of nails for the first time ever. Not a cinch. With Sheree's assistance there were hours of practice the night before, after the museum had closed. Four boards needed to be placed on the nails before Bob mounted. Foot first or butt first would be too weighty and could possibly skewer Bob.

During showtime, a friend who had also helped in coordinating gurney practice held ice cubes to Bob's lips. In response, he sucked like a tot on the bottle. The friend was also keen at policing the edges of the gurney. People crammed around and kept knocking into Bob. Sheree continually came by to check on Bob, once even giving him a deep tongue kiss. One friend was allowed to touch him. She gently slid her hands with a light feather touch up and down his body. Tracing over scars, tattoos, and stitches, her graceful fingers were mesmerizing.

Bob concentrated on his breathing like an athlete running a marathon. Intermittently he would let out a hog-heaven moan. And then ultimately started cracking jokes about the high he was getting from adrenaline and beer. One pal razzed him, he had never realized just how big Bob's balls were. Another guy lodged near the gurney asked if he could borrow some money. Bob told him to help himself, that the funds were up his ass.

The installation was not all hilarity. It rendered many people vulnerable and emotional. A few times I had to back off with the video gun because intimate confessionals were afoot. *Visiting Hours* acted as therapy for people who have long considered themselves fruits and nuts for their sexual proclivities. Complete strangers felt comfortable pulling a chair up to Bob's bed and spilling all. They left feeling not just sane, but empowered to be themselves.

At the New Museum this September, there are a whole bunch of additions to *Visiting Hours*. You get to work your way

through a field of life-sized Bob punching bags. There is going to be a coffin you can see yourself in (like Madge's dishes). Sort of a Winky-Dink effect with Bob on the other side.

But mostly, New York can look forward to hanging out and talking to Bob and Sheree (she's really nice and smart and never once raised her arm). Don't you have some stuff you think you might need to talk about?

Jessica Pompei is currently running a writing workshop in Venice, California.
Issue 14, September 1994

Hammering Back: How the L.A. Times Got It Wrong on the Hammer

By Brady Westwater

Christopher Knight fanned big time in his dissing of the deaccessioning of the da Vinci Codex by the UCLA/Hammer Museum. While every point he made had theoretical validity, his conclusion (that the deaccessioning was the ultimate crime against humanity) was quite overwrought.

Deaccessioning is always controversial, but there are rare cases—and this is one of them—where the true mission of the institution is more important than any one item. Knight agreed that the Codex (one of twenty in public hands, by the way, and far from the best of the lot) does not belong in an art museum, that the value of the work is its content, which can better be studied in reproduction. Few will be better able to put this primarily historical and scientific piece on the information highway than its new owner, Bill Gates. The presumed loss to the public of the Codex is not like the loss of a work of art where the primary experience is the firsthand examination of the subject.

Most egregious, though, was Knight's attack on the very existence and integrity of the UCLA/Hammer Museum. The Codex was sold to address a onetime situation (a lawsuit caused by the previous owner that threatened the entire art collection of the institution).

The decision to sell the Codex was made a full year before UCLA even became involved with the Hammer; UCLA and the current administration had absolutely NOTHING to do with the fact of the sale. All UCLA could do was make certain that the sale was conducted according to accepted museum guidelines, which it was. To claim that the UCLA/Hammer cannot be trusted with art because the prior administration contractually sold the Codex is an amazing jump of logic.

The basis of Knight's accusation is the claim that the sale blatantly breached the codes of both the Association of Art Museum Directors (AAMD) and the American Association of Museums (AAM). After reaching both associations and perusing their respective codes, the answer to Knight's claim is: since UCLA has become involved with the museum . . . drumroll . . . they have fully complied with every aspect of the codes of both associations.

Knight's suggestion that the museum was obligated to offer the Codex gratis to another institution came out of deep left field. The AAM does not even address that issue; the more restrictive AAMD Code reads: IV. Selection of Methods of Disposal; A. *Preferred methods of disposal are sale through publicly advertised auction, sale or exchange through a reputable, established dealer.* Not only is the auction method the first one listed, but the idea of giving away the Codex is never even mentioned as an option.

Mr. Knight further disparaged the Hammer for (he claimed) not promising to use the money from the sale of the Codex to purchase new artwork, which would be a violation of both codes. This is simply not the case (though there were some initial mixed signals in the press on this, illustrating the danger of relying upon the *L.A. Times* as a source of information on the arts); all the money from the sale and the interest will be

reserved solely for the purchase of new artwork and that has always been the case since UCLA has become involved. According to AAMD director Mimi Gaudieri, "The UCLA/Hammer Museum committed no breach of professional practices or ethics in their sale of the Hammer Codex."

Hopefully, these facts should settle the canard of the Hammer doing anything wrong and the *L.A. Times* should shortly issue the appropriate public apology to the UCLA/Hammer. That will undoubtedly be in the same edition in which Newt Gingrich and Hillary Rodham confirm their long-standing love affair.

Christopher Knight's real problem seems to be that he feels the UCLA/Hammer should not be allowed to exist. Granted, as originally conceived, the Hammer was to primarily be a museum of pre-modern art—a function which it cannot fulfill as a separate institution. Mr. Knight is correct in that assessment. Now, however, it has been combined with the collections of UCLA and on its board sits Eli Broad, who has one of the world's finest collections of contemporary art.

There are other major collections in L.A. which have no permanent homes; add to this the speculation about the future of the Norton Simon Museum. What the Hammer needs now is the time—and financial resources—to determine what kind of a museum it is going to become.

Until then, the Hammer should be evaluated by what it has done, not by the sale of a manuscript by the prior administration. In less than one year, under the leadership of Henry Hopkins, the Hammer has become one of the most innovative institutions in L.A. The Hammer has easily the finest rental/sales gallery in the country, one that could actually help develop serious new collectors. Its bookstore is second to none. The Hammer also has evening hours to allow people who work for a living to actually visit an art museum on a regular basis. The Hammer has, even more importantly, put on valuable shows we otherwise would have missed.

The "Bad Girls" show—in some ways a female response to MOCA's bad boy-rampant "Helter Skelter" show, should have been at MOCA, but there was no space for it there. In addition, the "Images of the Black Male" show organized by the Whitney is exactly the type of programming museums need, not only to broaden their audiences, but to bring challenging art and ideas to the existing art audience itself. The show is an intelligent, thoughtful look at race and contemporary art rather than the typical PC polemics that infest the art world, yet there was no room for it at the MOCA Inn either.

○Vincent Van Gogh
○Eric Clapton
○Brady Westwater
(check one.)

Thanks to the Hammer, though, Los Angeles will see this important show. This is in no way a criticism of MOCA or its policies; it is simply a law of physics that no two pieces of art can occupy the same white wall at the same time and the truth is that Los Angeles does not have enough walls, white or otherwise.

L.A. needs more space and more points of view. The Hammer's premodern collection might be of value in setting up an entirely different type of art museum, a museum in which one of the main goals is not to just display art, but to teach people how to look at art. Changing exhibitions could in one room show the difference—and similarities—between religious art from Fra Angelico to Fra Basquiat. We need to find new ways of opening people's eyes up to the art of our time. The interplay of the art of ALL times and cultures—side by side—might be the way to do it, using the collections of the Hammer,

the Fowler, and other institutions of L.A. in concert.

A further advantage is that the Hammer building itself, unlike MOCA's jewelbox, is no architectural treasure. It can be easily expanded and changed to meet new demands. The expansive outdoor corridors and spacious courtyard could be enclosed to more than double existing gallery space. The bookstore could be moved to the rear groundlevel and opened out to the Village to bring people into the building. The rental/sales gallery needs to be expanded and given further visibility to entice more people off the streets and more art into their homes.

The UCLA/Hammer is our only museum located next to a major university. It is our best bet to develop a true educational institution and the only museum located within a neighborhood (Westwood Village) where crowds of people, particularly young people, from all over L.A. naturally congregate. Los Angeles is a young city with young institutions; too many people look only at the short term and use current problems as an excuse for throwing up their hands and doing nothing. Few have the vision and passion of UCLA—now, hopefully, others will —in trying to turn a once-marginal institution into a vital part of our cultural life.

For that they should be congratulated and encouraged, not unjustly condemned for the supposed sins of their predecessors.

Issue 16, January 1995

The Art of the Schmooze: Molly Barnes' Blueprint for Art Success
By Mat Gleason

Many years ago, I wandered about the art openings in paint-stained jeans, not even sure of what I was hoping for and certainly having no idea of how to get it. As concepts of artworld success crystalized in my head, I looked around and realized a flaw—my art completely sucked.

I quit painting, discovered publishing, and have been extracting a revenge on those more talented than I for some time now. Perhaps if I had read Molly Barnes' *How to Get Hung* (Journey Editions, $16.95), I could have done what so many art-world denizens do so well—peddled my bad art above and beyond any imaginable amount of attention or acclaim it deserved.

Barnes, who was once art correspondent for L.A.'s KFWB News Radio in the mid-seventies, has written such a precise dissection of the art world and how its machinations work that I really hope the great unknown artists out there read it and memorize it. Of course, the lousy ones will probably read it too, and that will be that, as is always the case when slices of the pie are up for grabs based on who can elbow their way up to the table rather than on who truly deserves dessert.

This book could have been subtitled *Everything They Don't Teach You in Art School That You Need to Know*. Every page is devoted to pulling back the mysterious veil that so seductively shrouds the white cube. Advice given here is solid and can serve as a road map to those wanting to get ahead in the game—though it leans on a motto of superficial soullessness.

But back to that soullessness bit. Barnes' book reveals the art world's little secret, that trendiness is the rule of the day

and that King of the Hill is not just a game played in kindergarten. That Barnes glosses over these seedy aspects with a minimum of lurid detail (giving great gossip without naming names gets to be quite frustrating after a while) can be forgiven (hey, she's a player in the game, too). But the homage she pays to dealers and gallery owners in this book borders on a religious fanaticism. There is nary a sentence of advice on how to cultivate collectors of one's artwork. Leaving that to dealers is the reason artists get screwed over in the first place.

While the book overlooks a few critical areas of the art world's plantation mentality, it should certainly help accelerate the career growth of those willingly on the farm.

Issue 18, Fall 1995

George Herms: "Do Not Fear the Unknown"
By Mat Gleason

As the doors of the Whitney Museum elevators open to the massive Beat Generation retrospective, a large sculpture stands at the entrance along with the show's signage. *The Librarian*, a sculptural assemblage slightly resembling an anthropomorphic book beast, stands as the signatory visual piece of the Beat era. The creator of this antimonument is George Herms, a beatnik who adopted Los Angeles as his home after being arrested for underage drinking during his first visit here, back on New Year's Eve, 1954.

Artistic Journey: He came out of the Beat era, quickly sidestepped the mass-culture days (he equates the emergence of the Beatles as the end of the Beats), milled about—still on the fringes. It wasn't until the mid-seventies that he heard the term "art world" or was told that what he had accomplished amounted to a "career." In the early eighties he found a book on grant-writing and applied for the Prix de Roma and a Guggenheim grant. He got both!

While a notoriety accompanies his name and a respect is given to his oeuvre, Herms still exists in that murky area between caring about making art and not caring about how it ends up in the public eye. Enter veteran La Brea Avenue dealer Jack Rutberg, a silver-tongued gallerist with a reputation for decency and taste. About the worst thing this writer has ever heard about Rutberg is that nobody under sixty was attending his gallery's opening receptions. With Herms, who thrives on being around young artists, that has changed. He currently receives inspiration from the students at the Santa Monica College for Visual Arts, Design and Architecture. One former student in particular, Ms. Pixie Guerin, has informed more than just Herms' art. Pending the imminent divorces of the two, she is slated to become the SIXTH Mrs. Herms.

The collateral assemblage the artist is best noted for, represented in major museums by, and spiritually linked to, is a special brand of tactile construction always begging to be touched, fondled if the opinion of the self-proclaimed hedonist Herms is asked for. Rather than fear the age of technical marvels advertised by the Information Superhighway and with no interest in embracing silicon dreams, the artist is quite excited by the possibility of a culture so engrossed in the cerebral that it rebounds into an orgy of physical touch.

Here are some thoughts in the artist's own words:
Herms' universal advice to artists:
"The only sin in art is submitting yourself to glamour."

On art movements:

"I call my pieces WORKS because assemblage seems to end up being stuff made by an incestuous in-crowd who are being hoisted now on the public as their RESPECTED ELDERS, and it would be ludicrous to put me in with them."

On the place of the Beats in art history:

"Collage and assemblage was all kind of a road out of Abstract Expressionism for us, because it was a way of acknowledging and dealing with the imagery of the mass media. We had to use imagination to try out new things then, as always. They just don't come. Imagination is the major muscle of an artist."

An anecdote about remingling with what was left of the Beats at the Whitney's opening-night bash:

"Gregory Corso was sitting next to Pixie, he was drinking, we were watching Michael McClure recite poetry while Ray Manzarek played keyboards. Corso was getting progressively drunker and rowdier. Michael McClure's girlfriend offered him some codeine, but he just got more out of hand. Pixie got upset at his insensitivity and I must say he *was* acting like a child, but really, as disruptive and uncool as he was, you only had to realize that as the two guys performing were shouting to be heard and going at the top decibel level, there were just no dynamics to the performance, and that's not what art is about. Later, Kerouac's keyboardist David Amram improvised while an actor read some of Jack's writing and the difference was amazing. The dynamics and subtleties just came out. It was a real epiphany. Rock 'n' roll isn't jazz and there really is a danger in romanticizing things, romanticizing an era, bringing in things that weren't there. The right wing has co-opted images of the Old West, that it was a bunch of god-fearing missionary settlers, when it was a bawdy, dirty time of anarchy and drinking, murder and freedom and wildness. The railroads ended all that around 1880, and mass culture ended the Beats by 1965. So Corso getting loud at the show was a reminder that they can't just alter the legacy to fit their needs. But that is why these shows are so important, to preserve the unro-manticized truth about our battles for freedom of expression."

On his older works:

"There aren't many pieces of mine from the 1950s lying around. I got sentenced to six months for smoking pot around 1960 and my wife took thirteen rooms—we had a big old house—worth of work and made a huge pyre and they went up in smoke while I was locked up for smoke.

"Andy Warhol saw one of my pieces that had been ravaged by a flood in Malibu and told me it was really improved. Funny thing is, I agreed with him."

On his inspiration:

"The Beats were very nonverbal. The closest thing to an art theory I ever heard was when Wallace Berman told me that an artist's job was to edit reality. Ed Kienholz would always try to edit in the ugly while I have always tried to bring in beauty.

"My trip used to be to make a work of art each time a new drug came out. Thankfully, I had to quit that series before angel dust hit."

On the Nineties:

"The Nineties are about quality!"

Issue 19, Winter 1995

Lari Pittman Vs. Robert Williams
By Mat Gleason

Poor Lari Pittman.

With a survey of his drawings serving as a warm-up to a major midcareer museum retrospective later this year, he has certainly reached the point in his career where the attention should be focused on the breadth and depth of his art. Instead, one of L.A.'s finest finds himself the subject of a behind-the-scenes tit-for-tat between different factions of the Los Angeles critical establishment.

Call it the old guard vs. the older guard—it seems that when the *L.A. Times*' Christopher Knight labeled Pittman ". . .

arguably the most significant painter of his generation" this past January, Lari Pittman was perched to fall.

The fall came, it came hard, and it came in, of all places, the pages of the *Los Angeles Times*! It stabbed at Pittman just a bit harder than the man everyone perceived as its intended target—Christopher Knight himself!

When William Wilson, the Shemp of the *L.A. Times* Three Stooges of Art Criticism (Knight as Moe, David Pagel as Larry, if you will), had the opportunity to review Pittman's recent retrospective of drawings at the UCLA/Armand Hammer Museum, he pounced on it. In his usual glib and foggy prose style, which has made him a favorite of no one, Wilson nitpicked at minutiae, hammering away at discrepancies only he could perceive.

Take it from somebody who trashes art for a living, *Coagula* would not have published a review this blindly vicious. It was neither slightly informative nor pointedly dismissive; perhaps mundane prose sharpened into a hatchet, but nothing more.

Wilson's ditty managed to enrage the L.A. art world establishment, who came to Lari Pittman's defense in the form of a letter to the *Times*. Signed by twenty-three people who contended that Wilson's thrashing of the show was a personal attack on Lari Pittman under the guise of art criticism, it labeled the review an example of "deplorable homophobia." The letter's authors (including critic Amelia Jones, collector Clyde Beswick, dealer Richard Telles, and artist Jim Isermann) charged that Wilson's contempt and animosity for Pittman's work caused him to dismiss the artworks' universal themes as "camp, gay humor."

Of course, in the corporate climate surrounding L.A.'s only major newspaper, a simple essay arguing that a colleague had grown too big for his britches would be unthinkable. Inarguably, the major critical champion of Lari Pittman's career has been Christopher Knight. It isn't too hard to extrapolate that a vague, mean review by old man Wilson was intended as a snipe at Knight, the former boy-wonder critic who (in seven short years since joining Times-Mirror, Inc., from the Hearst Newspaper chain) has usurped Wilson's civic hegemony and consolidated power in a manner that would impress Machiavelli.

Would a *Times* reader have any background on Lari Pittman to balance against Wilson's offhanded repudiation of Pittman? Perhaps, in the last few years, Christopher Knight has written something of depth about Lari Pittman, something to inform *Times* readers about the greatness and depth of Lari Pittman's work.

Sadly, for Pittman fans, a database search of champion Knight's *Times* writing (one would assume that Knight would keep *L.A. Times* readers abreast of Lari's genius in the pages he calls home, since his *Last Exit to Eden* tome isn't exactly rivaling Rush Limbaugh on the bestseller list) over the past four years reveals little more than gushing over Lari's painting and Lari's impact and Lari's brilliance. A king of adjectives for bliss and beauty, Knight gives *Times* readers little physical description and NO objective analysis!

From Christopher Knight's 1992 review of MOCA's "Helter Skelter" show: "[Lari Pittman] is a Fabulist, miraculously transforming mundane images into dazzling concatenations. His obsessive, wholly ornate pictures continue to amount to

Pittman champion Christopher Knight.

some of the most significant painting being made today."

Translation: *Lari rocks!!!*

In Knight's 1995 Whitney Biennial essay, Pittman's paintings are "big, brash, go-for-broke extravaganzas of lust, death, glamour, madness and commemorative bliss." He asserts they "remain the most invigorating paintings being made today. They blow away everything else on the walls."

Translation: *Lari totally rocks!!!!*

And finally, in a quip from a 1995 Cirrus Gallery print retrospective, Knight called Pittman's work "raucously effusive paeans to life and love, sexuality and morality."

Translation: *Hey, hey, my, my, Lari's art will never die . . .*

The only other mentions of Pittman by Knight in the *L.A. Times* over the past three years have been to use Lari as an adjective to describe positive aspects of other, younger MALE artists (a favorite topic of Christopher Knight's).

So his hometown paper gives its readers two distinct personalities to analyze Lari Pittman: either Christopher Knight as the adolescent in the frenzy of air-guitar idol-worship or William Wilson as the evil-Freudian sociopath.

Since a museum show *does* signify at least one institution's willingness to merge its reputation with that of an artist (and considering that Pittman will have a full-on midcareer retrospective at the L.A. County Museum of Art later this year), a critical analysis of Lari Pittman's work needs to be THOUGHT-FULLY done, somewhere outside of the battleground known as the *L.A. Times.* (I didn't even bother researching reviews by the *Times*' David Pagel as he and wife Alisa Taggert lent two Pittman works to the Hammer show, one being their K'Tub'ah—that's a Jewish marriage contract for you Gentiles—designed by Pittman and longtime companion Roy Dowell!)

To thoughtfully discuss the work of Lari Pittman free of the politics of identity which Knight and Wilson haggle over, a quick scan of the formal elements employed by Pittman and the manner in which he uses them is in order.

The Pittman masterpiece is composed of an allover compositional technique that less resembles an abstract painting than it does the *horror vacuui* of an ancient Egyptian tomb wall illustration; dense information and imagery are everywhere. The few subjects holding visual dominance tend to have sexual overtones—penises, number sixty-nine—or linkage to commercial popular culture (one series featured Visa and Mastercard credit cards flying about) rendered in an intentionally flamboyant style that preserves a flatness in its form resembling the calculated coolness of the best Pop art. Over the years, Pittman's aggressive compositions have toyed with an over-the-top effeminism, the kind of machismo a man secure in his identity plays up. Pittman adds lines like a girl because his bright colors and bold form are as masculine as anything a swaggering Abstract Expressionist ever tried.

Where Pittman's truest innovations are found, though, are in his ability to breathe new life into the corpse of Surrealism. In spaces that defy and yet condense time, explain and erase actions, a dexterous approach to realism is filtered through an obsessive gaze beyond the real. The compositional end-results of his mixture of Sexy Pop and macho, emblazoned color are Surreal dreamscapes—a Salvador Dalí, not on acid as much as on MTV. On this level, Pittman's formal kindred spirit is another L.A. painter of note, Robert Williams.

While Robert Williams has toiled in a purgatory between galleries and storefronts, his approach to painting is actually close to Pittman's. Williams' use of a more three-dimensional dreamscape is the single major stylistic separation between the two. Both have a preoccupation with filling the painted surface with busy, often delicate compositional information. Both are more dexterous than these times call for. Both are obsessed with sex.

That Christopher Knight would be blind to these obvious similarities comes as no surprise. In his review of 1991's "Helter Skelter," the only art show Pittman and Williams have been coparticipants in, Knight lambasted what he called "the tiresomely repetitive vulgarities of Robert Williams' comic-book paintings." Do we have a Jesse Helms on our hands? Fawning one moment, brimstoning the next? Calling anything that does

not fit his personal lifestyle "vulgar" is the most cogent example of his inability to separate honest art analysis from personal politics. It is a scarily similar attitude to the masses of Pat Buchanan supporters rallying en masse to condemn immigrants or gays as a group. Knight's dismissal of comic books as an influential medium could be turned against Lari Pittman without too great a strain in pictorial analysis (one easy example: the flatness of Pittman's space could be derived from or commenting on modernism, and yet could be influenced by Hanna-Barbera).

If Robert Williams has an unmistakably heterosexual edge that Knight finds abhorrent, and I suspect this is the case, a glib dismissal is the easiest way to avoid expanding the dialogue about art into a meaningful discussion about how taste and aesthetics influence judgment.

What critics on both sides of the *L.A. Times* critical establishment have missed about Lari Pittman's work is its aggressive replacement of the clichés of Surrealism with a language influenced by cutting-edge popular culture. That this conceptual sophistication is in the hands of a dexterous master with –the poetic sensitivity of a bullfighter on Ecstasy–that is our reward. That he has been championed by dullards is our punishment.

Poor Lari. Accepted by an establishment that basks in his reflected glory only to shield it from those who would truly appreciate it.

Issue 21, Spring 1996

Letter from Freedom X
By Fred Dewey

Baudelaire bemoaned, in The Salon of 1846, *the state of the "public soul." Amidst "a vast procession of undertakers, political undertakers, amorous undertakers, bourgeois undertakers," the great poet wrote, "we all celebrate some kind of funeral." In this spirit, this author begins a column on the rela-tions between art, public space, and public meaning with three obituaries.*

Two major American artists, Bob Flanagan and Hannah Wilke, have passed away, and with them, we have lost two powerful conduits through which the ambiguities of the world screamed out against a docile art world and a politically neutralizing commercial culture.

Flanagan, to the very end, remained uncategorizable in commercial terms. Instead, as he said in a 1994 poster of himself, wracked by disease and in a wheelchair with oxygen tank and leather outfit, "Fight sickness with sickness."

Wilke's death is equally tragic, especially since she has received no serious acknowledgment from the predominantly male (but also conventionally "feminist") art establishment. As an artist who rejected the market and predated and surpassed the concerns of numerous 1980s female art stars, Wilke remained heroic to the end of her life, willing to put herself brutally on display as her body was ravaged by cancer and plugged with needles, losing hair and horrifying in the extreme. The world is not kind. But more importantly, it is unkind to those who fly in the face of the commercial culture's continual emphasis on narcissism, self, and beauty.

Carolee Schneemann, at an L.A. panel on photography and performance in 1993, noted that too much important work by women has been understood only after they died, citing among others the example of Wilke, whose critical pigeonholing as a "narcissistic exhibitionist" Schneemann courageously attacked. Typically, when the Wilke show stopped at the gutsy and independent Santa Monica Museum in late 1995 (the museum that premiered the Flanagan retrospective in 1993), the *Los Angeles Times*' Christopher Knight dismissed Wilke in a couple of sentences inside a long review of another artist showing at the same time in a neighboring side room. (*Ed.–our Senior Art Critic Shelley A. Berger gave it a deserving analysis in* Coagula *Issue 19*)

It is not simply the antifeminist tenor of powerful (if often publicly minded) L.A. critics that is outrageous. The regime of

disappearance can exert itself even in posthumous acknowledgment, and by women themselves. In Amelia Jones' catalogue essay for Wilke's *Intra-Venus*, the deceased artist's revision of her own earlier work as a striking beauty was installed in the funeral home of psychoanalysis—the horror of the work evaporating yet again as "radical narcissism." Fashionable formalism and inhuman theory seem unstoppable in Los Angeles, while narcissism is a favorite dismissal and refuge, perhaps because it is a safe withdrawal from, and dismissal of, attempts to address a public world. What few seem able to face is that perception within the capsule of the self, what Benjamin called the "phantasmagorias of the interior," is entirely complicitous with the market. Wilke, facing us directly, first years ago in her beauty, then at the end in the horror of her actual existence, devoted her life to exploding narcissism and its total ability to buttress both capitalist and so-called "radical" theory. Coming forth as one is, to address others, remains the greatest enemy of power and lies.

One of the most peculiar mechanisms in the decline of the public realm is a fashionable strain of criticism in L.A. which embraces the confluence of narcissism and pop culture. Dave Hickey, in a March lecture at Otis, espoused this in praising the need to respect one's internal responses to art, citing a beautiful neon guitar in Vegas as worthy of appreciation for its "vernacular" beauty. No doubt. The problem is that the forces Hickey laments—the "managers of meaning"—are not simply museums and academics. The *market* manages and dominates meaning, and even more, makes beauty a deadly mechanism not only of control but of silencing dissent and the actual world we are in. Those things not beautiful, an increasingly vast part of the American landscape, not only do not get discussed, but the power of art to speak to us of ugliness in a sublime and challenging way is made to vanish.

The work of attacking icons and every new religion—the preserve of art before

Warhol made commercialism hip—has become a sign of treason and heresy. The cults of persona, surface, and transgression not only can't correct for power, but strengthen it.

Both Flanagan and Wilke engaged issues that are disturbing to *people*, and it is as people that they worked and gave generously to friends, colleagues, and the public. They made their own experience into crucibles, bringing the private into public, and, like Hans Haacke—another artist willing to burst the narcissistic envelope of aesthetic power—speak to us of a time of unprecedented mendacity and callousness.

As another great *refusé*, the French philosopher Felix Guattari (subordinated in America to his writing partner, the academically acceptable Gilles Deleuze), put it before his own recent death—now subsumed in a wave of Parisian necrophilia—"Existence is not dialectical, not representable. It is hardly livable!" Bravo. Sooner or later, we must begin to speak again of the world we live in, of the facts of life. Therein lies the beginning of beauty and the end of the closet in which we live to disappear.

Issue 21, Spring 1996

My Noise
By Lavialle Campbell

Because I am a woman, African-American, and a feminist artist, issues of my "Otherness" in the art world are varied and at times extreme.

As an "other," I approach documents such as Thomas McEvilley's book *Art and Otherness: Crisis in Cultural Identity* with a great anticipation. The fact that issues of "Otherness" are being addressed (even with the author coming from his own status as art critic) is very important to those of us who are "Others." McEvilley states, ". . . *the self of the viewer is at stake in an art exhibition, not the self of the artist.*" The fear of Others is so

My picture.

prevalent in the art world that the power structure completely shuts out anyone or anything that they haven't put their own personal stamp of approval on. The power structure of the art world maintains its sense of entitlement and selective history to the detriment of anyone who does not look and think like them. I believe, as McEvilley writes, that "*The European colonial myth of the non-humanness of conquered peoples was evidenced in the claim that those people were outside of history—history being the white way of organizing the narrative of communal memory.*"

What is the fear? Why is it so difficult for the power structure of the art world to learn about and accept other cultures into the whole? We are all forced to learn only about European-based history, art history, and ideas. What is needed in the art world is inclusion. McEvilley states, "*The reality of contemporary art as a shared enterprise of artists in Europe, America, India, China, Japan, Australia, Egypt, and so on requires a revised view of history as having multiple streams and multiple directions.*"

As an emerging artist, my contact with the art world began with art school. I encountered severe problems at UCLA.

My experience at UCLA speaks directly to a Eurocentric view that permeates the art world. One instructor did not want to hear about the historical implications of my work during a critique. The pieces that I presented were altars. She had limited information on African and African-American history and became hysterical when issues were raised about which she had no knowledge. This critique ended with my walking out after her tirade of yelling and eventually swearing at me.

During a conversation with a different instructor (for a final project in photography), I was asked who my audience was. I wasn't sure what he meant. He clarified it by stating, "If your audience is your community, there is a lot of symbolism you can leave out of the work, but if your audience is everybody, you don't want to be an asshole and try to cram your culture down someone else's throat." This instructor, being a well-connected white male, obviously didn't realize that his European history/art history has been "crammed" down my throat and the throats of Others for hundreds of years.

A teacher once asked me during a drawing class final what made my work valid. He qualified this by analyzing that a lot of my drawing was based on personal experience. I found this odd, considering that this was an instructor whose work was clearly based on personal experience. Was his work more valid because he was white, male, gay, and represented the power structure of the art world and I was not only a female, but an African-American female?

Outside of academia, one need only look as far as the morning paper. It is disheartening to experience the art critics of the *Los Angeles Times* and their limited view of the world at large. Very seldom do you see a review of the work of a person of color, if at all. This attitude came through clearly in Susan Kandel's art review of Gaza Bowen's (a Jewish woman) work: "*The danger of making work about one's own history is that it has the potential to alienate all those who don't share that history. This was one lesson of the art world's short-lived infatuation with multiculturalism . . .*"

Does Kandel's arrogance only surface when she is faced with issues she cannot control? Clearly, there is no room for investigation or further expansion of her mind.

Another *Times* critic, David Pagel, gave a lecture at the Armand Hammer Museum on "Generosity and Cynicism: Critiques of Pure Abstraction." His lecture made me certain that he had no interest in any work that was outside his very narrow scope of art. His sarcasm and disrespect for Otherness came through in the remarks he made about several of the works done by women in the show, and specifically about Annette Lemieux's *Black Mass*, which depicted Chinese workers carrying placards that were blacked out. When an audience member mentioned that she felt she could derive substance and meaning from the piece, he remarked, and I paraphrase, "What could it mean, black is beautiful?" Pagel's ignorance overshadowed anything of importance he could have said during his lecture.

Social critic bell hooks perfectly summed up Pagel and his minions when she observed that "*Sadly, the conservative white artists (and critics who control the cultural production of writing about art) seem to have the greatest difficulty accepting that one can be critically aware of visual politics—the way race, gender, and class shape art practices—without abandoning a fierce commitment to aesthetics.*"

Others need to be included—to be alongside whites in the art world—not patronized and ghettoized. Others don't want to take anything from those with power. We just want to be along for the artistic and historic ride.

Issue 23, September 1996

Letter from Freedom X
By Fred Dewey

Who then is this New man, this American?
–Hector St. John de Crevocoeur

The society of the lie is triumphant in the United States, revealed in the extraordinary success of two souls lost in the ever-growing rabbit warrens of manufactured reality. The first, John F. Kennedy Jr., was described by one editor upon last year's launch of his political magazine *George* as "inherently interesting." This is the mighty beating pulse of America's cybernetic curtain, the cult of personality. One might ask what is inherently interesting, and for whom, in this son of a man of imperial sentiments and good looks and a woman only slightly more democratic than Imelda Marcos. Meanwhile, the truly "inherent" interest lies in making sure "a former Marine and a frustrated artist"—as the *New York Times* put it—stays as clean as possible. LAPD detective Mark Fuhrman, polite and deferential to authority and a sociopath and perjurer to everyone else, is fined $200 and sent home, while the thief of a pizza slice is sentenced in perpetuity to the gulag. The attorney general of California calls this a model of our "system working," and the message is clear.

What passes for culture in America is increasingly the beautification of power's gangsterism, the hiding of truths behind banalities, the crushing of the people, and the elevation of pop culture, fueled by a sewer of hypocrisy and careerism. The cult of personality matches precisely the immunity of a power whose violence is magically unknown. An aesthetic and narcissistic envelope allows ugly deeds to remain immaculate, first of all to their executors. To provide one sordid example, government documents released by the *San Jose Mercury News* on October 6 definitively point to police, FBI, and CIA involvement in the birth of the crack epidemic in, and supplying of automatic weapons to, U.S. ghetto gangs. You ask, what does this have to do with art? Everything, for not only has the aesthetic become the tissue of corruption, but art is its mainspring.

Fabricators of reality, indeed anyone who can keep a straight face, are celebrated as gods in veritable Aztec rites of slaughter and *isms*. Europeans are astonished at the way American elites continue to believe this will work, when from the outside, and for growing numbers on the inside, the American fiction has collapsed. The bargain sale of values has turned upon culture (which, when properly understood, strengthens and secures the world) with ravenous fury. All that is left is a simulacra of the public, and worldlessness. From the first days when Martin van Buren, the demonic early-nineteenth-century architect of the Democratic party, devised the foundation of our modern politics, the art of splitting what is done from what is publicly known has been the key to the machines and those who rise through them. Van Buren knew one must sever the persona from action, appearance from what is; only through this can the machines and their parts grow and spread.

The structure of American society has widened the split between knowing and doing into a chasm, producing mass rootlessness and fear. People move about in entirely virtual

environments, identifying with things that never existed and never will, elevated one week, broken down the next. This art is enforced by murderous, assassinatory power. To the machine lie of the radiant future, perfected under communism, the twentieth-century American order has added pleasure. One prominent metaphysician of the virtual route described it: "Our hearts beat in the machines. This is Eros."

It is time, as Solzhenitsyn put it in 1974 in *Under the Rubble*, to give up on the smatterers, the intelligentsia most of all, silently backing this order of fraud and intimidation. Solzhenitsyn's answer was to summon that thing the ambitious most despise: an individual. How is an individual made? Not by success or visibility or climbing the social ladder, but by squeezing through the tiny hole in the filter, no bigger than the eye of a needle, which is *nonparticipation in the lie*.

The East understood Solzhenitsyn immediately, and a parallel culture found its root. Where then are the Solzhenitsyns, the Palachs and Sakarovs willing to stand up and challenge late-twentieth-century America's society of the lie? The answer is, waiting for Oprah. As Solzhenitsyn put it, peasants are not the only ones to marry for a bowl of cabbage soup. Pop culture icons form the semiotic anchors of the new party, and its strategists and scribes pack academia. Little apparatchik Madonna, in *Love Don't Live Here Any More*, a 1995 video, made love to a marble column as if it were Caesar himself; she will now incarnate Eva Peron. John-John gets married, more voices of dissent disappear, police hoodlums walk, and the prisons swell. Art can scarcely keep up.

Solzhenitsyn stated clearly that the hole in the lie is big enough for only one person at a time. You must be willing to endure loneliness, to abandon the lie exactly as it presents itself to you, for it extends even to the most intimate of relationships, in the bedroom and the boardroom. While you may not get that new car, promotion, fancy spouse, art deal, or passing grade on that final exam, you will at least join a handful of people who have made it to the other side to a truly human community. If enough individuals make the sacrifice, *one at a time*, the tiny opening will loosen and stretch, allowing a flood to pass through.

The American system relies on people never finding the world or one another. The elites rely on this, buttressing the pasty stage-set filter that separates us from each other and from ourselves. We may be surprised, however, how many, at every level of society, are ready for the arduous journey through the filter and the lie, to freedom. For Solzhenitsyn, the first step was small and entirely within our grasp.

It was to breathe.

Issue 24, Mid-August 1996

Letter from Freedom X Baudrillard: Chance Does Vegas
By Fred Dewey

The New Slots

As the possibility of public space and culture is being attacked from every imaginable political angle, the goal seems increasingly to turn America into a great desert. Even more parts of American society are under attack by the political order, and with them even modestly prosperous and confident people are reduced to the status of frightened beggars. The society of the lie is folding people into machinic processes of unprecedented brutality and calculation, making it the era, as Baudrillard has described, of the perfect crime: reality is murdered and the killers cannot be found. Nothingness and virtualism are manufactured with industrial proficiency like toy parts, the gears of a clock, the replicating mitochondria of cellular automata.

Organizing fiction has abolished the space of appearance, and we no longer remember what it is to be free. Terror, the total machine, is the only recourse by every manager to counter the resistance of a people aware they face extermination. To make terror possible, everything must be uprooted, an order of chaos established. The spring is commercial consolidation. Who can hope to locate the *political* agents of destruction inside this communistic fiction of a hidden hand? The raw, cold metal of gears and the relentless, cruel clink of coins, cheap food, and toxic probabilities turn upon everything in sight, including friendship. In the casino, every motion appears to be based on pulling the levers ourselves, grinding ourselves to desert dust. Self-elimination, or perhaps better yet–Stalinism a-go-go. Those massacring the world remain unseen. The casino is a machine that makes the political vanish; it is the emblem of the world's murder, the site where we proudly arrogate to ourselves the title of its executors.

scale of the building and its lights, the crystal mysticism of the slots, and their clean glass, brass, and white moving parts, colors, and endless Philip Glass sound score. It was a world dictated by the totalism of social equality. Every imaginable person became exactly the same, measurable only by how much money they ended up with, how many coins they could insert, machines they could move, drinks and cigarettes they could swallow. The latest-model sports car sat gleaming high on a pedestal, the object of worship. Meanwhile, at the exit sat the vehicle of two who tried to steal, kill, and get away and weren't part of the state: the drab military-green car that Bonnie and Clyde were shot to death in, its imploded bullet holes a banal warning. A young African-American girl bedecked in a uniform, when asked how it was to work in this place, told me riding up in a back elevator, "It's hell. It's really awful." Sartre was wrong. Hell is not other people. Hell is what happens when reality makes otherness impossible.

The First Circle

No event could have materialized this industrialization of disappearance and simulacra and the task of trying to break out of it than one taking place recently in the parched, chillly Nevada landscape, inside Whiskey Pete's casino on the border of California. A wall rising out of a dry lake bed, its neon glaring like a star, the complex of casinos, hotels, and park rides beckons from miles away. The road forms a ribbon passing through a breathtaking desert of light and air, shaped by millennia, with no outposts along its path up from Los Angeles through snow-capped mountains. At night, the road forms a glittering cell-like highway alternately feeding the machine and evacuating those with nothing left. Whiskey Pete's is the first circle on the road to hell, and its isolation makes everything much clearer than the metastasizing monster a few leagues away. Driving there with my very own Virgil, my protection, friend and L.A. poet Ellyn Maybe, I was struck as we drove into the parking lot at sunset on Friday by the toylike yet brutalist

The Great Wheel

This underworld, for three days, had its own special visitors, an assemblage of artists, thinkers, journalists, and New Age visionaries, all there to have fun, network, party, and put things in perspective. Brought together around the theme of chance by writer, *Semiotext(e) Native Agents* editor, and filmmaker Chris Kraus and an Art Center student group including Sara Gavlak, Pam Struger, Giovanni Intra, Dan Frydman, and numerous faculty, this loopily constructed "conference" was designed, in Kraus' concept, to bring together people who "would not normally talk to each other." Referring as often to poet Ted Berrigan and the need for irreconcilables as for utopia, Kraus' winning informality and delight in contradiction infused the conference, the same anti-institutional mindset that infuses the antiacademic and antihierarchical *Native Agents* series. The best way to investigate radical possibilities between art and life is to see, in fact, how and where "philosophy rocks." Sited emblematically in an auditorium done in

western bordello style, replete with fake balconies and fake doors behind them presumably going to nonexistent rooms for nonexistent love-trysts, with a state-of-the-art sound-and-light-stage system, plush carpet, elegant chairs, and a fully stocked bar, the Chance conference posed the great American question both in its content and its form: Can one enter the heart of the machine and survive?

Where Is Emptiness?

In a strange sense of grinding gears, those embracing determinism seemed to win out, whether the determinism of the I-Ching, Wall Street "chaos," or the "science" of chaos theory. Stirred by wheels within wheels, a bizarre, ephemeral cult congealed and dispersed, making chance as much of a machine as chaos itself, allowing politics to enter, interestingly, through the voice of Calvin Myers, an Indian activist fighting nuclear destruction of the land, and Diane Di Prima, the old Digger from San Francisco and quite possibly one of our most existentially political poets. Baudrillard noted in a concluding press conference on Sunday that "simulacra and simulation make it impossible to have a space of representation." How then do we move in the world? Baudrillard's keynote Saturday night lecture, Nietzschean down to its soles, contrasted our increasing fractalization, which he bravely identified with virtualism, with the embrace of destiny, that which we cannot deny, in order that we might begin to allow the world to "think us." The idea that we make everything ourselves, from make-believe to make-do, has produced a catastrophic turn towards self-hatred, suicidalism, and total dispersal. Our desire to disappear, and indeed to vanish into the simulacra, is the paradoxical effect of our total emphasis on self as the root of freedom. Baudrillard proposed instead the radical alterity of transferring power back to the world and others. His performance as a cabaret "singer" in a nightclub jacket, reading a random selection of passages from his *Cool Memories* and backed by Art Center "Chance Band" rockers

Mike Kelley, Tom Watson and others, was more in the mode of entertainment. Kraus wanted this to be entertaining. But the void was everywhere, its filigrees carefully woven. Few spent much time thinking about Baudrillard's brilliant, Butoh-like, Artaudian gesture commanding the audience to "suicide" him.

The Chance Roll Abolishes the Dice

The weekend began with a Friday afternoon performance, or "opening lecture," by DJ Spooky, a hip-hopper from New York who writes (as Paul Mitchell) theoretically informed art criticism for the *Voice* and others. Known for sets of jazz recordings played backward and citing Stockhausen as often as roots ritual, Spooky made clear this would not be the usual parade of academic papers. Spooky has spoken against what he calls "compression," that force that tears us apart and is about "being pushed out of the world," something he locates rather strangely in hip-hop's "armed" mentality—is the problem African-Americans being armed, or shooting the wrong people? Marcella Greening followed this with a discourse on chaos and semiotics, suggesting "within a bounded space you can have an infinite number of possibilities," that determinism can be embraced without one being able to determine anything, a combination that seemed to compound the problems with both determinism and uncertainty. Shirley Tse offered a fascinating upending of notions about the relation between the artificial/unrooted and the natural by showing slides of Hong Kong, where artifice, she suggested, can actually be about anticolonialism and rejection of the American order, throwing in a hilarious image of plastic duckies washing ashore to reveal the simmering play of replication and its effects on nature itself.

Fiction and fragments of the world mixed at ever-increasing speed. Towel, a band from San Francisco, came on in Chiapas masks, producing a searing, stunning foray into terror noise, feedback, and refusal. Overwhelmed, Di Prima appeared afterwards in front of the red curtain with a mike to read quiet

stories and wrestle, not entirely successfully, with the space, which seemed almost to vote her out. A modest sort, and not one to showboat, Di Prima some years back stated that her life was the stake, that it was living we gambled with. The reading, containing the extraordinary opening to *Calculus of Variation*, "postulate a woman," also drew on her *Memoirs of a Beatnik*. In glaring contrast, the first "keynote" concluded the evening in a dizzyingly self-congratulatory attempt at a Vegas show act by transsexual cybernetician Sandy Stone. Talking about remapping the surfaces of the body, then burying the audience in her embrace of personas, kitsch, and a fascist view of progress and technology, Stone tried to soften "herself" by a dialogue with her daughter shown in a slide in front of a computer screen. Stone was so busy repeating her book title at every opportunity that she managed to demonstrate only the boundless careerism and pseudo-thinking that permeate academia. During the next two days, Stone moved through the conference like a machine, her head clicking this way and that, her gaze hollow, her face humorless, the fist of authority, a humorless entourage of Stone-youth marching behind her.

Love of Fate

The next morning, I breakfasted with *Origin of the Species* author Barbara Barg, there from New York with her band Homoerotic, who detailed the magic of the game as "getting into the flow, sussing it out." A friend of hers spoke of how card sharks observe others' "bad habits"; airportlike announcements called out, "May I have your attention. Transportation is now boarding . . ." After breakfast, Paiute Indian Calvin Myers spoke for some time, without notes, about nuclear devastation and Indian attempts to reclaim their own ecology. He was followed by Sheppard Powell, who discussed the I-Ching, Burroughs, and omens. The lecture was unpopular with some in the art/theory crowd, yet it suggested interesting strategies, becoming open to "new situations," the I-Ching's hexagrams as germinal, embryonic stages, "potentialities which arise in different situations." Much as Greening had spoken about finding patterns and exploring bounded situa-

tions, Powell described the I-Ching as a way to discover latencies. Baudrillard, as if carrying this forward, introduced the Butoh troupe with a section on Butoh from *Cool Memories*, describing its theater of radical illusion where "space is never free, the body an outer shell." Butoh's illusion "envelops the form with the sign of its disappearance," a point he would take up extensively the next day in trying to break out of dialectical polarities through reversal and embedding. Oguri, of the Oguri and Renzoku Butoh troupe, was the theatrical highlight of the conference, creating the uncanny sense of seeing a copy of our own avant-garde theater. It made clear how much we have stolen from Butoh—just think of Artaud, the *Living Theater*, Richard Foreman, and countless others. But it was Oguri who outshone them all. In one particular moment, doing a breathtaking solo, Oguri mutated into a spider, stopping to reprimand the audience with his finger, then mutated into a sitting monkey. Using negative space to give birth to the world in the viewer's imagination, this offered precisely the opposite of the obscene, the world as a porno movie where everything is there to make our imagination disappear. It was hallucinogenic. Insofar as we are compressed into dots to be blown away, this stretched the dots out and made them back into humans. That afternoon, walking across the parking lot with Baudrillard back to the hotel, he chuckled, pointing at the buildings and the conference. "Oh," he said, "it's all so supernatural, so supra-natural, here."

Death in the Bush of Ghosts

The afternoon offered the band Ohm-A-Revelator and Doug Hepworth, a Wall Street trader explaining how chaos theory was as good a predictor of stock movement as any. Considering how much damage Wall Street has done to America and how much it is the ultimate American illusion, this was most peculiar. That evening, Ann Rower, a New York novelist who coined the term "transfiction" (the recombination of fiction and transcription), continued her investigations into the rich relations between daily life, art, pop culture, and autobi-

ography, making the air crackle with a high-octane excursus into sex, delusion, and relationships. The all-female band Homoerotic cheered the room with its free-spirited blend of political critique, bongos, and tough guitar licks. Then, on to the main keynote, Baudrillard, on making oneself a destiny. His main point? "We hate the world as it is." Describing how the other has almost entirely disappeared from our horizon, how we have thus descended into a suicidal state where atomization does not stop at the level of individuals but continues on down, Baudrillard framed chance as "the only sanction of the reversibility of self and world," a reversibility that he considers to undergird the "precession" of the simulacra. He called instead for transferring "onto the world, to the event of the world, to the appearance of the world, the responsibility to think us." Taking a position diametrically opposed to Sandy Stone, who not only celebrated her fractalization but its complete amorality, Baudrillard paradoxically reinterpreted the harmony with the world sought by the gambler: "The world takes the responsibility of the game." Destiny is thus the discovery of possibilities, for in the world, every decision or action parts the waters of destiny and reveals another universe. Developing a Butoh-like idea, he spoke of making illusion "a more subtle form of reality that contains within it reality's disappearance," and destiny as a "more subtle form of will which contains freedom within the sign of its own vanishing." In this, what is usually lost is precisely Baudrillard's attempt to *contain* disappearance, not so much to describe it. The world cannot be reversed. In our parking-lot conversation, I had asked Baudrillard what he meant by the supernatural. "It is a way of speaking of something that is not transcendental, not naturalistic." That is to say, the ghosts are material, but it is the people and world that have become immaterial.

Room Service

The hotel-room art installation series "Hotel California,"

curated by Gavlak and Strugar, and the reading series (which took place in the rooms at designated times) "Motel Suicide," curated by Frydman, offered an attempt by art practice to get at some of the problems posed by casino reality. The installation included Carol Irving's polygraph-based work, *Truth 1996*, where she asked people to answer intimate questions "truthfully" and had crocheted a quilt of the polygraph needle zigzags; Liz Larner's and Kitty Beamish's *Learn to Deal,* a text/video meditation on the machinery of "money, power and glamour," manicures, and poker; and Laura Paddock's and Jonathan Williams' draped and painted fabric room beckoning like a womb. All installed in the back wing on Saturday and Sunday, these rooms featured readings, the audience programmed by cards to rotate through like gear nubs in a slot machine. The readers included Vince Johnson, Ellyn Maybe, Amy Jones, Lisa Anne Auerbach, Jim Fletcher, and Luis Bauz, among others. The conference seemed equally balanced between trying to make sense of experience and finding any attempt to personalize things problematic. In a distinction made by one of the few in the visiting multitude to have worked in a casino, Liz Larner later expressed frustration that people, myself included, seemed more interested in the biographical detail of her casino work than what she had done with it. "I did this," she said, "because I wanted to do something *with* this knowledge," to get away from "one-sided perception and stereotype." The casino seemed to take art and evaporate its most salient features.

Becoming the Stake

Baudrillard asked at the press conference on Sunday: "Behind every image, what is it that disappears?" the question cultural studies has entirely averted by continuing to believe that representation still exists. The panel discussion that closed the conference confronted this a bit more, especially with Stone quoting Vonnegut and taking a position diametrically opposed to Baudrillard, stating "You are what you pretend to be."

Debating this might have put things in clearer view. Powell read an I-Ching throw done for the event and Jeremy Gilbert-Rolfe responded by querying whether the I-Ching was not perhaps about administering chance, challenging the audience to come up with a new theory of infinite recombination, rather than sticking to the proscribed hexagrams. Di Prima let in much-needed oxygen when she admitted regulation by chance was attractive yet required an important distinction: "Chance doesn't happen to me, I am chance." As if playing on the extraordinary Butoh performance by Oguri, she asked "How do I become friends with space?" Since, emblematically, "when you're dancing with a partner, you can't predict your partner's next move," the solution must be "experiential freedom," a more sophisticated and rich notion that one could explore at that precise moment. When Stone defended theory by calling it storytelling, Di Prima shot back, vigorously: "Theory people cling to a story but with storytellers and poets, the story is different each time." After a ruckus about the case of Saro-Wiwa (a Nigerian hanged for opposing Shell Oil) and how individual rights and human rights matter even if there is no identity, Di Prima elegantly embraced the array: "Be an individual or a multitude," and the conference was over.

Over lunch I turned to Di Prima, as a salve, and it was then that she stated that in her view, the turn to theory could be dated to the repression of the 1960s, poetry having been abandoned. The only solution was to begin "surfing with full knowledge of your own nonexistence." Now in the 1990s, what if this 1960s cliché can be updated, building upon the idea that nothingness is really *politically manufactured*? Saying that she wanted "not a party, not a theory," Di Prima is clearly more than a survivor. She is part of the great American tradition of antiparty, anticant rebels who founded the country before the blood of Indians rose with the State.

Filmmaker and poet Pasolini once described entering the hell of society and personas to reemerge as a poet: One is "absurdly unaware of that exclusion from the life of others which is the repetition of one's own." This is the narcissistic mirroring and replication of nothingness that the casino and its legions convey, a kind of dead zone of turbulent consumption. We are, as Di Prima put it, "shot through with void." As Ellyn and I tried to leave the place Sunday night in the pitch dark, then ran low on gas and had to drive back to the casino across the lake bed–the absence of exits made it impossible to turn around on the road–I thought of Pasolini's use of Dante's *Inferno* to deal not with fiction but to declare himself moving through the world: "I turned back towards all that is darkness, devastated, shapeless: the fatality of one's own being, one's own birthmarks, the fear of change, dread of the world: which no one ever was able to escape." I am still there, trying yet again to leave, beneath Whiskey Pete's sign blinking "You Can Win" and "Prime Rib." I am also sitting inside, in the restaurant, next to Di Prima as she quotes a line from Blake, one of the most powerful expressions of human grace: "The doors of heaven open twice a day for every man, woman, and child." Two universes, two possibilities, and Chris Kraus, organizer of the Chance conference, would have it be no other way.
Issue 25, January 1997

"Too Jewish?" at the Armand Hammer Museum: Too Hot to Handle?
by Irit Krygier

People said I was too Jewish–and I even suffered from anti-Jewish prejudice from the Jews themselves.
–Jackie Mason, quoted in Sander L. Gilman's essay, "The Jew's Body," in the catalogue for "Too Jewish?"

How is this exhibition different from all other exhibitions? It is about Jews and it examines issues about contemporary

Jewish life and the depiction of Jews in popular culture. That makes some Jews and others in the Los Angeles community, and I am sure elsewhere, feel threatened. Somehow every other community applauds their artists when their oeuvre addresses issues of religion, race, national origin, gender, or sexual orientation. When Jewish artists do this, however, the community goes *meshugah* (berserk).

When "Too Jewish?" opened in New York at the Jewish Museum, it won favorable reviews from Michael Kimmelman in the *New York Times* and others in the art press. The show was discussed in articles appearing in *Artforum* and *Flash Art,* among other publications.

In Los Angeles, the exhibition included symposia at the Armand Hammer Museum, which involved members of the rabbinate and Nancy Berman, the head curator at the Skirball (the Jewish museum in Los Angeles which is known for insipid contemporary exhibitions that eschew issues of any kind—the same is true for the pathetic program of exhibitions at the University of Judaism's Platt Gallery), and others.

Rabbi Omer-Man, the president of Metikva: A Center for Jewish Wisdom (an institution that I have never heard of and I am a Jewish woman who has been living in Los Angeles for twenty years), said the following in the *Los Angeles Times*: "In this show, I am confronted by people whose experience of Judaism is completely different from mine, people who haven't spent fifty years studying it, yet they are speaking with as much authority as a rabbi." You bet—these artists all have a lifelong experience of being Jewish, and that knowledge forms the content of this exhibition.

The *Los Angeles Times* Sunday Calendar chose Rabbi Omer-Man, whoever he is, to analyze this exhibition, instead of the artists and/or the curator as they do with every other feature article on any other exhibition. Why they did this is beyond me. This approach to the discussion by the *Times* is outrageous and very condescending! The *Times* did not have an African-American church leader or other community leader discuss the Hammer's "Black Male" show! Christopher Knight reviewed the "Sexual Politics" show and had no problem analyzing the issues in that show even though he is not a woman, because it was an art exhibition and he is an art critic! Yet, for a feature analysis, the *Times* chose a rabbi who obviously knows nothing about contemporary art at all. He missed all of the references in the exhibition to art history and the current cultural scene.

Who cares what his opinion is? No one in the art world, I am sure.

KCRW, our local National Public Radio station, took a similar approach on the highly respected program *The Politics of Culture*, where "Too Jewish?" curator Norman L. Kleeblatt was furiously attacked by members of the local Jewish press, saying that the same points were made earlier on such venues as *Saturday Night Live* and are fodder for anti-Semites!

Baloney, or should I say, Pastrami! These people obviously spent about twenty seconds looking at this exhibition, as revealed by their comments, which amount to contempt prior to investigation. These are the same arguments that were used by members of the Christian Coalition urging the boycott of Martin Scorsese's film *The Last Temptation of Christ*! I have the opposite reaction. I love this exhibition. I think that it was brilliantly and ambitiously curated by Kleeblatt (over a five-year period, apparently) and contains works of art that are insightful, sophisticated, humorous, intelligent, and moving. These artists and writers obviously have a deep understanding of art history and the contemporary critical discourse and are players in the contemporary art world itself. I predict that the catalogue, with an introductory piece by Linda Nochlin and insightful essays by its contributors, will become a milestone for discussions of Jewish art and culture and well it should, because it blows a wind of much-needed fresh air into the Jewish cultural landscape.

Issue 26, March 1997

Wrapping for the Rhetoric: Dave Hickey and Beauty in Art

By Jennifer Faist

Beauty seems to be the buzzword in the art world these days. In his book *The Invisible Dragon*, Dave Hickey relays a story of how this seed was planted and a prophecy for the nineties was first revealed. Distracted from his daydreaming at a panel discussion, Hickey was asked for his opinion on the "Issue of the Nineties." His off-the-wall reply was, "Beauty . . . the issue of the nineties will be beauty."

The reaction to his "total improvisatory goof" was disappointment and silence. Hickey wondered, "Beauty? Pleasure? Efficacy? Issues of the nineties? Admittedly outrageous," but was determined to pursue it. Though no one else seemed provoked, *he* certainly was. Ruing what he felt to be a loss of beauty, he wondered, "How we have come to do without it?"

If we have lost it, as Hickey suggests, maybe we should go back and try to remember where we left it. Where was beauty before we lost it? In reviewing philosophic history we have certainly run the gamut in aesthetic theory. "Among the ancients the fundamental theory of the beautiful was connected with the notions of . . . the general formula of unity and variety. . . . Among the moderns we find that more emphasis is laid on . . . the conception of the characteristic." The struggle then became to reconcile these two conflicting tendencies, the "universal" and the "individual." To this day, the war still rages.

The dynamic relationship between art, the artist, and the art world influences the ever-changing ideal of beauty. We're always tiptoeing around beauty but never actually getting to it. And even if we think we find it, it changes again. In short, "there is no definition of beauty that can be said to have met with universal acceptance." And, as Nietzsche suggests, there never will be one, since, "the 'beautiful in itself' is not even a concept, merely a phrase."

So then, *is* beauty the issue of the nineties? With all his musing on beauty, Hickey doesn't wrestle with aesthetic Issues but concedes, ". . . if I seem to have splintered the idea of beauty out of existence by projecting it into this proliferation of 'beauties,' well, that is more or less my point." Hickey admits he has "habitually suppressed the traditional contraiety of beauty and ugliness and of pleasure and pain," and has limited his discussion to beauty's function. He states, "the subject here is 'beauty'–not what it is but what it does–its rhetorical function in our discourse with images." With regard to the function of beauty, he states, "In images . . . beauty [is] the agency that cause[s] visual pleasure in the beholder." But he doesn't stop there.

For Hickey, the true function of beauty is to attract (or seduce) the beholder; images argue for things, a kind of "visual litigation" or visual politics, and the visual pleasure valorizes the content. The purpose of the image is to reconstruct the beholder's view of things, and without this intention, "the image has no reason to exist nor any reason to be beautiful." Beauty is then "required to recommend images to our attention or to insinuate them into the vernacular; and when these rhetorical strategies are actually *employed* . . . we are so conditioned to humbling ourselves before the cosmetic aspects of the image we simply cannot distinguish the package from the prize . . . the 'form' from the content." In short, beauty is wrapping for the rhetoric.

Unfortunately, Hickey is more intent on discussing beauty as the attractive wrapping for the image and the power of that image rather than the issue of beauty itself. And that may be why he feels that today's art is "so visually impoverished." His obsession with the beautiful image (particularly figurative imagery) creates such a tunnel vision that he turns a blind eye to anything without imagery or rhetoric.

Hickey obviously has no affinity for this "antirhetorical flatness," as he calls it. He insists on an either/or imperative.

There isn't a nonrhetorical, only prorhetorical or antirhetorical, only pro-aesthetic or anti-aesthetic. To him, "the flat picture plane came to represent the property line dividing the mundane world of lesser beings from the exalted territory of the artist's incarnate prophecy." Hickey sees modernist nonobjective work as a power play rather than a striving for beauty through materials themselves.

Not only is he tired of "flat," but he is also tired of being preached to by ugly images and anti-aesthetic text. Ultimately, though, he is still advocating political art, just one that is candy-coated, that is, beautifully wrapped. He has merely substituted pro-aesthetic political art for anti-aesthetic polit-ical art.

Hickey is obsessed with visual rhetoric to the point that he virtu-ally ignores other forms, contents, and contexts. He places supreme value on the visual sense to the point that even the intellectual sense has little value if it doesn't have the visual to precede it. And what about the other senses? They don't seem to fit in at all. Though he spends much time discussing the package/prize game, Hickey doesn't actually seem interested in beauty itself. So then what is he really interested in talking about?

While canvassing artists, students, critics, and curators about beauty, Hickey stumbled on what he saw to be an inter-esting twist that he felt contributed to the cause of the current mistrust of beauty. He found "if you broached the issue of beauty . . . you ignited a conversation about the market," more specifically, "the corruption of the market." He "discovered that the 'reasoning' behind this presumption is that art dealers 'only care about how it looks' while the art professionals

ArtBabe.

employed by our new institutions 'really care about what it means.'"

Hickey is obviously dismayed at this conception of the art market. Their gripe is that "beauty sells . . . if it sells itself, it is an idolatrous commodity; if it sells anything else, it is a seductive advertisement." Hickey doesn't share this atti-tude; he likes the fact that beauty sells. He has "pushed his conception of beauty toward the most 'interested' arena, the art market."[1] To Hickey, the work exhibited in com-mercial galleries has the opportunity to be evaluated and validated by the public. He believes that "galleries can be a forum for exchange of ideas,"[2] much more so than public institutions. And here is Hickey's real gripe.

Hickey can't seem to satisfy his need to criticize what he calls the "therapeutic institution." He believes that we have done without beauty because we have reassigned its traditional function to the thera-peutic institution. For Hickey, the real tragedy of this system, though, is that we are told to "distrust most of all the appear-ances of images that, by virtue of the pleasure they give are efficacious in their own right." We are told that it is good for us, and thus the institution has "lift[ed] the . . . burden of efficacy from the work of art."

This statement leads us to the heart of Hickey's rhetoric. The message that he is interested in conveying is his idea of what is "good" art. Obviously, for Hickey, good art is one that practices the revered visual litigation. Quantitative evaluation of good work is calculated through its rhetorical beauty (the only beauty he considers). In an interview with Chris Scoates, Hickey states, ". . . we're talking about art we can look at a

long time, write a lot about, think about a lot, will pay a lot for. These are the quantitative measures we use to determine the 'quality' of art."[3]

And the supreme value of the rhetorical beauty lies in the intent of the message it conveys. Hickey believes that "those whom the world would change must change the world." And so, the highest value lies in the cultural outsider's intent in and attempt at changing the world. "Beauty is a weapon; you just have to aim it."[4]

The problem is that Hickey may be attributing more power to art to effect change than it actually has . He may also be mistaking intent to change the world for an attempt at genuineness in art. Genuineness is a value for which artists strive, and so they talk about what they know—themselves—but not necessarily with the intent to change the world's view. The motives behind autobiographical work are not necessarily an attempt to validate the artist's lifestyle, yet Hickey can't conceive of any other motivating factor, or at least none so virtuous.

The one stumbling block to good art delivering its message and changing the world is the therapeutic institution that does not give this "quality" work access to its own audience. Obviously, he prefers the commercial art market over the therapeutic institution for this reason. He can't see how anyone would wish otherwise. Though most are not pleased with the curatorial output from the institutions either, nor happy about the power and control the institution wields, Hickey tends to go a bit overboard in his criticism. His biggest criticism of the institutions (which hits closest to home for Hickey) is that "the transactions of value enacted under the patronage of our new, 'nonprofit' institutions are exempted from this cultural critique, presumed to be untainted. . . ."

". . . as a critic, if I take exception to the worthiness of work in a public space, I am not just criticizing the art, I am questioning the fiduciary responsibility of the curator."[5]

A critic can't write an uncomplimentary review of a museum show? Take, for example, Peter Clothier's review of "Pure Beauty," an exhibition at MOCA, in *Art News*. Clothier was not impressed with the work or its curatorial thesis: "A problem lay in the show's didacticism, as though the irony it explored were central to today's art preoccupations. Amid so much evidence that artists are now reinvestigating values that were rejected in the seventies such a thesis rang stale and hollow."[6] Clothier stated exactly what Hickey wants to but claims he can't—It's old; it's stale; it's been done—and outright questions the curator's thesis for the show. Just because they're shoving "bad art" down our throats doesn't mean we have to swallow.

Hickey's argument against the therapeutic institution seems to lose credibility a bit with such a weak supporting statement about criticizing such institutional exhibitions. The real reason behind the real gripe may have more to do with his past role as art dealer rather than his current role as art critic. Though he spends much time stating that we have reassigned beauty's function to the institution, more important is its corollary: that power and control to determine art's value, who gets to say what is good art and what gets seen at all, has been reassigned to the curator. The power has shifted, and the "bureaucrat who monitors desire" has taken over for the "autocrat who monitors appearances." The loss of status and power to dictate and promote art's value as a dealer may actually be more of a sore point than the loss of power to discuss and validate art's value as a critic.

Ultimately, instead of talking about beauty itself, we've been discussing art's use: ". . . to say that beauty is the agency of visual pleasure reduces beauty to charm. . . . Any discussion of enticing visual mechanisms is rather a discussion of the pleasant, not beauty."[7] Beauty has become a means rather than an end. Instead of a thing good in itself, it has become a thing useful (particularly with respect to its moral usefulness). And the art process has turned from one of "making" to one of "acting." Though beauty is not an action, the exchange is. There is always a creator and beholder, maker and buyer, an artist and the public (with the institution in-between). The art world is more concerned with the exchange between them, not

with the simple existence of beauty.

A loss of verification, the suspicion that an accepted definition of beauty cannot be found, has led us to reduce art to morality. The "oughts" of what beauty should be have become the "oughts" of what morality should be. We've given up on finding universals in aesthetics but still want them in ethics. We have come to exclusively discuss the ethics of the art exchange and of art making itself, virtue vs. corruption, altruism vs. selfishness, generosity vs. parsimony, and the "good" artist making "good" art. Whether they're right or wrong, good or bad, is not the point. The point is that we have changed our discussions from what we should think beauty *ought* to *be* to what beauty *ought* to *do*. Yet still there is an undeniable nostalgia or desire for a return to beauty. Peter Plagens summed up this desire: "In spite of the fact that nobody's yet come up with a foolproof formula for transcendent aesthetic quality, the evidence of its existence—however fuzzy around the edges and however undulating—is overwhelming."[8] And that's why Hickey's tactics work.

The irony is that, like the beauty of the images that disguise and appeal to attract the viewer, so does the facade of a discussion of beauty mask the real issue of import to Hickey. "Postmodern aesthetics is in a quandary . . . recent art theory and criticism remains incapable of accounting for aesthetic pleasure (or pain), and has either tried to avoid the issue entirely or subsume it into other discourse."[9] And that's what Hickey's done. Beauty is his camouflage to lobby for his own ethical and political agendas, "good" art, the "freedom" of the art market, and the "corrupted" therapeutic institution. Once again, wrapping for his rhetoric. We unquestioningly accept the nobility of a discussion of aesthetics without realizing that, again, we are only being told what is "good" for us.

Like the artists Hickey admires, he is out to change the world too. But to ensure his success he's had to become the prophet making the prophecy come true. Through his published work and in various interviews, he tries to create hype and a bandwagon in the hopes that everyone will jump on.

Unfortunately these tactics tend to devalue the thing he professes to be elevating–Beauty. Beauty becomes merely charm, and Kant warned that "[these charms] actually do injury to the judgment of taste if they draw attention to themselves as the grounds for judging beauty."

As Peter Schjeldahl noted, "There is something crazy about a culture in which the value of beauty becomes controversial,"[10] and though Hickey may be attempting to elevate the value of beauty, he is only succeeding in contributing to the craziness. Hopefully, the art world will unwrap the package and see his "prize."

1. Sue Spaid *Love's Labour's Lost: Love's Gift's Found, a.k.a. "Beauty as Duty"* (Los Angeles, 1996), p. 4. "Interested" should be taken in the Kantian sense, "with interest."

2. Chris Scoates quoting Hickey in "Speed and Fire: An Interview with Dave Hickey," *Sculpture* (May/June 1996).

3. Ibid.

4. Ann Wiens quoting Hickey in "Gorgeous Politics, Dangerous Pleasures: An Interview with Dave Hickey," *New Art Examiner* 21, no. 8 (April 1994).

5. Scoates quoting Hickey, "Speed and Fire."

6. Ibid.

7. Spaid, "Love's Labours Lost."

8. Peter Plagens "The Good, the Bad, and the Beautiful,"*New Art Examiner* 21, no. 8 (April, 1994): 19.

9. David Levi Strauss "Aesthetics and Anaesthetics," *Art Issues*, no. 27 (March/April 1993): 21.

10. Peter Schjeldahl "Beauty," *Art Issues*, no. 33 (May/June 1994): 25.

Issue 26, March 1997

Letter from Freedom X: Carolee Schneemann & Artaud

By Fred Dewey

The Disease of the Modern

It is one of the fatalities of modernity, and of postmodernity as well, that the radical differences between society, art, and culture remain barely explored. The bloody catastrophes of this century nonetheless pose a question: What if culture, in the sense of caring for things that are and have been made, turns out to be something other than art? What if society and power somehow want culture not to exist, leaving only things? What if the social is at odds with everything that nurtures, facilitates, and secures our world? What if what we call "culture" has become merely the ravenous life process of society, and nothing more?

The discipline of economics is, in this realm, the state's greatest tool and its greatest mask and occultation. The art world is one part of this great supernatural machine; how we think of art is deeply compromised, it turns out, by supernatural problems. The machine's activity, like the social machines and their movement and discourse, occurs round the clock, rendering people phantoms, taking phantoms and elevating them to the status of people. America has descended into the occult, with ghosts and forces operating at a distance. Self-interest has become a veritable party fiction organizing every realm of American society, and

Herms seen at Schneemann scene.

so the ephemeral tissue of democracy is undermined at its weakest point of human psychology. Public space is opposed by a great war and the domination and terror it is producing. The paradox is that war is in some sense a natural outgrowth of society, which seeks through its machinery to transform what needs to be public and visible into the secretive, functional, economic, necessary, and covert. War is the end of all liberal values, and indeed of self-government. Without a counterbalancing realm to society and its war, without tolerance, openness, and plurality, freedom is friendless. The social will pull everything into its maw; it not only may lead to war, it thrives on militarization, homogenization, and the corruption of political values. As mass society has produced mass culture, reality is industrialized, from perception and sensation to emotion and movement. Tending what is and has been made—the central activity of culture—slows the social's ever more restless, ravenous movement, and so culture itself must be eliminated.

The Theater of Cruelty

It seems in some sense clear, almost a cliché, that the former Yugoslavia, like the Spanish Civil War in its time, offers an embryonic example of the situation power is driving us toward. We are in the world-obliterating stage of something few can describe. Reality and world can no longer appear, as everything is folded into colossal hierarchies that control meaning and action and crush the space of appearance. This uprooting and channeling by a world-destroying mentality has permeated down to the last sign, icon, and concept, down into the structure and possibility of language. It makes people turn from commonalities and friendship, from mutual interest, awareness of the world and the ability to speak about it, and, finally, most of all, from assembling to act, be seen, and heard.

This was, and remains, most visibly the problem in all war-torn areas, as was revealed by a panel of women from around the world, held in January 1997 in Venice, California, part of a larger conference at UC Riverside on "Frontline Feminisms." One particular identity that seemed to weave through the procession was "Women in Black," a loose organization that seems to arise miraculously in numerous places as protest. Women on the panel continually pointed out that it was they who were the first to stand up against war in their home countries, often at great cost. A vivid manifesto from a Croatian group called for an implicit defense of public space as the only way to recover freedom and dignity, not through abstract solutions, but women coming forward with their own narratives, all different, and meeting to speak to each other. In a razed landscape, women asserted precisely this elemental nature of politics: to act, speak, be heard and seen, to preserve and listen to their stories and so stabilize the world. Doing this simple thing became radical, though it may even have been inconceivable at first. War, it turned out, had reduced people to behaving like animals. Those reduced to this saw that it was a short step to being placed in piles and ditches.

It is of interest to look at what one might call–rather than neurotics and psychotics–war victims, people who have witnessed and felt the butchery and savagery of the social and responded on their own. Intellectuals have ventured into this battlefield, notably during the 1960s with Norman O. Brown and R. D. Laing. Possibly because of their restricted focus on the family and psychoanalysis, Brown and Laing failed to fully attack the full horror of the social and the problem it poses for culture. The question they raised, however, was how people are, in effect, "suicided by society," to use the brilliant phrase offered by Antonin Artaud during the last year of his life, writing about Vincent van Gogh in the aftermath of World War II. Van Gogh was labeled a psychological case, much the way Artaud was, his rage a sign of internal abnormality. Artaud spoke of this in terms of a body without parts, or as Gilles Deleuze and Felix Guattari called it, the *body without organs*–a kind of zero point produced by society carving out the body and leaving only an undifferentiated flux of intensities, pre- and postlinguistic, barbaric and nomadic. While the two French philosophers embraced this nomadism as freedom, Artaud's position was far less enthusiastic. Van Gogh was pulverized, vaporized, his madness the last residue of defiance against the social. Was not Artaud's earlier theater of cruelty, rather than a solution, similarly a terrible possession ritual revealing the despotism of society for all to see?

Spells and Gris-Gris

Artaud, like van Gogh, sought to create out from under the rubble, against horror. When he wrote in 1937 that the world was going to be destroyed, and in 1945 that it *had* been destroyed, he was dismissed as a lunatic. When he spoke of flames burning everything up, especially bodies and language, and aching to burn *first* before one was burned, no one considered that, far from being psychotic, this desperate man had keenly felt the great machinery of the ovens. As became immediately clear in the extraordinary Artaud drawings made from the late 1930s through the last days of his life in 1947 and shown at MOMA during the fall of 1996. Artaud suffered tremendously, while the appellation of psychotic and "ill" continues to this day to render docile one of the most ferocious and disturbing minds of our time. As the show and exquisite catalogue of the drawings suggest but dare not state, Artaud presciently sensed the voodoo and occult powers of the twentieth century and modernism, a primitivism no one can face and survive but against which counterspells and mad speech at least afford an element of resistance. Sending extraordinary letter-spells covered in burn marks and color scratches to Hitler, and doing the same to some women in his life, Artaud, mad and asocial, acted towards a realm of power–beyond sexuality, beyond economics, verging on the supernatural–which he felt could only be properly treated with equally occult approaches. He ranted and railed not against normality but the insane world, and ever more furiously and angrily. When

Artaud spoke in his poems from the end of his life of faces full of death and sketched his friends' faces with plague marks and pockmarks crosshatching their surface, he was speaking of a level of coding not even they could see. The world had collapsed in war, roiled by the pestilence of cruelty and terror. Was not Artaud quite entirely on the mark? Couldn't one argue the psychosis was *around* him, expunged by him, and that he was branded insane because he refused not to speak of this cruelty and savagery?

The Human Visage

The MoMA show was all the more disturbing for this, for all around it lay the death edifice of the mausoleum, faces and walls of stone and plaster without life. Artaud in this context seemed horrifically out of place. The provocative fact obscured by siting these drawings here is that these were attempts to tend and care on paper for what was happening and that everyone *else* needed to flee from. They were a defiant act of culture rather than of art. Who could be more insane, when the greatest single rule that guides the social is that no one must talk about what is in the world? Artaud was desperately trying to cope, and it was his genius to see normal faces as plague-ridden, twisted, to see this inchoately as the legacy of militarization, bureaucracy, modernism, and the hypercoding of the social field. That he uttered, like a channeler, the hysterical rants of Hitler, or showed himself bound and exploding and shot by soldiers of the French Revolution in the show's most powerful sketch, *The Projection of the True Body*, reveals only how much he understood the roots of the nightmare, born in the riot of the social that the French Revolution inaugurated. When previously Artaud had spoken of the "theater of cruelty," was he not speaking of a world where the political realm is not safe, where people have no protection against society, where horror bears mercilessly down and makes appearance and action perilous? If this is art, it has nothing to do with self, only the raw, brute, and ugly fact of appearance, lending "expression" a new and indescribable meaning. Artaud refused

to be suicided. He made ugly things and gestures, and the roar of ugliness and shit infused his howls of rage.

Native Beauty

Ironically, art in Los Angeles has been struggling with the problem of ugliness, shit, and mess for more than a decade, notably in such figures as Mike Kelley, Paul McCarthy, and others. This is interesting, for in Los Angeles, beauty has been successfully depoliticized, wielded like a great club, and history almost no longer exists. The ability of aesthetics to comment on what is ugly in the world has had to be re-created from scratch. This re-creation has a remarkably airless quality until one realizes that it comes on the heels of a major body of work by one of the great pioneers of public appearance, Carolee Schneemann.

Schneemann has been written out of the history books, no doubt because of her unmanageable nature and continuing refusal to be part of the orthodoxy of each social moment. Schneemann has consistently flaunted the social niceties, and indeed in some cases literally, making a spectacle of the hidden and silenced, as with the infamous *Interior Scroll*, that work that brutally violates the biologizing not only of women but of sexuality, a powerful political manual of resistance, typed on a narrow folded scroll, pulled out of her vagina, that emblem of biological domination. An early draft of this scroll was prominently featured in the thoughtful, appreciative, and long-overdue retrospective of her works, "Up To and Including Her Limits," at the New Museum, curated by Dan Cameron. It is this early scroll, in a Lucite case, that positively stuns, capturing extremely articulate expressions of women's disappearance in the history of contemporary art. Unsurprisingly, the guardian of dead culture, *The New Criterion*, attacked the whole idea of the piece, revealing Schneemann's unerring ability to incur the wrath of whoever is typical of a particular zeitgeist at a particular moment, and often unbeknownst to those at the time.

Schneemann's work is serious and demands a much more

detailed appreciation than it has as yet received. The New Museum show is a major step forward and the museum deserves to be lauded for it, but Schneemann's work will probably remain uncollected. She somehow lacks that packaged feeling. Notably, *Mortal Coils*, a tribute to friends of hers who died recently, is a powerful metaphor of the attempt to memorialize without fetish. In it, dangling ropes gently turn in flour that dirties by the end of the day, slides of faces project on the back wall, descriptions of her friends, apt and precise, hidden on the sides. It has been dismissed in criticism perhaps most of all because it is so astonishingly understated, so given to restraint and thoroughness where others use posturing and hyperbole.

Plague Column

It is Schneemann's genius to have taken Artaud's rage against the social and use it to inform and drive a moderated, consistent, and extremely sturdy body of conceptual "events." In treating this, by trying to turn Schneemann into a conventional artist with "works" and dates, Cameron's system didn't quite convey the conceptual richness of her work. The drawings jump off the wall and, along with her documentation, seem the most compelling and revealing part of the show. It is the parts that don't work as "artworks" that, like the best of conceptual art of the 1970s, come alive and refuse the machinery of wordlessness. Indeed, it is the scroll she didn't use, and the written texts that go with the works, which jitter and glide through conceptual space to provoke thought, as timely now as they must have been incomprehensible then. One yearns for process, for the nonschematic, which Schneemann was constantly striving toward, for her work is a great scroll itself, making the mute body speak.

What distinguishes Schneemann, in fact, is the way her work departs from the category of "art," approaching much more the category of action, and so, paradoxically, as Cameron rightly senses, the work of the Abstract Expressionists. Yet action is political by nature; it breaks the realm of the auto-

matic, the unrevealed, and means "to take an initiative, to begin." Her work most frequently reproduced in visuals, *Up To and Including Her Limits*, where she hung in a harness and scribbled on the walls around her, videotaping the affair, is the perfect comment on and mirror to Pollock's "action painting," which she shows to have been distant indeed from action. Schneemann theoretically shows how acting is not the same as making; intimate experiences are transformed and made fit for public appearance, for until they emerge into the realm of appearance, everything remains in the shadows. In contrast to the invisible Pollock and his highly valued objects, Schneemann is visible and her works almost valueless–in both the good and tragic sense–showing her limits rather than hiding them, putting herself on display for all to see and respond to, through the means of video. This is deliberately action rather than product: here, the trace or product is indelibly tied to its creation, rather than reified in the worldless realm of globalizing, imperial abstraction.

The most exasperating aspect of Schneemann's work remains her tendency to employ mystical symbols or references and in a way considerably less palatable than Artaud. But even in these symbols and processes, the act is central, the establishment of meaning by a person in the world, rather than mystical mumbo jumbo. The work that offers the title of the show shows how much the who-ness of the artist matters inside symbolization and meaning, standing as an impediment to abstract categorization and positioning. Even performance artists, whom Schneemann is misleadingly associated with, remain hidden behind masks of category and pose, seldom coming forth themselves with the directness Schneemann musters again and again. By suggesting Schneemann belongs more to Abstract Expressionism than Fluxus, performance art, or anything else, Cameron opens up the intriguing idea that she has made herself into an expressive instrument, a declaration. But she does so in an uncategorizable way. Her body situates the social and reveals its patterns, doing what Artaud could only hint at theoretically. The bloody crawling and writhing of

the seminal *Meat Joy* suggested, in a way no photograph or static sculpture could, the horrors of slaughter, carnage, and sexual promiscuity erupting in the American empire of the mid-sixties. In this sense, the works could not be further from abstraction and are indeed revelatory of history.

Plumb Line

It is unfortunate that art history blocks the viewer, at Schneemann's moment of greatest visibility, from seeing her for the theoretician she is. Rosalind Krauss and Annette Michaelson try to assimilate her into their paradigm of "visual culture," but Schneemann is actually attacking the idea of images and their domination of thinking and perception. Her goal, far more a persistence of action than any persistence of vision, suggests a horror at visual culture, linking image and imagemaker in the work as doubly accountable. The two, she suggests, must not be separated, for what is at stake, in a classically Artaudian framework, is the expropriation of bodies and minds by occult forces. It may be in this sense that Schneemann appears at openings and in public like a pagan witch.

To borrow a phrase from video artist Tony Oursler, the goal must be "returning the Citizen to the body." One could detail the large number of artists who have borrowed from Schneemann, but none have understood the sophisticated way in which she has tried to bring the power of speech and action against the automatic and biological. The topic of her massive influence is awkward—the New Museum cut such a discussion from the catalogue, especially Schneemann's anger about it. Schneemann is left to exist in the barest, least-adorned existence, marking and speaking and writing, which is ironically, in some ways, her place. Schneemann wants the who, the human being, not to be hidden, parlayed, or turned into a thing. By putting herself forward yet not claiming it as "her performance," Schneemann aims her work at the cult of personas which structures public meaning into a simulacra of action. Schneemann is well aware women can generally only become

major figures when they are dead, much as her tragic soul-sister Hannah Wilke has.

It is not the commodification of the world but its reification that is Schneemann's target. The process of making seems to unravel and leave its main feature: action and speech, declaration, even in the swinging of a nude in a harness. Schneemann subverts the narcissism of body politics: the body speaks, but from deep inside comes a tale of crimes and betrayals which refers not to the body but to quite external factors. Psychoanalysis has been mercifully superseded. Schneemann's body is not so much without organs as de-biologized, making herself a political creature of speech and witnessing directly out of the biological hole, this dark place that is so mute. For this alone, *Interior Scroll* may be one of the most powerful works of twentieth-century art, blocking the hidden regime of replication that has rendered every body a potential corpse.

The Irreconcilables

Against all odds, people continue to toil without recognition, verging on madness, suicide, or poverty, as Foucault once put it in the case of Artaud, of "medullary ruin," the most human of all refusals. People set up their own spaces, go their own way, and strive to appear, though the hidden hand keeps knocking them down, closing the door and shutting the windows, strapping them down for more shocks, or simply cutting them out of the discussion, as Schneemann has been. Just as the Yugoslavian women defended their speech and narrative powers for each other in the midst of genocide, so Artaud and Schneemann manifest the resurgence of speech and gesture out of horror and chaos, in spite of a now hard, now soft dictatorship whose contours evade our grasp. Those who escape the momentum of the social to categorize and position, to make automatic, are independent and irreconcilable. It is they who, in the face of horror and lies, deserve the highest honors we can bestow. Constitutionally unable to climb the greasy pole, their eyes and mouths cannot be closed. They become pariahs, and only more conscious in the process.

Savage times require howls and cries of rage. Hannah Arendt once described art as not made, but as a certain thing that has "become tangibly present, to shine and to be seen, to sound and to be heard, to speak and to be read." Individual people make the difference in this, and to that end, the women of Croatia, Schneemann, and Artaud are less artists than art, action . . . some sort of political essence. For this, they deserve a measure of glory. It is their agitation and disorderliness that tame the jaws of chaos and place them back in the bit, and perhaps in time hold out the possibility once more of poetry and song to illuminate our barbaric times.

Issue 26, March 1997

Guess who-lu?

Suck on This: Roni Zulu, L.A.'s Mad Tattoo Artist

By Erika Icon

Lately I have become quite adventurous, so a few months ago I decided to get a tattoo. I had gone with my friend DJ Plan Nine from Outer Space when he got his tattoo and I was hooked. After I got my tattoo, I began to think about tattoos as affordable art.

The tattoo artist who did my tattoo is the world-famous Roni Zulu. Roni Zulu used to work at the Black Wave on La Brea but now owns his own shop, Zulu Tattoo. He has a two-month waiting list and he is definitely on the lips of all who dig tattoos around town.

I went to Roni's tattoo parlor to interview him. When you enter the place, you are definitely in "Roni's World," and it is like no other tattoo shop on the planet. The walls are painted in a huge zebra print, there is African tribal art all over the joint, including a real stuffed armadillo, and a large collection of Spawn toys. I immediately felt at home. Roni is quite striking himself with his wooden disks in his ears (which he calls "Zulu Plugs"), wild dreads, and that swirly, Maori tattoo on his face.

Roni has been slinging ink for three-and-a-half years. To look at Roni, you would never believe that he grew up in a household where his father was a warden and his brother a Southern Baptist preacher. He was always drawing as a child, even on the walls. Trapped in an overly conservative home, Roni did what many of us artists have done: he bailed at sixteen.

Roni attended an Ink Slinger's Ball with some friends, where he decided to walk out on corporate America (he was working as a commercial artist at the time). A few years later, he won "Tattoo of the Day" at the Ball. He learned to tattoo by apprenticing, and his first piece was a tribal tattoo of the four winds. Many people would not allow him to apprentice and he has been harassed (even received death threats) for being a black tattoo artist.

Roni did a Japanese Kanji tattoo for Queen Latifah, who he says is "pretty cool." He has also tattooed Me'Shell Ndegeocello

and the comedian Flex. But the tattooing he can brag about most is his tattooing of the Samoan royal family. He tattooed them freehand, in their huts.

Roni is even crazy enough to have tattooed himself. He did tattoos of the African mask of divinity on one of his legs and a tiki on the other, just prior to being named an honorary member of a Maori tribe in New Zealand, from whom he had to get permission to get the tattoo on his face. The tattoo, called a Moko, is pure decoration, and unlike most Maori facial tattoos, does not denote a family crest.

Towards the end of our interview a customer came in early for his tattoo session. He has a very detailed tattoo of two dragons which takes up his whole back and has taken over twenty hours to do. Ninety-five percent of Roni's tattoos are custom work, and he loves doing color and superrealistic tattoos.

I asked Roni if there are any tattoos he won't do, and he said that he won't do rings on people's fingers because the ink won't take to the palm side of your hand. His vote for the stupidest tattoo is getting names of boyfriends or girlfriends on your body.

Roni prefers to do tattoos in his shop, although he does do conventions, such as the upcoming Anaheim Convention Center show in May. He usually consults with people one month before they come to get their tattoos done to book the date and to go over the design. Many people want tribal tattoos, the style that Roni has become best known for. The size, detail, and time it will take to do the tattoo all affect the price.

He has just added a new tattoo artist to his shop, Jessica June, and he is very excited to be working with a woman tattoo artist. I will be visiting Roni in about three weeks for my next tattoo and you should definitely check him out.

Zulu Tattoo is located at 350 N. La Cienega. The shop's phone number is (310) 289-1600.

e-mail Erika Icon at Girlicon@aol.com.
Issue 27, May 1997

Genuflect
By Gordy Grundy

Death of a Showman

In Los Angeles, showman Michael Todd was busy packing. He had to catch a plane to New York in order to attend a Friar's Club roast in his honor. It was a special time. He was lovingly married to the most beautiful woman in the world. He was the proud father of a baby girl. His recent achievements had earned universal critical praise. For the first time in his life, his finances were stable and abundant. Life could not have been better for Mike Todd.

That night, Friday, March 21, 1958, Todd gave his bride, actress Elizabeth Taylor, a good-bye kiss. Much in love, Elizabeth wanted to join her husband at this prestigious testimonial where the great entertainers and comedians of the day would be roasting the headline-grabbing Todd. Unfortunately, Elizabeth Taylor suffered from a heavy cold. She had just started work on the film *Cat on a Hot Tin Roof*, and she needed her strength. Reluctantly, this devoted wife finally agreed to stay in Los Angeles.

Mike Todd was one of the greatest American showmen whoever lived. Known for his brash personality, Todd would risk everything he owned (or could borrow) on his belief in an idea. His Broadway successes overshadowed his many failures. Todd's greatest achievement was the all-star production of *Around the World in Eighty Days*. This Best Picture won five Academy Awards and made Todd a fortune.

Mike Todd met his friend and biographer Art Cohn at the Burbank Airport. The weather looked ominous. High winds and heavy rains stormed the Southwest. Not to worry: the pilot of the Lockheed Lodestar said that flying conditions were excellent above the storm. At 10:41 P.M., the *Lucky Liz*, the name with which Todd had christened his private plane, took off for the Great White Way.

Several hours later, shortly after 2 A.M., the pilot struggled to fly through a fierce storm that raged over New Mexico. No

one knows exactly what happened. Thirty-five miles southwest of Grants, the *Lucky Liz* crashed and exploded in a rugged valley between cloud-covered mountains. All on board died instantly.

Martha Does Marfa

Our source on the prairie reports that Martha Stewart, America's favorite aesthetic, has been boning up on Minimalism at the late Don Judd's compound in Marfa, Texas. Simplicity and space could become the next hot thing. Or would that constitute a crisis of conscience?

The Healing Power of Pop

Too tired to light a cigarette? Too numb to switch off the televangelist? Too weary to cinch the knot on the noose?

The "down" times in life must be tolerated; they are part of the balance. To sweeten the bitter, music is often the first step on the climb out of an emotional ditch. You can discolor the blues. Following are several songs that can bring fresh blood to those anemic times.

"Accentuate The Positive." Johnny Mercer and Harold Arlen slap us upside the head with their succinct lyrics. Arlen takes a position of absolutes. ". . . Accentuate the positive, eliminate the negative and latch onto the affirmative. Don't mess with Mr. In-Between . . ." You are forced to choose: Is that glass half full or half empty?

"Sing Your Life." On his *Kill Uncle* CD, Morrissey gives us a sweet philosophy for the millennium. The wise and earnest lyrics urge us to know ourselves and be proud of it. Where the truly jaded may sneer at such an elemental message, Morrissey has fortunately invested great wit and a bouncy beat. Sing it.

"Gone!" The Cure has written a wild one for their *Wild Mood Swings* CD. It features a catchy, syncopated beat and swingin' lyrics, yet the perspective is an odd one. As mood music at an intervention, it might motivate an addict into rehab. Even if this point of view does not apply to you, the message is solid with a believable "go get 'em" attitude.

If music can tame the wild beast, it can also be used to recircuit a bad attitude. Your soul will sing, and that's the point, to gas up the carburetor.

True Tales of the Hyperreal

You can be a winner without the effort. Succeed without sweat. Your laurel leaf crown is made of fresh-scent plastic.

Several stores in the Banana Republic chain were selling trophies at $39. (My friend bought one of the majestic faux-silver cups on a heavy black-lacquered base at the sale price of $19. She wants to engrave it with "Trophy Wife.")

No assembly required. Just place on your mantle and insinuate.

Lingo

a full set of luggage \ n : 1: refers to the heavy circles and swollen bags under one's eyes, usually after a long night of wild and excessive behavior: Looks like you've got a full set of luggage! (Courtesy of our hard-livin' real-estate sources.)

Nature's Balance

There is a harsh price to pay for the pleasures of the beach, the smell of the salt air, the lulling roar of the waves, the minimal clothing, the kiss of the sun.

You can't find a decent restaurant in a beach town.

The Big Paddle

Most tribal cultures feature their own customs, rituals, and belief systems. The Southern California surf culture is no exception. Long before Gidget and Moondoggie scampered across the sand, real surfers in the thirties and forties took a more philosophical approach to life, death, and the sea.

This is a culture of self-reliance, appreciation, and dignity. The Big Paddle reflects that ethic. Like the African elephant that lumbers off alone to die, an aging waterman grows to where he can no longer enjoy the things that give his or her life its meaning and pleasure. When life is ebbing and the body

gives out, the surfer knows that he is ready for The Big Paddle.

At sunset, on a day like no other, the surfer will wax up his favorite board for the last time. Sometimes, he or she will be joined by friends. A toast will be made for a safe journey. Other times, the ritual will be initiated alone. It is a time of contemplation and reflection.

Before the sun can set against the horizon, the waterman will place his board into the Pacific and start paddling. He aims to follow the sun. Forever. He will paddle until he can paddle no more. He will effort until his strength has been depleted. He will die with dignity, on The Big Paddle.

Gordy Grundy is a Los Angeles–based painter. Reach him at ggrundy@aol.com

Issue 29, October 1997

Celebrity Profile: Kenny Schachter
By Liz Balogh

Kenny Schachter, many will say, has no business being in the art world. His degree is in law, and in his own words, he "didn't even know such a thing as a gallery existed" until 1988. Within a year of discovering the gallery system, though, he started dealing art, and in 1990 he curated his first show. Since then, the man has curated over thirty shows in Manhattan, always in a space that is being rented or borrowed for a month at a time. While the show is up, he keeps what he calls "Korean grocer hours." During the course of the show, there are scheduled readings, performances, anything that says, "come on down!" For this behavior he has been called inelegant, even dangerous, by those who would like to keep the average Joe from perusing their pristine walls, sullying the art by their very presence.

I met Kenny Schachter about a year ago. While strolling down Greene Street I discovered this sprawling but disintegrating space, crammed with art. It was a large group show, but I remembered very little of it. I did, however, remember Kenny. Therein lies the rub: it is Kenny who makes the impression, not always the work. The exhibit is trademark chaos, making it difficult to remember an individual piece but very easy to recall the feeling of the show. What is that feeling? An absolute frenetic energy. In a business where dealers often pass for corpses and their surroundings for mausoleums, frenetic energy ain't a bad quality to have. Since that meeting, I've found that the guy has been all over the map. In May 1996 he was invited by the London Arts Board to curate a show entitled "Sex, Drugs, and Explosives." In November he was off to the Arlington Museum in Texas for a show and some lectures, as well as a two-week exhibit on Wall Street to benefit the City Harvest charity. Bumping into him at an opening, I asked him if he would do an interview with me. He agreed, and we met at his home in the West Village, which he shares with his artist-wife Ilona, new baby, and dog, Hey. We then settled in the studio for a little chat about his experiences in the "backstabbing, exclusive place" that is the art community. I push the button on the tape player and let it roll.

KS—Do you have some mean-spirited questions for me?

LB—*Maybe I should go home and rethink my questions, I guess* Coagula *has a reputation to keep up. Start by telling me how you became the artist-curator you are today.*

KS—When I was a kid, I had a corkboard. I had no friends. I would cut out pictures from *Sports Illustrated* and stuff and I would put the pictures on the corkboard.

LB—*And they became your friends?*

KS—No, Pop Tarts were my friends, but that's a different story. I basically had no interaction with my family, siblings.

LB—*You grew up in a pod?*

KS—Well, isolated. My mother was a hobby artist, painted on the walls. She died twenty years ago. I never took art classes or went to a gallery until Andy Warhol died and they were

selling off his possessions.

I went to Sotheby's. I thought it would be his work, but it turned out to be his collection. I saw all these pieces that I had seen in museums, Twomblys, Joseph Beuys, and I thought that was so cool. Then later I saw an ad in the paper for a Twombly and Beuys show at Hirschl & Adler, and I went there. That was the first time I had gone to a gallery. That was in 1988. I took out an unsecured loan and bought some prints right off.

LB–*When did you put on your first show?*

KS–1990, but I started dealing art right away. I was selling to private dealers in six months. I had taken the bar exam in 1987. I wrote a few chapters on entertainment law and then took a job selling ties. I sold ties all across Ohio, North Carolina. It wasn't that great an experience.

LB–*I bet, but it can't be far from selling art?*

KS–Same difference.

LB–*You've said before that the art world was an exclusive place, but it sounds like you were accepted pretty much right away.*

Method Schachter.

KS–Not at all. I made work, shoved it under my bed until I discovered that I could put on my own shows. In the third show I curated, I started to put in my own work. I would have an idea, or issues that interested me, and I would use it as a construct for a show.

LB–*When did you realize that the art world was beginning to take notice of you?*

KS–To tell you the truth, I thought they would from the very beginning. I thought that I was doing something fresh, showing good work. I thought I would get reviews, sell work. I learned from failing. I once rented this space in Lucio Pozzi's building, trading away an enormous amount of art that I had acquired or was given to me. I put up this show thinking I would sell a fair amount of stuff.

LB–*And what happened?*

KS–I sold one piece for $350 and a bus bench. . . . Okay, now do you want to hear some stories or what?

LB–*Yes, Kenny, I want to hear stories!*

KS–All right then. I'll start with Postmasters. In 1992, I curated a show there. Christian Schumann, Spencer Finch, Beth Haggard, Devon Dikeou, and Jonathan Horowitz. We had a couple of agreements regarding Christian Schumann's work.

When some of his stuff started to sell, Magda Swon–this was a gallery dealer who I overheard say that she didn't even like Schumann's work–decided to give him a drawing show. We had two agreements, one that I would get an X percentage for the piece that I commissioned for the show. The second part of the agreement was that I would get an X percentage for this first drawing show. I'll say she reneged outright on the first part of the deal. Then when I asked for the small stipend owed on the drawing show, she replied that I was "inelegant" for asking. Shortly afterwards, I sold a piece of his [Schumann's]. Magda wouldn't even give me the 10 percent commission that is standard. She later picked up 75 percent of the artists that I had in that show and didn't even so much as say thanks.

LB–*What makes you do these shows, what the hell keeps you going?*

KS–I don't know, I just can't help it, I think it's genetic. But I could never have a gallery. I hate the rigor of the every-day thing. For the three shows I do a year, I love sitting in the gallery like a hood ornament. I think that it's really important to be accessible. But I've had Fredrick Petzel come in and look

at my hours, six days a week and say "This is horrible!" He saw it as some sort of an affront.

LB—*What do you think of the New York condescending attitude towards independent curators like yourself as opposed to, say, Europe?*

KS—New York is horrible and cynical, but you can make a place for yourself. It's worse in Germany, especially Cologne. London has a great atmosphere for projects, but there, you're either Saatchi or non-Saatchi. I met an artist in London, Daniel Coombs, who was in the "Young British Artist" show in September in London. I was going to show him in New York. When Saatchi caught wind of it, they forbade the artist to show with me in New York. So the attitude prevails. New York is the best place for art because of the sheer variety . . . there are a lot of collectors here as well. You can find a support system if you work at it.

But listen, now I'm on a tangent. Here's something I really want to tell you. It's a Barbara Gladstone story. I had a collector who wanted me to buy him a Matthew Barney photograph. I called Anton Kern, who at the time ran the gallery. I asked Anton if he had any Matthew Barney photographs that I could buy. I told him who I was, and that I was buying them for a collector. He then asked me who the collector was, and I told him. He said he had five photographs to show me. We set an appointment for the following Saturday morning at 10 A.M. I get there and Anton tells me they have NO photographs to show me. He said that there had been a lot of "heat" surrounding Matthew Barney's photographs, and they had to be really careful about who they sell to, so we have no photographs to sell to *you*. Now you tell me when you've heard John Galliano, or any designer, say, "Hey, you're a fat ugly bitch, so we're not going to sell you this dress!" Tell me another field in our society where you can get away with this. To further the story, I called someone who was a good friend of Jonathan Napack, who was writing for the *New York Observer*. Jonathan called me immediately and said that he was going to write about it. Because I always have this tendency to put my

foot in my mouth, especially after a glass of wine, I sent Barbara Gladstone an invitation to one of my shows. On the back I wrote a little note saying "Thank you for your generous hospitality, read all about it in the *New York Observer*." In the meantime, Jonathan Napack had called Barbara Gladstone to do an interview with the Ice Queen. Gladstone started screaming at him because she had read my invitation. Of course the article never saw the light of day. Napack was completely intimidated by her. He doesn't talk to me anymore. This is the kind of world I'm up against.

LB—*I'm getting a little depressed now. What are you working on for the future?*

KS—Well, I have this show at the Arlington Museum in Texas, a show on Wall Street, I've been teaching at NYU, and I'm talking with Scribner's about a book, a sort of *You'll Never Eat Lunch in This Town Again* sort of thing.

LB—*You can always brown-bag it with me . . .*

I left the interview somehow energized. Even with all the stories of betrayal and humiliation, this guy inspired me, and let me tell you, that is a hard thing to do.

Two weeks later, I saw the exhibit Kenny curated at 25 Broad Street in the financial district of Manhattan. It was the most cohesive show put together to date by this rambling artist/oaf/motivational speaker. The space itself was inviting. In the furthest corner of the room, under eerie fluorescent light, was a strangely beautiful cyberskeletal figure painted on blue-and-white raw fabric. The piece *Seed at Zero* by artist William Saylor was the standout of the evening. The artist used kelp with a binder as his medium and stretched the fabric over electrical conduit.

Also worthy of note were John Lekay's crystalizing heads boxed in Plexiglas and made from paradichlorobenzine, or in layman's terms, urine cakes. I am beginning to see why so many think Kurating Kenny must be stopped.

Let's hope he's not!

Issue 27, May 1997

Keith Haring and Those Who Knew Him Best: Family and Friends Discuss the Artist and His Recent Whitney Museum Retrospective

By Adrienne Redd

Every time I make something I think about the people who are going to see it and every time I see something I think about the person who made it.

–Journal entry by Keith Haring, July 15, 1986

The retrospective at the Whitney Museum of American Art was a dizzying and vast exhibit, comprising nine rooms of monumental works, the extant subway drawings, video creations by and television spots on Haring, and journal entries, drawings, photos, and scrapbooks dating to his preteen years. It was all made comprehensible by the emphasis on Keith Haring's warmth and humanity. Rather than critique the work of the best-known artist of the 1980s and one of the most accessible fine artists ever, I spoke to Keith's parents; a sister; his boyhood friend, Kermit Oswald; and his high school art teacher to get a sense of who he was. The debate over how the intent of the artist, the perception of the viewer, and the metaphysical reality of an object converge to create the quirky phenomenon of art will never end. But Keith Haring and his art seem particularly well-suited to a discussion of the artist as a person versus what he intended and what he made.

Born in Reading, Pennsylvania, Haring grew up in the small town of Kutztown, Pennsylvania (population 3,500 when students from Kutztown University go home). Educated in the public schools, Keith then took printmaking courses for two years at the University of Pittsburgh and at Oswald's urging, moved to New York City to study at the School of Visual Arts.

From brightly colored, faceless, dancing figures on T-shirts and posters to huge interlocking grids of shapes to searing indictments of Christian hypocrisy, the images that Keith Haring produced were seen around the world. But the people who knew him and shaped him in Kutztown, Pennsylvania, distance themselves from his prominence in and influence by the New York art world and nightlife and from his homosexuality, emphasizing instead the happy pictures he created and the friendly, approachable person he remained until his death in 1990 from AIDS-related causes. At the same time, family members and teachers say that the origins of Keith's style and talent were apparent in his childhood experiences and creations.

How did Keith's small-town upbringing produce the bold subway-graffiti artist who transformed the face of American art with a powerful lexicon of whimsically simple, blatantly sexual, and angrily satirical symbols? It began with a childish pastime and was energized by Keith's not quite belonging to that world. Keith's father, Allen Haring, and several of Allen's seven brothers enjoyed cartooning and doodling and drew characters for Keith and other children of the family. Karen, one of three younger sisters says, "I liked a lot of his things. He used to do things that would fill in a space with teeny, tiny shapes, no characters. I remember he had taken a photograph of himself on special paper you could draw on and then did watercolor on top of it. I always liked that cartoon-type stuff with people and animals. That photo was done when he had long hair in 1976, so it was his senior year in high school." Kermit Oswald explains Keith's sense of alienation: "He was the only son, the eldest, and a little revolutionary. He is the only person I know who ran away from home more than once. There was something inside of him that made him do crazy things. He was always searching for something, not just something concerning his sexuality. He would run to the shore every summer to

search inside himself. I think his sisters and his parents have a starry-eyed view of him."

Keith's high school years unmistakably revealed his talents. Nita Dietrich taught art in the Kutztown school district for thirty-three years and had Keith as a student for all four years of his high school career. She says, "I gave my students free rein. I led them in the right direction but then it was up to them. His style evolved even before he came to me. I saw it in his junior high work. Line was always predominant. He would bring things to the Kutztown Fair and there you could also see this inclination to work with line. He was not interested in ceramics or jewelry, but he did batik and that was a natural outlet for his line schemes. I do have a prized possession, a batik he did in his senior year, which hung over my storageroom window [in the classroom] and which I took home with me when I retired."

Mark-making extended beyond the classroom, and Dietrich adds, "Keith was my paperboy, too, and lived only a block from where I live. Two blocks of cement were replaced on my side of the street and he scratched his initials in the wet cement. It still says 'K. H.'"

Oswald, himself an accomplished jewelry designer and successful businessman and Keith's friend from first grade on, says that Keith's work was first and foremost a "dialogue with the front page [of the newspapers]." He continues, "He was responding to the media almost every day of his life. He was usually outraged by the news of the day and responded to it in the studio. That was the wonderful thing about his work. When England invaded the Falklands, Keith drew an octopus person that represented imperialist England." The retrospective includes part of the series of absurdist collages of headlines from the *New York Post*, one of the most famous reading, "Reagan Slain by Hero Cop; Pope Marries." However, the dialogue with pop culture began even earlier. A wistful poem written in prepubescent years to an anonymous "you" appropriates a line from a Carole King song. In a journal entry from February 1987, Keith himself wrote, "It's about understanding not only

the work, but the world we live in and the times we live in and being a kind of mirror on that. I think it happens really naturally and inevitably if you are honest with yourself and your times."

Like his interest in popular culture, Keith's integration of text and pictures began at an early age. Allen Haring says, "We played the pass-along game where you draw something and then the next person adds to it. I guess some people write stories that way too." The retrospective showed the growing vocabulary of characters and symbols that eventually coalesced into nonverbal narratives; it began with an exercise done at age ten where Keith wrote descriptive words about the entities in a drawing—a dog, a boy, a horse, and a fence. This leads up to the fantastical animation where beings metamorphose into other beings and dogs jump through holes in people.

Oswald explains, "The lexicon of images was a parade. Not to oversimplify, but the baby, the dog, and each and every character was released much like a fashion designer releases his fall collection. The early drawings had people and dogs, and then a snake, and then the Batman character with wings, and then the angel. And at the time when each entered the drawing, there was all this stuff going on in the real world and in the media. It was a suspenseful process, which kept people on the edge of their seats. The zigzag man is my portrait. That's Kermit. It's my Warholian fifteen minutes of fame. And to walk in there and see these things up on the wall brings me to my knees. We spent hours in the museums from our teenage years on and I never dreamed I would be on those walls." The realization of Keith's fame is still a strange thing for Keith's family and friends and, it seems, was for Keith himself.

He remained open and generous to the end. James Carroll, director of the New Arts Program in Kutztown, says that the graphic accessibility of Haring's work was also true of his personality. "The thing that is interesting is that most every time he came to Kutztown he spent some time at the elementary schools. He was one of the most accessible artists and if you called him on the phone he would pick it right up until the last

day he was alive. A Japanese art dealer wanted to meet Keith and wanted me to introduce her and I said, 'You don't need me to. You can just call him up.' And Keith even said, 'Why doesn't she just call me?' He was accessible not only to young people but to all people."

Keith's mother, Joan Haring, says, "Keith was so down-to-earth, never snooty. I don't think of him as a famous person; I think of him as our son. He never had airs. He thought art should be shared among everyone and he instilled that in others. We still give away his buttons and T-shirts and if schoolchildren call for information, we load them up with magazines and books—if someone is sincerely interested in his work."

The emphasis of the Whitney curators is on the art more than the man. "Keith Haring is the most universally recognized artist of the 1980s, but this popular status has tended to overwhelm his stature as an artist," says David A. Ross, director of the Whitney Museum of American Art. "This retrospective attempts to refocus the critical perspective on Haring's work, while broadening understanding of the phenomenon that is Keith Haring."

Oswald disagrees, in part, with Ross and the Whitney's presentation of Keith's work as fine art held separate from pop images and everyday objects. "It would have been too ballsy of a move for the museum," he says, "but I would have shown more of the commercial things that he gave to the public. Between the larger paintings and the later works, in the room with the monkey puzzle and the Warhol Foundation elephant, I would have placed the Swatches and the $20 T-shirts. I would have shown the other things he was making at that time. I would have placed T-shirts between the $15,000 paintings or at least the originals from which the T-shirts were done. There were beautiful drawings that were the originals; no one sees them, but they were beautiful.

"One of his great efforts was to make his work accessible to people who normally didn't have access to art and it would validate all of that commercial work by placing it in museum context. He was working to knock down those barriers between expensive art and commonplace objects. That's an important political point. He didn't just get successful from what was shown in galleries. Everybody on every continent has seen his T-shirts." To this, Carroll adds an insight: "Academic training was not a big part of Keith's work. It was about resolving his own questions, which is what art should be anyway."

Another reason to focus on the person who made these works is the curious contrast between the sweetness of some of his images and the depravity of others. A ten-year-old child, my daughter, was the perfect companion with whom to see the retrospective because she saw to the core of the issues that Haring depicted. A boldly lettered poster in the first room of the exhibit says, "Everyone knows where meat comes from. It comes from the store." Her comment on this was, "That's about how people lie to themselves that animals didn't used to be alive." About the brutal satire of fundamentalists and televangelists—portrayed by a massive untitled acrylic-and-oil painting from 1985 showing a tentacled monster emblazoned with a crucifix and spearing a man through his brain, taking his money and cutting off his penis—she commented, "I guess he doesn't like Christianity very well." She found the babies and other simple drawings "cute" and asked about another painting, "Is that a man putting his penis in a dog? Gross!"

Again, the people who knew Keith the longest provide valuable insights into these contrasts. Oswald says, "We were gypsies, always moving. I tried to drop Keith's name to get a studio and the woman wouldn't sublet the house because of those dogs in the subway. She looked at me and said, 'You are friends with that guy who draws pictures of people fucking dogs?'"

Oswald adds, "He was a prophet more than a genius and he had this really beautiful way of cutting through the bullshit. There was nothing phony about him. He could cut through things and produce an image and a certain kind of truth. When I look at that dog and that penis, I ask, 'Did he *do* that, did he *see* that, or did he *think* that?' and 'Are you seeing the past *and* the future and are you seeing the character or *are* you the

character?'–all at once."

Keith's later works were capable of shocking his parents, who never discussed his homosexuality and to whom Oswald had to break the news that Keith had AIDS. Asked if there was anything in Keith's work that surprised them, his parents laughed nervously. His father responded, "There were some rather risqué drawings. Sometimes before taking us to an exhibit he would warn his mother," says Allen Haring, "'Mom, this one has penises in it.'"

Nevertheless, from the point of view of his family, his goodness and compassion shone through. From the time he moved to New York in 1978 he was concerned with and worked toward causes, including literacy, nuclear disarmament, and AIDS education, even before he was diagnosed with HIV. His sister Karen says, "My son was only a year old when Keith died in 1990. My sister Kay's children are older so they do remember him, but there is a mythology of Keith. Even my daughter who is five has grown up seeing his work, not just in our house, but on T-shirts and posters and *Sesame Street*. She says, 'Hey, Uncle Keith made that.' And even my son recognizes his work, although he never knew him. They have watched some of the interviews on tape and they know he is a famous artist and as far as I know they know he was a really good person, that he liked kids. When we go to art shows and tributes they get the sense that he did lots of great things for people. I think he was able to pass on his generosity and his ability to enjoy life as much as he could. My daughter went with us to the children's village in New York, where they dedicated a wing to him and transferred a mural of his. The kids could say, 'Yes, Keith was a part of places like this' and could feel that they know him. And the AIDS awareness gets passed along as well. They know what he died of and we talk about that too."

Of his being gay, Karen says, "It was just another aspect of Keith and whatever he did was okay with us because we loved him. My parents were worried about what everybody else was going to think because coming from a small town you wonder what the gossip will be."

To this, Jim Carroll adds, "I remember when he died in February 1990. I talked about Keith being a genius in an article in the *Morning Call* and I got a phone call from someone who was upset that I called him a genius because he was gay. You know, there are a few people who want to run our society. The Christian Coalition wants everyone else to assume their dictates. I was very taken aback by that–their assertion that I shouldn't have praised him, but you have to give praise where praise is due. You take a call like that as a prank but it wasn't a prank. It was strange." Carroll's voice trailed off.

Asked what her favorite work of Keith's is, his mother, Joan Haring, says she likes the mother and baby. "I also like the things he does with angels and the ones that look happy or tend to be children's things or the things that look like animals."

His father says, "I like the crawling baby and the dog. I do not care for morbid drawings. I know he was expressing dissatisfaction with things that weren't right in this world. To go to a show and see those is one thing, but I wouldn't want them in my house."

Haring's retrospective culminated with what I call the Keith Haring dance party, a room in which a Grace Jones video produced by Keith plays on a continuous loop, the colors and wild objects reach a crescendo, and the music blares. One has to experience this in the moment and that moment is the best point from which to contemplate the artist, who he was and what he meant to do.

But this was also where Oswald feels the exhibit falls a bit short. There are images of Keith Haring, his boyish, quizzical face looking out from the walls, but Oswald says, "I think I liked the exhibit very much. There are a lot of different emotions for me in a lot of different ways. I think the museum did a really good job of pulling together the important works. It's difficult for someone like me who knows too many things. There are pieces and periods that are missing or are not represented. It's difficult to find out where some of Keith's things are. Also, it's the job of an artist to be dissatisfied with just about everything.

The show will be very exciting to people who don't have the knowledge of the work that I have. Still, I felt tremendous emotions to see it all again. I was in tears right off the elevator. Everything that was there I have seen at one time or another."

Oswald continued, "There are fifty or sixty drawings that I framed, and I get a kick out of seeing where they ended up. Framing these pieces of paper gives them a life of their own and it allows them to go places. For me, one thing that was missing was Keith's self-portraits. He did some great self-portraits. We happened to own one that he painted in 1985–a great example of him. There was no image in the show that was him and most of his work is faceless, but the portraits are not. That is my one criticism."

Issue 29, October 1997

Letter from Freedom X: Manuel Ocampo, Biting the Hand that Feeds You

by Fred Dewey

On first glance, Jean-Michel Basquiat and Filipino painter Manuel Ocampo could not be more different: the conceptual expressionist with two-dimensional, nonrepresentational, allover surface, affirming the uselessness of common speech, and the cartoonish, seemingly nineteenth-century stylist, using iconography and symbolism, archaic images of demons, devils, crosses, and blood to simulate tradition and summon an atrophied realm of understanding, outrage, and critique. Yet it is in the realm of action, and the position of the painter *qua* painter, hating society and hating painting while propelled to participate in them, that Basquiat and Ocampo, the latter working some years later, appear to have found common ground. In terms of the art world, both became pariahs and supposed

troublemakers, ruthlessly exploited by galleries while trusting the durability of their vision, treated as *Wunderkind* even as social forces amassed to drain them of life and tear them limb from limb. Each produced this frenzy by seeking to renew ambitions for painting, not as an expressive medium but as a two-dimensional surface of speech addressed to the public and common world rather than the art world. That Basquiat did this has been almost forgotten; Ocampo's activity in turn would have been impossible without Basquiat's nose-thumbing at professional and aesthetic rules, and his renewal of the gesture of painting as defiance rather than as polite behavior, expression, or formal, abstract innovation.

Beyond Simulation

Ocampo, as extraordinary as his work seemed at first when it burst upon the scene in the early 1990s, revived an act that, in lesser form, was used by appropriation art and its reference to tradition in simulation. But far from simulating previous styles, Ocampo made a physical leap back over the ruins of modernism, over the artistic ruins of his own country, the Philippines, to reclaim a symbolic and iconographic power as non–mass-fabricated activity. This leap was palpable at first glance, as if he had somehow opened a door onto a forgotten and beloved country. Like Basquiat, Ocampo seemed to have miraculously grown in a strange and different world, a place that offered a vantage on mass society and its increasingly ravenous consumptive processes. By growing up in the East and not the West, preserving his own grounding in the outside, and as a youth making fake icons for a priest and icon-seller, taking cartoon classes, and observing his journalist parents, Ocampo, self-taught like Basquiat, may have come face-to-face with the devastation of his own imagination and thinking at the hands first of the Spanish, and then the American empire.

Coming to America for "the real thing," Ocampo took up residence in Los Angeles and became quickly associated with L.A. thematics, embodied notably in MOCA's early nineties

"Helter Skelter" show. Ocampo's demons and showing of guts, blood, and shit were always, however, of an entirely different order from L.A.'s hipster embrace of Charles Manson and mass gross-out. Indeed, what makes Ocampo so peculiarly troubling, in spite of his debt to Basquiat and even his L.A. contemporaries, is his refusal to compromise in his relation to contemporary American culture and the postwar American domination of art. His work seems astonishingly out of whack, almost empty, as if he were lost in some belligerent simulation of a lost epoch. There is nothing coy or high concept about his work, just the repeated, angry expression of someone upset with the hypocrisy of the world. Ocampo, like Basquiat, soared on the apparent arrival of a powerful "authentic" and bold gesture, but the content rankled. Disliked by his L.A. contemporaries for his sudden notoriety (he was one of the few in "Helter Skelter" to win the tepid acclaim of *Time*, via shock-killer Robert Hughes), Ocampo was ground alive in the savage free-for-all violence of L.A.'s commercial art milieu and, offered an invite from Rome, gave up and left, thereby, in the eyes of many, demolishing his American prospects.

Who's Eating Thorns Now?

With his unabashed return in fall 1997, the "Heridas de la Lengua/Wounds to the Tongue" show at Track 16 gallery leaves the indelible sense that painting may no longer be Ocampo's passion. Instead, Ocampo seems poised on the edge of something new. The show tends not to emphasize his fertile productivity of the last three years from his new home in Seville, Spain, but, unwittingly or deliberately, two mediums that defy the large, painterly gestures that brought him notoriety while in Los Angeles. The show is surprisingly modest and understated, while the two most triumphant aspects of it are effectively throwaways, a scathing installation that attacks the art world and its commercial fetish structure, and the marginal street art of tattooing, in league with his friend Don Ed Hardy, also showing in the space. The tattoos, set aside in a small freestanding room with tattoo stand and music, are striking, lining one wall

next to Hardy's more conventional work. Here we see the banner "Beuyz in da hood" with an image of a Nazi knife through Beuys' head; a can of "Beuys 'Lard' Extra Fat Grade A"; a rat being skewered next to the banner "*Ceci n'est pas un pipe*"; Duchamp's inverted urinal with the banner "Art Saves Lives"; a devastating *Tilted Arc* reference; a tattoo of a blank canvas with the banner "Forever White"; banners of "Death Before Painting" and "Death Before Decoration"; "I Love the Art World" with a rat sitting on a pile of gold, chewing a coin to test it; and a tattoo whose banner sums it all up with "Something Stinks" over an egg cracked open, "50/50" stenciled on it, full of shit.

Ocampo's loathing of the art world and painting in this show, as well as his ability to force questions into a public space, to create a public space by reflection upon the darkness of our times, defies Santayana's cliché that "American life is a powerful solvent." This dissolution, for Ocampo, is domination pure and simple, and it takes aim at everything. It is, in fact, imperialism, operative in Los Angeles as it labors, perhaps more visibly, around the globe with what John Adams called long ago, in naming British imperialism, "the law of brickbats and cannon balls." This force, what the political caste now calls "globalization," has replaced the thinking mind and expressive and perceiving head, symbolized in one of Ocampo's disturbing recurring icons, World Baby, a diapered infant with a globe for a head, one arm a stump, the other wielding a cross. No longer is the means of knowing the world possible, since the globe is everything; instead, infantile and regressive, World Baby wanders from painting to painting, country to country, a monster as scary as anything created in human history, equal to the Inquisition, equal to the Holocaust, equal to the darkest side of a past we thought we'd left behind.

Like Ocampo's God, the roach wielding a knife and pearls, like the Klanlike hooded figures in white, black, and red, the painted icon is repeated not as a type so much as to raise the question of how art might counter this imperialism. Imperialism is predicated on channeling the capacity to think

and imagine into a circumscribed number of tropes, forms, shapes, and images. Ocampo's use of icons and types, it turns out, is not as archaic or peculiar as it would seem, for the imperial order relies also on recurring types, images, and narratives we convince ourselves are new, while the world is crushed under our own feet. What Ocampo has done is to resituate the ancient, archaic human proclivity to think and imagine in narrow channels, through icons, in the unexpected terminology and local traditions of his own native country. In a time of erased tradition, Ocampo says, get closer to where you came from and then travel.

Devotion

The stump of one of World Baby's arms, where the hand has been cut off, Ocampo has said, is a reference to the plantation owner cutting off the hand of a person who is not productive enough. The linkage between allegory, politico-economic critique, and Ocampo's own life is brought to bear powerfully in the installation that seems the only thing of real interest to Ocampo in this L.A. show, *As a Dog Returns to Its Vomit or the Difficulty in Conceptualizing a Use Value for Painting.* The demand for exhausting and obliterating productivity, now globally enforced, is lamented throughout the numerous faxes on the walls. World Baby is what is demanded of us and is specifically what the artist is reduced to when conducting a career. As Ocampo theorizes in the show's catalogue in a revealing interview with the equally ingenious and courageous public/political artist Daniel Martinez, paintings have nothing to do with authentic gestures but are entirely related to labor, "objects of exchange," "commodities." Ocampo theorizes painting as labor and says he hates it; by contrast, with deep irony, he lines the walls with the faxes between him, his wife, dealers, and shippers, calling these the "art," thereby seeking to invert the relationship between "the private" and "the precious." These faxes reveal not only banal details of an art career, from shipping and consignment lists to international bank deposits, but also a consistent concern with keeping track of where his works are, which collectors have them, and their names. He keeps insisting, he keeps not being told. Then, hidden almost randomly on one side is a July 15, 1997, fax terminating his relationship with Annina Nosei Gallery in New York, stating "this art world's small and we will eventually meet people who collect my work." Ocampo's complaint to his most recent gallerist, only a few months before this current installa-

Ocampo, Anti-kultur

tion: "You insisted on keeping an unfair upper hand." The ghost of Basquiat may rattle in Nosei's basement, but not Ocampo's. If there is one thing Ocampo refuses to let go of, it is memory, and memory and painting now must exert a whole new force. Memory is now on the wall, though for libel reasons most likely, the names are blacked out.

Ocampo is, in this, rethinking the activity of the painter, setting this up as a raw gesture without the economic discourses someone like Haacke might use. The effect is a kind of expressionist and slightly nasty politics, linked temperamentally in three dimensions back to some of the early paintings Ocampo made echoing George Grosz, especially 1984's *Nightclub Bathala*. Social horror is embodied aesthetically now, after a decade and a half of mastery of painting, in the mess and disarray of trampled works on the floor—you are invited to walk around on them, and people do—shown shockingly in prefootprint condition in the catalogue. Meanwhile, the banal order of the faxes floats above the disaster, clocks revealing the three key global time zones for the art world. The result is shocking and cold, and one is left with the dizzying sensation that this artist who says he would like to close out his career as a museum security guard—he wore the uniform to the opening of this show—does not like what America and Europe are doing. The notorious incident with one of Ocampo's many swastika-filled paintings—put in the basement of the Documenta IX show, roped off, where it naturally drew more attention—suggests that behind the bitterness and anger there is a profound desire not only—as he admits and celebrates—to bite the hand that feeds him, but to expose cliché in the most loaded areas possible. To follow one of the painted hammocks in the installation which calls out in Spanish to "help rebuild what has been destroyed" is to dig into the sewer of human ruin, and, at the same time, to show how very little, even after modernism, even after Pop, even after Warhol, we have advanced beyond the witch dances of the Middle Ages.

The Pillars of Hell

Ocampo's images are ugly, stirring, and troubling because of the deep processes they circle and dive into, the political realm that images invoke and rely upon. Indeed, perhaps more than anything, what Ocampo does—and here he again comes out of Basquiat—is to say that art can refer to injustice's spectral realm in a way that creates, rather than diminishes, meaning. The Klansman riding the American eagle, the flying sphinx with swastikas, Humpty Dumpty, Alfred E. Newman, all are part of what has been done to us. When Ocampo shows demons and skulls, decapitated, blood-spurting corpses, and haunted, flat pseudomedieval land-

scapes, when he uses icons to turn spectacle on its head and find a postreligious symbolization, it is as if suddenly, almost miraculously, we have come full circle in the ages. The extraordinary domination of modern man's imagination by *icons* is thrown before us with all the tactile and sensual resources centuries of painting can muster. To invoke the past and archaic techniques is not, it turns out, to be Simulationist, Mannerist, or neo-baroque, but to show how Mannerist and baroque our concept of a break with the past is, how much we have unmoored ourselves in simulation and are now more iconographically dominated than the most primitive and idolatrous sixteenth-century churchgoer. That is to say, what Ocampo achieves by refusing to work the terrains of immaculate and orderly Conceptual, Minimalist, or postmodern art is to reveal how sordid, bloody, archaic, and disgusting the immaculate, clean, orderly, and modern are. The ugly is the true terrain of art, not the sanitized, Disney/Vegas machinery we masochistically call popular and even more stupidly call culture.

Ocampo sums up the lesson of imperialism for us all: for a long time, the Filipino subjugated by Spain painted the new God without knowing what it was he was painting or for what purpose. So the person under imperialism is handed a language that is not his and works it, icons embraced whose very function is to obliterate resistance that wells up from our desire to form images that speak of the evil in our lives.

History Is Made in Full Daylight

It is a peculiar paradox that Ocampo came to America, the country that conquered the Philippines, crushing its war for independence in its first, absolutely paradigmatic exercise in raw imperialism . . .

What Is the Pig God?

Who but Manuel Ocampo would title a painting with the most reprehensible, indeed life-threatening of Italian and religious insults, *Porco Dio*? Who and what is this greedy, lusting porker? Ocampo is explicit about how at every turn destiny is bound up in racism, but perhaps it is not enough to simply say the problem ends there, as American political history shows. Ocampo said of his being put in the basement during Documenta IX, "I was invited as an American, then kicked out as a Filipino." It is not race, however, which operates here as the principle, but imperialism. The pig god of imperialism makes us niggers; its motion of selling is tied up in stereotype and persona, the traffic in human souls and processes establishing beauty and aesthetics to hide the unspeakable. Racism offers insight into the means of the truly ugly, showing how it can be made, how images engage the deepest levels of emotion mobilizing people into vast, globe-spanning formations that summon gods we do not know and whose purpose we must not fathom. If Ocampo offers one key insight, one key theme, it is how this mobilization makes us all *penitentes*, people who suffer to achieve redemption, who think yet more punishment and self-abolition, yet more obedience in embracing alien gods, will save us. We are sacrificing ourselves on the altar of our collapsed imaginations. In the end, our sin is not religious but political, and the greatest artists of the twentieth-century nightmare are the hooded priests who know how to steer the horses of the people's tremendous imaginative power, the hooded saviors of dreams and hopes, riding into the apocalypse with us panting like pigs in tow.

In showing these pillars of hell, the pen, as gallerist Patchett notes in the Ocampo show's catalogue, may be mightier than the sword, but the brush is mightier still. Debating what it means for the brush to be so mighty is one task this new generation of radical painters poses for us all. If they sometimes come up short in showing us an optimistic and roomy imagination, they nonetheless have posed a question rarely asked anymore: Whose imagination is it that we inhabit? What if it is not ours? How then can we hope to exist? If the past must then be revisited, who can show us the way better than the pariah who alone, reviled and stumbling, consciously honors its perilous warning?
Issue 30, December 1997

The LowDown on High Art #28

COAGULA

(Ko-WAG-yoo-luh) ART JOURNAL • *SUMMER of '97* • FREE

N Y ♥ P A T

Coagula
ART JOURNAL

Peter Plagens:
The Coagula Interview

Issue #13 Summer '94

REVIEWS REVIEWS REVIEWS

Kids These Days: Burning Man Grunge Orgy Lights Communal Desert Sky

By Jennifer Dalton

Taking place over Labor Day weekend in the middle of the largest dry salt lake bed in the continental U.S. was the pseudoprimitive Festival of the Burning Man. Former landscape architect Larry Harvey and several others started the Burning Man eight years ago. The annual event originally took place on the beach near San Francisco but caused trouble with the local authorities a few years back and was moved to its current location about two hours northeast of Reno, Nevada, on a barren salt flat in Black Rock Desert.

Art that simultaneously exists in time and space is always compelling. The big doomed man was between four and five stories high, made of wood and neon, packed full of fireworks, with a rice paper lantern head. Billed as a monument to transience, he was actually an homage to the cyclical, repetitive, perennial nature of body and life. Throughout the year, people construct the man, rebuilding him in virtually the same shape, all to be burned again, so that we may return to the same place and see the same thing but feel differently about it.

While much temporal or performance art focuses on the body, at the Festival of the Burning Man, the dryness, the heat, the cold, the whatever-you-can-cook-over-an-open-flame diet, the dust, the brightness, the lack of privacy, the porta-potties all alter the way one views the spectacle and what one brings away in the brain and spirit when one leaves.

Most impressive was compelling three or four hundred people to drive between eight and twelve hours (most attendees were from San Francisco or Los Angeles) to stay two nights in the bitter climate and dust of the desert, hundreds of miles from what cynical urbophiles would call civilization. It's quite a feat for lazy people just to get up and witness art that is in a free gallery across town, much less a barren, inhospitable desert.

A makeshift city of tents and cars congealed around the city's center. An entrepreneur thought to bring a cappuccinomobile and nearby a group celebrated with a Christmas cocktail party. Later, they went caroling (one of them being naked). The desert teemed with what some might call weirdos—just ask the residents of Gerlach, the closest (25 miles) town from the camp.

The man burned on the last night of the forty-eight hour

festival. Prior to the burning there was a ceramics workshop, a desert fashion show, performances by artists and musicians, and much ritualistic abuse of controlled substances. Reverend Al of the Los Angeles Cacophony Society burned a terrifying baby doll to a crisp (placed in a stroller stuffed with fireworks) in front of a frenzied crowd, providing a lovely prelude.

After an erection ceremony and much fanfare (people with big torches engaged in a dance around him), the man was lit. The beautiful flames snaked up from the right, leaving his raised left arm for the last bite. He took about ten spectacular minutes to burn in fantastic spurting colors until he collapsed backwards onto the ground. The crowd of several hundred dancing, festively costumed frolickers and music-makers moved around him to accommodate this new position. Bolts of lightning in the surrounding hills heightened the visual experience to a creepy, exhilarating, supernatural level.

Unfortunately, this near-supernatural experience was contaminated by the overwhelming media presence at this year's festival. An HBO camera crew, already having gotten our goat by showing up at a gorgeous local hot spring earlier that day to catch on film all of the skinny-dippers, combined with several other camera crews to crowd in front of the mere festivalgoers. This obsessive documentation at the expense of experience was not to go unpunished, however; just after the man had fallen to the ground, an enormous, all-obliterating dust- and rainstorm commenced. Hundreds of confused, inebriated celebrants ran hither and thither. The camera crews ran, panicking, to their luxury RVs, presumably more afraid of being flooded in camp than hitting and killing the rest of us while driving in blinding dust. No one was flooded out, and the party moved to individual camps, where the nice dumb songs and fires continued all night.

Issue 9, Winter 1993

MOCA's Helter Skelter: Disneyland Meets Mapplethorpe

By Mat Gleason

It has taken an army of overpaid Los Angeles hypesters to convince (successfully) every ponytailed pseudohipster from Riverside to Malibu that MOCA's "Helter Skelter" show is the cutting-edge art of our time. That they have managed to actually drag these yawners into a museum—voluntarily—is commendable. The sheer number of people at MOCA's Temporary Contemporary space on a weekend afternoon reminds one of, oh, the Whitney on a Thursday morning (which, for L.A., means that this show is a big deal).

The advertisement-filled *L.A. Weekly* even gave "Helter Skelter" a cover story—news in itself except that it was probably a slow week for police brutality. This ensured attendance by most Angeleno suburbanites with an R.E.M. CD in their collection. On two separate weekend visits I overheard more than one patron exclaim, "You mean you have to PAY to get into museums!?!"

Of course, four bucks for this show makes $7.50 for *Wayne's World* look like a good investment.

Yet a review of the crowd digesting MOCA's fast-food menu seems more in order than any attempt to seriously consider the exhibit itself. Poised between highbrow aspirations and lowbrow inspirations, "Helter Skelter" attempts that ultimate middlebrow desire: shock me, but not too much. That it delivers this in droves is cause for celebration among the Howard Stern

crowd, but not anywhere else. Like a teeter-totter that skims but avoids Jesse Helms, "Helter Skelter" is the rented porno video you show your girlfriend, leaving the VCR on not more than thirty seconds after she says "ooh gross!" for the second time, ensuring *you'll* still get laid.

"Helter Skelter" posits Los Angeles artists as arbiters of schizophrenia, illustrating for everyone else how everything is fucked up these days (like we don't have CNN). This provincial slew of SoCal artists has a hefty sprinkling of women and minorities. If it had been a New York show with the same pretensions, the art would have been just as lousy and all done by White Male Oppressors.

The show's centerpiece, Chris Burden's *Medusa's Head*, is simultaneously aesthetic and conceptual enough to pull in all patrons, connoisseurs, and dudes alike. A giant dirt clod suspended from above and covered with more model train diorama paraphernalia than most K-Marts stock, the piece was obviously placed front and center to make a good first impression. Too bad "Helter Skelter" falls apart so quickly. MOCA's clientele are soon forced to enter the rest of the exhibit and confront a show not unlike the turd that takes three flushes to be rid of.

If Los Angeles is a fool's paradise, then Mike Kelley is the king of court jesters. Since he's all set to have a big Whitney retrospective in 1993, I'll save most of the ink in my poison pen until then. Most, but not all. Kelley's claim to fame seems to have been a career based on exposing pretension in the arts. His "Helter Skelter" piece mimics an employee lunch/meeting room space. The search for proper art for the proletariat is solved by Kelley in placing blowups of fax art, crude caricatures, and vulgarian philosophies about the rooms in overwhelming proportions. Ho-hum, museums are now decorated by shipping clerks.

That the piece is just another example of "Helter Skelter"'s setting for one-liner gags does not really do justice to the thought of raking Kelley over critical coals. MOCA's permanent collection features a Kelley piece of overwhelming proportion which consists of a hallway of giant sign-painter renderings of various philosophers and artists with little Bartlett's quotes of theirs discussing the fine line between creative inspiration and violent madness. The hallway leads to a dead end that features a little crayon drawing done by a mass murderer (one that they caught). The entrance to the hallway has a box to give donations to a victims of violent crime fund. The box is Plexiglas so we can examine everyone else's conscience, too. Mike Kelley wants it both ways–he wants to critique Foucault *and* Archie Bunker. This would be fine by me if he had started out critiquing CalArts graduates. It's hard to simply single out Kelley in a land of easy targets, but he's the latest golden boy, and it comes with the territory, Mikey.

Local boy Raymond Pettibon holds up perhaps the best, managing an entire installation that is refreshingly free of pretension. Llyn Foulkes definitely spoon-feeds analogy-hungry museumgoers, supplying enough burned-out superhero connections so even your preteens can "get it!" Meanwhile, Manuel Ocampo is digging in to be some kind of East L.A. Bosch in MOCA's Prado West. The joke ends up to be on Lari Pittman, whose busy easel paintings already look too "eighties" (pssst, hey Lari, the show is subtitled "L.A. Art in the *Nineties*"). Don't buy a Pittman unless you spend a lot of time watching old Billy Idol videos.

The irony, in this show where four out of five pieces attempt to be the centers of controversy, is that the one installation that could actually claim that title is hidden away in a back gallery. Paul McCarthy's *Garden of Eden*, a collection of Astroturf and robotic masturbating mannequins, is only risqué in a post-Frohnmayer world. But MOCA could certainly have scored integrity points by putting this one out on the main walkway instead of a place so removed from its beaten path that schoolchildren can easily be led way around it. MOCA could have, but they wouldn't have. Not for "Helter Skelter." Judging by the turnout and the lowest-common-denominator art on display, MOCA's "Helter Skelter" is simply a show whose purpose is as far from that of raising issues as one can get.

The show seems to be set up entirely for the purpose of raising rent money.

Issue 1, May 1992

Karen Finley: Memento Mori at MOCA

By Mat Gleason

The problem with "political" art is its distance from "art" (aesthetics). The problem with "women's" art is its tendency to be women's art and not just art. To transcend these labels (even though they're gonna stick) should be the goal.

The question is HOW? For 1992, the answer is: tap into Karen Finley's energy, because she is making political, feminist statements that thoroughly succeed aesthetically, emotionally, and intellectually.

At The Museum of Contemporary Art, Los Angeles, Finley is presenting a two-room installation, "Memento Mori," the first museum exhibit of her ten-year career. Although best known as one of the "NEA Four" (four artists denied grants from the National Endowment for the Arts because of the "offensive content" in their art; stay tuned, the court date will be announced soon), she is certainly none the less sheepish about her view and her art. A hallway that proclaims "God is a woman" and "The Virgin Mary is prochoice" leads to a room with a moving narrative on one wall about a childhood friend administering a self-abortion with Drano; along with sloganeering vanities ("I was not created to please men") and a bookshelf with creative retitlings (the subtitle to *The River Witch* reads "People call women mean names when they don't need a man in their lives"), marking pens are made available and a wall is left for YOU to write your mother's *maiden* name.

Finley's other mural-sized prose pieces deal with her close friends who have died of AIDS. Along the way, volunteers offer carnations to be woven into a lace curtain and ribbons to be tied onto a lattice of posts, all in memory of people YOU know who have died from AIDS. In addition, "Memento Mori" includes AIDS patients, with volunteer attendants, lying in beds, all to drive the point home. The solemn force of this installation simply overpowers and overrides the trite tendencies inherent in the usual, tired attempts at "interactive" art.

Fine Art Babe.

In spite of her battles with censors on Capitol Hill, Finley has now become embroiled in a controversy with Tribune Broadcasting. On the late-night, very post-primetime *Dennis Miller Show*, a performance of hers was scratched because it was deemed "inappropriate," according to the *L.A. Times*. The *Times* story quoted Finley as saying "I think Dennis Miller is just as bad as Jesse Helms. What's the difference?" Tribune Broadcasting President Don Hacker in Chicago anxiously awaits your calls at (312) 222-3941, while the soon-to-be-if-not-already canceled *Dennis Miller Show* has a viewer voicemail number (213) 871-8198. A tip sheet from MOCA provided these numbers and *Coagula* is greatly indebted, as Mister Hacker is likely to be as well.

Finley's "Memento Mori" is a moving piece. Originally presented at New York City's Kitchen space, the installation should be required viewing/participation for anyone thinking of voting Republican this November. The show will continue its run through

Issue 3, August 1992

I Don't Want No Retrospective: Henri Matisse at MoMA

By Javier Barcelo

The biggest (though not necessarily the baddest) show in New York City this fall was Henri Matisse's retrospective at the Museum of Modern Art. I did the entire show in about forty-seven minutes, making a conscious effort to take my time (but it's still a record for this show, or so I am told). Henri Matisse was a wonderfully talented artist whose innovation and best work–from 1907 until about 1914–were as important painterly contributions as any made this century. The work that preceded and followed this seven-year period is, with few exceptions, utterly vacuous–both historically and aesthetically. Lots of pretty designs, patterns, colors, and naked women for everyone to get off on. He was a fundamentally conservative artist who never made a nonrepresentational painting in his life.

This busy, decorative, meretricious stuff betrays the monumental austerity of his prime. The show's problem is that the garbage far outnumbers the truly good works. Why MoMA's John Elderfield packed this show with so many inferior paintings is beyond me. If you have yet to go (it closes January 11, 1993), my advice is to simply skip the entire second half of the third floor.

Issue 5, Winter 1993

Kim Dingle at Kim Light

By Mat Gleason

One would be hard-pressed to find an artist working today who simultaneously excels in both conception and execution as well as Kim Dingle. Her solo show of new work at the Kim Light Gallery on La Brea emphasized a dramatic, thinking approach to presentation. Her subject matter, women in exclusively classic masculine actions and positions, reached a higher ground rarely visited by typical attempts at addressing politicized issues.

By avoiding sermons and concentrating on solid images, her visions of a reconstructed reality hung in the gallery as if these images belonged everywhere, pretending that some equality revolution had already succeeded. Women of all races can wrestle and box. Tributes to female soldiers shall abound. The revolution will not be masculinized. These are the messages of Kim Dingle. She succeeds so well through her simple avoidance of pamphleteering that one could critique this show (and all of her work) solely on her formal approach to the medium and still end up with a glowing assessment.

Her paintings succeed in asserting themselves on many levels. One could rave about her ability to render a prepubescent girl's bangs, or her mastery at simulating motion through multiple imagery that alternates the drawn and painted, or the drama in her combining muted color with expressionistic brushstroke; as one could easily hail her suddenly vicious slaps to our notions of the role of women, the role of growing up in a confined orientation, the manner that clothing plays in role-assimilation–along with plenty of other ideas based on thousands upon thousands of our individual perceptions.

Kim Dingle's fresh vision lends hope that the decade of the 1990s may bear more fruit that combines the sweet taste of the visual aesthetic with the tart taste of the conceptual politic. Paint on, Ms. Dingle, paint on!

Issue 5, Winter 1993

Not content with the most beautiful spaces and extraordinary installations in contemporary art, the Dia Foundation has purchased a red-brick factory across 22nd Street for permanent spaces devoted to Andy Warhol and Cy Twombly.

–Janet Preston

Two Short Reviews of On Kawara at the Dia Center for the Arts

The best museum show of the season: The Dia Center for the Arts where On Kawara has an installation of his infamous date paintings and a chronicling of one million years.

Both the art and the installation are meticulously done. One is reminded of the power of Kawara's art to concretize time for us in a manner that few artists have ever been able to do.

His paintings were radical then and, within the context of much contemporary myth-making, psychobabble, and overall self-indulgence, his work looks as fresh and vital as ever. I'll take him over Jasper Johns any day.

The show opened on the first of January and will run through December 31st.

–Javier Barcelo

Two hundred people braved a January storm for On Kawara's opening at the Dia Center. Kawara's impact surpasses that of Samuel Beckett; the exhibit is the single greatest show this writer has ever seen.

The key to Kawara's genius: a room with ten books listing one million years, year by year, for hundreds of pages per book, eight columns to a page, single-spaced. Civilization occupies the last half-page. An ontological stun gun.

L.A. Underbelly Exposed Birk and Ocampo: City Beat

By Mat Gleason

Two recent solo shows in Los Angeles have done more to encapsulate our times in this town than all of the anniversary uprising documentaries to date. Sandow Birk and Manuel Ocampo are two young (both are in their early/mid-twenties) L.A. painters. None of this careerist conceptual strategy crap–they paint. Their painting styles, solidly debased from convention, suggest a lack of concern with traditional representational styles as well as those trendier approaches to picturemaking which require agents, contracts, and weekly press releases. The viewer gets both sides of the *Corpus Angelenus*–the inside and the outside.

Manuel Ocampo's psychology of text and horror is as ominous a signpost as the 10 Freeway's Alameda offramp at 3 A.M.–there but for fortune go I. Yet, as his recent paintings at the Salander-O'Reilly-Hoffman Gallery evidence, prolonged viewing seduces one with a creepiness all too familiar, unwanted but unavoidable, more like a hemorrhoid on the brain's ass or constipation of the conscience.

Drawing on multiculturalism as a neutral inspiration–neither heroic nor contemptible–Ocampo assaults the outer eye with that which is going on behind it. The enemy is not confined to a color or culture but rather to a timespan of tragic history which has simply led up to 1993.

While much attention in the press is paid to his Filipino roots, Ocampo's paintings almost seek to defile all of humanity. He gives a voice not to a group or a cause, but to the angst of suspicion and misery that so haunts these interesting times. Dismissive of attempts to portray him as some angry young man of color, he nevertheless sticks out in the lily-white art world. Unlike previous bad-boy exploitation experts, though, his art is not a collection of one-liners on an autobiographical foundation. Ocampo's paintbrush transfers the debased Spanish colonial style into a hideous depiction of everything we want to forget about being human: swastikas, carnage, exploitation, hatred, and fear. No gimmicks, no sermons, and no way out.

Everything that the Beach Boys represented about Southern California in the early sixties is gone, replaced by the classically inspired realism of Sandow Birk. His most-noted paintings invoke the imagery of premodern paintings to illustrate Los Angeles of the 1990s, not as a schtick but as a blunt statement that most non-Angelenos would consider typical of Southern California's arrogance. Birk paints Los Angeles like Florence in the Renaissance or Paris in the nineteenth century: as the most important town of its time. Sandow painted Los Angeles in burning turmoil way before the first King verdict—a multiracial populace at war with each other and with the city itself. To pose his subjects in familiar compositions (via the seventeenth century) is not as much appropriation as it is sympathy for the subject, the solemn act of putting the denizens on a pedestal as tall as the First Interstate Library Tower featured so often as a reference point in his work.

Birk's latest paintings juxtapose newspaper accounts of gang-related shootings with graphic portrayals of what the simple tragic event might have been like—before the TV trucks showed up. Birk believes in timeless homage, seeking both to document these times and provide a little art-history magic as a sign of optimism about Los Angeles. Unlike gimmicks, faith these days is a hard sell.

Issue 7, Summer 1993

Tim Hawkinson: Solo Show at Ace Gallery
By Mat Gleason

The quintessential Tim Hawkinson piece in this solo show, which occupied half of the cavernous Ace Gallery, was *Signature*, a machine that signed the artist's autograph onto a roll of paper, only to slice off the signature into a pile and start again. It was a profound commentary on art stardom, depersonalization, mechanics in the computer age and, in its own disheveled construction, appearances. It is rare in these times when a show is so bursting with ideas and a single visual theme or link (series art) is so completely (and successfully) ignored that, even after multiple viewings, it remains difficult to accept that one artist did it all.

There were large-scale pieces of conceptual turpitude and smaller "almost-inventions," one such being a clock that will make a complete rotation in 10,000 years. Other highlights: huge discs coated in gum-wrapper foil, overinflated rubber naked male bodies suspended and near bursting.

The show was an exhaustive look at the tinkerings of one mind so honed to the thought process that it capably manifests its wilder ideas for us to absorb and enjoy.

Dennis Hollingsworth: Solo Show at Studio Raid, Los Angeles
By Mat Gleason

The death of poststructural criticism (that debased attempt to use language to debase itself along with beauty) and its dwindling legacy are welcome news, celebrated in the work of

painter Dennis Hollingsworth. A recent show at Los Angeles' Studio Raid Gallery (now Claudette Lussier Fine Art) highlighted this rising star.

The artist approaches text and letters–the tools of language–as the conceptual side of beauty, and delights in making sensuous forms out of abstracted fonts. These are juxtaposed over seductive abstractions (which, for all their beauty, could, if left standing alone, be accused of bordering on eye-candy) to arrive at a provocative sensuous median.

When posited over more figurative motifs, the letteramas unify the picture into some beautiful page from a foreign encyclopedia–the image is important simply by its inclusion/depiction, but there is a vague, deeper cohesion. The connection stands visually but leaves us longing for a conceptual whole, a tie-in. Without pointing us in a direction, the work uplifts by imparting a deep sense of mission to the viewer to strive for knowledge, truth, and enlightenment.

Dennis Again: Solo Show at Lee Arthur, New York City

By Janet Preston

Working from a diverse Filipino-American background, Dennis Hollingsworth had a promising New York debut September 21 at Lee Arthur Studio. The young artist appropri-ates oligarchic images, some from the history of Filipino colonization. One such is a famous photograph of first Philippines governor William Howard Taft (all four hundred pounds!) encumbering a water buffalo–the perfect metaphor for American dominance.

Hollingsworth cloaks and decorates these images with deliberately obscure visual languages, as if to throw American incomprehension of fourth-world reality back in its face. There is a certain unsettling jejuneness to the work that makes the viewer look again for meaning. Dennis is deliberately vague about his intent, opting to let the viewer/critic decide, but with his winning intelligence, can he get away with tact along the road to career advancement and artistic sincerity?

Issue 9, Winter 1993

Pseudo-Critical B.S.: Roy Lichtenstein and the Sixties-Refusin'-to-Die Rag

By Mat Gleason

On his fortieth birthday Roy Lichtenstein was a wealthy, famous artist, the preeminent purveyor of the Pop style, a style that would come to be as much a marker for the 1960s as the Grateful Dead. Like a Grateful Dead concert, his retrospective (which began at the Guggenheim in New York and traveled to L.A.'s MOCA) appeared as a self-indulgent ritualistic foray to the uninitiated. It managed to have the fortysomething set's style-acolytes swoon to images of an accessible cutting edge from yesteryear, like Deadheads oblivious to the concept of musical innovation that doesn't feature a Jerry Garcia slide-guitar solo.

Lichtenstein's career mirrored the chronology of the sixties' legacy in general and the Pop style specifically—from vanguard representational motif to mainstream hip to cultural anachronism (paradoxically, the Grateful Dead spent about twenty minutes in the vanguard and went straight to twenty years of cultural anachronism until they finally arrived at the curious mainstream hipster status they enjoy today).

And yet, just as the Grateful Dead has carved a niche and succeeded within popular music despite themselves, they have never produced a cultural icon on the level of, say, *Highway 61*, *Sgt. Pepper*, or *Sympathy for the Devil*; similarly, while Roy Lichtenstein is permanently linked to the Pop comic image, he has left us no Marilyn, no soup can.

The art world now gives just about anyone a career retrospective, so enduring the likes of the Licht Show is to be accepted. Whereas Warhol became a social octopus with tentacles in every cookie jar, Lichtenstein remained a productive inmate in the prison of success. While the concept of non-Warhol Pop as hip or relevant outside its own time is a bigger illusion than the best imaginable LSD trip, the generation that ruined art criticism through mindless blather about "signifiers" is now sadly and perpetually locked in the need to messianize any participant in its decade of glory, so great is its need to signify sixties greatness.

The strange thing about this grouping of work is how it so mirrors the generation that came of age during the Pop occupation. Like the baby boomers, Lichtenstein's oeuvre is a self-absorbed, self-referential lot that found what it thought was a new way to view the world and, without ever questioning itself or attempting anything more than peripheral stylistic variation, used this same blueprint to remake the world, increasing in size and bombast as it vacillated on any remnants of meaningful content. The result was not failure, but rather dull success.

In Lichtenstein's *Interiors* of the early 1980s, we see posh living rooms with Lichtenstein Pop paintings on the walls mirroring boomer obsession with casting all analysis of any event through a prism made of their generation's cultural references and perceptions. Lichtenstein's appropriation of other artists (which began surprisingly early in his career) is like classic rock radio formats that reduce whole careers to two or three signpost hit songs.

Meanwhile, on the other side of MOCA was the understated retrospective of Vija Celmins. A cynic might note the dual presentations of representational artists during an economic downturn. What Celmins' show eerily shared with Lichtenstein's was a certain reflection of their era. While Roy was busy accessorizing the bombastic and pretentious chic, Celmins was methodically searching for an epistemological certainty while in a state of utter humility. How else can the depiction of a vast starfield, successfully undertaken with a pencil on a small piece of paper, be explained? Her legendary concentrations on objects was to serve as a record of service,

not to the object or the process, but to the truth, to knowing wholly the reality of the event of depiction. Lichtenstein has spent a career forcing a deep concentration on the superficiality of people, events, and objects as if to completely subjugate them to his own stylistic ego.

Perhaps Celmins represents everything good and noble about the 1960s–it's a wonder she wasn't assassinated. Lichtenstein gives us what we have come to expect from sixties diaspora: self-impressed style only interested in proclaiming its own greatness.

Issue 12, Spring 1994

"Pure Beauty" at L.A. MOCA: Pure Ugly

By Mat Gleason

Where do they get these ideas? Imagine "Pure Beauty" curator Ann Goldstein at home one night with boyfriend/art teacher Chris Williams. Imagine that some of the hyper-conceptual crap that Williams pawns off as art is piled in one corner of the bedroom while MTV is on the tube in the other corner. Ann Goldstein looks above his eyes and sees the two reflected onto that ample hairless dome of his and gets inspired by this vision. She then rounds up the few students of her yokemate's who hopelessly conform to his dull sensibilities, approaches the MOCA board, and cries, "I've got some kids, let's put on a show!"

Pure beauty.

While this scenario may not be accurate (Williams' head surely reflected the entire contents of the room in sharp focus), is it possible to consider a "Pure Beauty" scenario that doesn't involve love being blind wherein L.A. MOCA doesn't end up looking more like a fashion college putting on an undergrad show and less like a world-class museum?

This ménage à trois x 2 + 1 token gay artist included: Thaddeus Strode dancing on a wooden palette, Pae White imitating design, Jorge Pardo installing cabinets, and Sara Seager mocking bureaucracy. There were no highlights, no feasible anger, no arrogance, not even a grand self-immolation, save a poster of Nirvana hung in the group's "reading room." Smells like wimp spirit.

"Pure Beauty" was, simply, the worst show in the history of L.A. MOCA, the only competition of this severity being the abominable summation-of-eighties-garbage "Forest of Signs" show, another product of the vision-free Ann Goldstein! But where "Forest" was a C+ dissertation on deconstruction for hipsters, "Beauty" is a *Tiger Beat* article on art as a function of being hip and young.

In its attempt to show hip, young L.A. artists, it failed–none were hip and most weren't all that young. Most egregious, though, was MOCA finally getting around to doing a show of quality provincial talent and entirely overlooking talent in favor of the flavor of the month. It was *that* flavor, cool punk irony, which proved to be as stale and unsatisfying as Halloween candy in a Valentine's Day box of chocolates.

Like all punk rock, the art presented in the show aspired to disdain greatness, to minimize awe, and to provoke angry sentiments through dissonance and charisma-free bluntness–

yet it couldn't even get these right, or even well.

While mimicking the antagonism of punk on its surface, "Pure Beauty" failed to follow through—instead of leaving an indelible shocking bitterness in the experience, it managed only to provoke viewers into an almost parental dismissal, forcing people to extol the virtues of MOCA's tired Klines and Rothkos like the mother pining for Kenny Rogers when the son played his Dead Kennedys album too loud.

The artists in "Pure Beauty" are not the punk band playing revolutionary music, but the punk fan playing a punk album in suburbia. Their artistic output is only shocking to the unconvertible and the height of pathos to the rest of us.

They quote pop culture and advertising neither as critique nor celebration, but rather as an attempt to put themselves into those dialogues, to use the art world as a launching pad for a career of a different sort.

Like dishonest punk, they snarled, posed, and sniped, but every last one of them really wanted to be (art) rock stars. These twerps want to be as cool as Mike Kelley (they're still buying that myth), as aloof as Beuys, as controversial as Serrano, and as successful as Baldessari.

If these aging kiddies become junkies they may have the Beuys thing down, but someone oughtta tell 'em that the Serrano thing ain't happening again in this lifetime (there won't be an NEA to kick around after 1996), and the breakthroughs and brilliance of Baldessari ain't happening again, not in this culture at least. So this gang of seven poseurs can only take solace in the fact that they're all cooler than Mike Kelley.

Of course, that's only because they aren't him.

They make art as a stab at MTV, in a rock-star pose, wanting Sid Vicious infamy and Cobain-style impact (that's Dylan for you boomers)—but completely unwilling to die for either. They have shock down to a science, like an easy bar chord and an amp turned up to 10.

Will David Geffen buy their art and then sign the band?

Issue 16, January 1995

The Whitney Biennial as Art World Cancer

By Richard Beenen

The worst Biennial in the past decade sponsored by Philip Morris Companies Inc., blows few puffs of smoke.

The cancer begins on the fourth floor. As the elevator door opens, one is confronted with the nauseating vulgarity of Lari Pittman's busywork. What do consumerism and homosexuality (artist premise) have in common? Nothing. Lari, Lari, Lari, please revert back to your purely decorative abstractions. The fourth floor features a group of abstract painters who scratch at gesture including: the master Cy Twombly, the derivative painting of Harriet Korman and Sam Reveles, the exhausting swirls of Brice Marden, the embarrassingly pathetic paintings of Brice Marden's spouse Helen, and the color-filled doodles of Terry Winters. Other painters include the earth-textured corpselike paintings of emeritus Milton Resnick and the cosmic arts and crafts of Philip Taaffe and Stephen Mueller. Contained in the same room is the unleashed talent in Toba Khedoori's wall-length painting on paper: a train and floating endless windows without a building construct a space of their own; both expansive and finite, her themes suggest an unfinished provinciality. Heavyweight sculptor Richard Serra offers a skimpy second-rate piece accompanied by photos of his previous mastery. Barry Le Va installs his site-specific poured ultra-cals. The plans shown in the catalogue, however, suggest much more than was actually delivered. The installation of Jason (Donut) Rhoades pushes the edge between crap and garbage and a whole lot of extra time on his hands. The admiration for Brancusi is purely in vain.

We move on to the innovative Andrea Zittel. Her functional futurist furniture offers isolation or socialization, comfort or shelter, intimacy and fantasy. This cubical domesticity comes complete with exemplary videos. These pieces

suggest viewer participation, but none is allowed. Next artist, Rirkrit Tiravanija. A constructed room of plywood and a live band practicing behind a screen showing an unwatchable boring film of Marcel Broodthaers in Hyde Park. Neo-Dadaism? I don't get it. Upon leaving the fourth floor we see the dysfunctional ceramic vessels by Andrew Lord.

The malignancy continues on the third floor where work is loosely grouped like dying fish on a cement floor. Among the worst of these flounders is Nancy Rubens' mess of mattresses bunched together with decaying cake (lovely). The feeble folk-art driftwood and seashell crafts of Bessie Harvey (corny) and the ambitiously pointless abomination, Nari Ward's greasy severed hearse and carburetors behind bars; oven pans and burned baseball bats (dumb). We approach the mundane cartoons of Peter Saul and the new fresh Christian Schumann. Then how would you like a date with verbally and sexually sodomized Sue "never been properly fucked" Williams? Seek professional help, continue making art, but please do not show it to anybody but your therapist. Which brings us to the suspected trust-fund workings of Nicole Eisenman. The wall mural and drawings are mildly entertaining, but the bulletin board installation reveals just how much extra time you have on your hands. Next, Nan Goldin's voyeuristic vacation snapshots of Japanese subculture and Catherine Opie's sisterhood, body-piercing, and tattoos portray less than Cindy Sherman's poignant slash-doll amputees. Canadian photographer Jeff Wall's panoramic depictions encompassing the everyday capture a graceful sense of suspended time: Monumental in size, a photomural entitled *A Sudden Gust of Wind* (a witty reference to Hokusai, a nineteenth-century printmaker) is displayed backlit, enticing the viewer to investigate the present without the burden of the past. Another artist, Matthew Barney, photographs elicit ecstatic and evil fascinations of Dionysian revelry. These fascinating techno-despotic creatures fuse myth with science fiction. Least but not last is pilgrim Frank Moore's overstated environmental and domestic scenes writhing with in-your-face obviousness. Yeah! I got it.

Down to the second floor we open with the elegant subtlety of Agnes Martin, the sublime minimalism of Robert Ryman, and the wit and perceptual twisting of Charles Ray's *Self-Portrait in a Bottle*, only to be soiled by the clumsy concepts of Lawrence Weiner's etched crosses showing underlying layers of museum paint, with unrelated suggestions stenciled on the wall about things happening to pearls, cannonballs, glass, burnt cork, and concrete, referred to by the artist as language. The second floor contains more, much more not worth mentioning.

On the ground floor sits Gabriel Orozco's chopped (shortened) elevator car taken out of its shaft. Clever, but not very uplifting.

Jason "Colossus" Rhoades.

And for those who have plenty of spare time, the Whitney Biennial presents thirty-five film and video artists comprising nearly 1,300 minutes curated by co-organizer John G. Hanhardt.

This 68th Biennial is curated by Klaus Kertess and will travel to Prague, Czech Republic. It is the second—hopefully the last—to be organized by a single curator.

Curatorial pandering and a motion to suppress any evidence of stirred controversy: this exhibit is guilty of a bland dwindling mediocrity. Objection sustained, rephrase your idea of cutting edge. Objection, overruled. Please remember all my admonitions to you. Do not discuss opinions about the exhibit. Do not conduct any deliberations until the matter has been submitted to you. Do not allow anyone to communicate with you with regard to the exhibit. We will stand in recess until spring of 1997.

Issue 17, May 1995

Claes on Ice

By Janet Preston

Has Claes Oldenburg lost his edge? What a funny question, as if the salon of Soft Pop ever had one.

But the truth is, no artist of the sixties meant more to the anti-Vietnam war movement than Oldenburg. His *Lipstick Ascending a Caterpillar Track* dominated Beinecke Plaza at Yale University where the mob-marches on Washington were planned, and happy demonstrators spray-painted slogans on the sculpture. Its symbolic power compelled Yale authorities to hide *Lipstick* in a college courtyard.

ᴵᵗ ꜱʰᵒᵘˡᵈ have been.

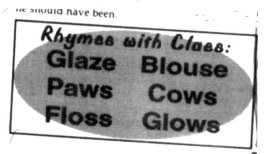

Rhymes with Claes:
Glaze Blouse
Paws Cows
Floss Glows

Oldenburg's influence can be perversely subversive. By debunking the formal perfections of Western culture, Claes opened the door to Damien Hirst. Robert Gober and Jeff Koons owe a greater debt to Claes than to any other artist. And what of Oldenburg's East Second Street store in 1962? Has any installation been more imitated? Oldenburg's strung-together underwear forms a line between Hans Bellmer and Cindy Sherman.

Well, who can blame Claes for getting fat, sassy, and Coosje, doing bloated pageants in Venice? Of course, his work has suffered, becoming a parody of a parody of a parody. Occasionally, the formal appeal of a piece makes one smile. That's about it.

It's too bad the real thing has lost his curveball.

Issue 18, Fall 1995

Florine Stettheimer at the Whitney: Flavor of the Month

By Janet Preston

She died in 1944, but every twenty-five years or so, somebody tries to revive her. Her name is Florine Stettheimer and she is one of the worst painters of the twentieth century.

In 1975 feminist critic Linda Nochlin wrote that Henry Geldzahler had walked Andy Warhol through crates of Stettheimers in the basement of the Met. Nochlin then proclaimed Stettheimer the retrospective founder of the pattern and decoration movement. P&D operates on the principle that pretty patterns, no matter how banal, somehow constitute art. The go-go eighties fortunately wiped out the Florine revival, but not forever.

This year, in a fit of *fin de siècle* insanity, Jeffrey Deitch, Holly Solomon, and Elizabeth Sussman of the Whitney Museum have sniffed a whiff of Florine flatulence with major Stettheimer exhibitions.

Let's acknowledge that art insiders get their rocks off by spotting Mondrian, Duchamp, and other Florine flora in her paintings. How precious. This does not justify the flat, immature spatial relationships, washed-out colors, clichéd jazz-era accessories, and all-around kitschiness that characterize every piece of junk put out by Stett the hack.

Hell, nobody liked her work then, so why shove it down our throats fifty years later? Hilton Kramer called Flostett the greatest unknown artist of the twentieth century in his *New York Observer* column. That should tell you how talented she was.

The Stettheimer big lie illuminates the persistently pathetic herd behavior of art-world biggies who should know better. Are these people taking too much Prozac, do their

shrinks cost too much, or have they just given up thinking?

In *Artforum*, which put one of Stett's limpest efforts on its summer cover, Brooks Adams grossly prances through Floland like Mickey Mouse on mushrooms. It sounds as if Brooks would like nothing better than to be a tired old virgin, getting drunk on Pernod and nodding out in his finger bowl.

What is to be done? For one, we could move all the Stettheimers into Barney's and have Glenn O'Brien design an ad campaign around them. Better yet, let's rip 'em off their stretchers and wallpaper the Whitney restrooms with them.

Sorry, Florine, but you suck.

Issue 18, Fall 1995

Venice Biennale Wrap-Up

By Deborah Kurtz

This year's 100th anniversary of the Venice Biennale was to be director Jean Clair's big moment of late-twentieth-century revisionism. The body and the figure were given mouth-to-mouth in order to supposedly break the hegemony of abstraction's hold as THE artistic statement of the twentieth century. After three years of New York art fixated on the body, this big theme show lacked any punch and could have just made a nice lengthy magazine article instead.

The twenty-nine individual country pavilions pretty much sucked, with a few exceptions. Israel's pavilion of Joshua Neustein was a convoluted hit, as was the Polish pavilion with a guy who has been doing little sequential number paintings for thirty years à la On Kawara, but very different. I hope my editor remembers his name, because I can't find my catalogue. Bill Viola's video instalation in the American pavilion reinsured his position as one of the world's best and certainly America's preeminent video artist–case closed!

Noteworthy because it was so bad: Katharina Fritsch sucked big doggy dick in the German pavilion.

Venice is a nice theme park for an afternoon, but too many ugly tourists and not enough good places to eat.

Issue 18, Fall 1995

Serious Art Criticism: Words and Things

By Shelly A. Berger

I was mixing story, anecdote . . . with visual representation, while giving less importance . . . to the visual element that one generally gives in painting. Already I didn't want to be preoccupied with visual language. . . . Everything was becoming conceptual, that is, it depended on things rather than the retina.
–Marcel Duchamp in *Dialogues with Marcel Duchamp* (DaCapo Press, republication of 1971 English translation), pp. 38–39.

Pushing the Duchamp-inspired "nonretinal" approach to extremes, a Susan Otto collage in the POST gallery group show "Self-Portrayal" went a step further in form than Reiniger or any of the "Muses" collaborations. In *To Whom It May Concern (Suicide Ransom Notes)*, Otto used language as the exclusive element in this artwork. *To Whom It May Concern* consisted of a series of seven clichéd suicidal messages, including *You'll Be Sorry When I'm Gone* and *Goodbye Cruel World (Please Feed My Dog)*. The messages were constructed from mostly black-and-white (i.e., death) with a few red (i.e., blood) and blue (i.e., veins) letters cut out of newspapers and magazines.

This surrealistic collage technique, as old as Duchamp, would in and of itself be dull. But it was brought to life by the audio recording of an answering-machine message: "*We need to talk . . . I'm not going to be here for you anymore unless you start being honest with me . . . I'm really concerned that you're heading for disaster . . . um . . . I wish I could do something for you but . . . I don't know what . . . [and] it's wearing me out worrying about you . . .*"

The speaker's monologue portrayed a frustrated friend?/lover?/actor? finally giving up on a suicidal

person?/artist? who refused help. The implicit metaphor suggested a much larger, more eerie relationship: the speaker representing the voice of our collective conscience, and the one refusing help representing our entire globe, hell-bent on a path of increasingly tolerated human and environmental genocide. In *To Whom it May Concern*, the artist switches roles from purported suicide victim to frustrated truthsayer, exhausted but still trying to warn us of our own impending doom.

Words and things. (Interestingly, this is the more accurate translation of Foucault's "*Les mots et les choses,*" which has always been translated into English as "The Order of Things.") In the world of what we still call "art," words and things figure as prominently as the traditional "retinal" elements Duchamp so wanted to deemphasize. Which brings us back to that old adage: "Watch out. You may just get what you wish for."

In Otto's suicide piece, the "retinal" element has disappeared entirely. Language and thought are all that remain. Oddly, the piece self-referentially sings "retinal" art's swan song, as if to say "*Goodbye . . . you'll be sorry when I'm gone.*" Perhaps Otto simultaneously suggests that the "retinal" in art is not truly prepared to die, but is merely screaming for help in the same way that anyone attempting suicide cries out to be saved, subconsciously praying to remain alive.

Issue 20, Spring 1996

The Pageant of the Masters: Summers in Laguna Beach, California

By Richard Smith

This summer I was handed the most impossible assignment I have ever had as an art writer. The Office of Alumni Relations at Claremont Grad School asked me to address a group of alumni on an excursion to the Laguna Beach Pageant of the Masters.

At first, my mind reeled from the assignment. Don't these people know, I thought, that the fine-art world ridicules this pageant, don't they know we disdain it as too corny for words? I sulked; I felt like Calvin being called upon by Miss Wormwood. Then I got the list of those attending, almost entirely graduates from the management and business programs, with only a couple from the humanities. What can I possibly say to them about this, I worried.

Indeed, what can one say about the Pageant, where a huge cast of local amateurs stages, with elaborate lighting and costumes, artworks by such masters as Seurat, da Vinci, Rockwell, and Daniel C. French? Art critics ignore it, and the only press it gets is by feature writers.

But why, I thought, stand up in front of these highly educated folks and tell them that what they are about to see is really tacky? After all, I'm not that much of a snob myself, anyway. So I decided to try to address the subject of "why?" Why is this event not considered art, and why did all my friends from the art world laugh and roll their eyes when I told them about my predicament? Especially why put it down when, for a couple of decades at least, we have been complicating and destroying any distinction between the phony categories of high and low art? Here, after all, are the categories destroyed: the Pageant enthusiastically parades before us not only works of the high masters, but also works in cut crystal, children's book illustrations, and porcelain knickknacks.

Also, in the running narration that accompanies the show, only the aesthetic opinions of two authorities were quoted: Bob Hope and Will Rogers. I could feel myself getting into the spirit of the thing.

A traditional cliché of aesthetics is that artworks are removed from time, that somehow they are stopped, framed, archived, and interpreted rather than used. In opposition, real objects are transitory and unimportant. The prime examples are Duchamp's readymades. The Pageant plays against "art" by emphasizing not the external moment but the process. Almost all the publicity photographs show the cast costuming, making up, and just hanging out. (My favorite photo, worth the

price of the program, is a shot of Jesus and the disciples, taking a break from posing in *The Last Supper*. Someone has just told a joke and they are all laughing.) It all looks, from the publicity, completely "real." During the staging they even reveal, with a Monet painting, the actors assuming their places under the cold worklights. In other words, they take "art" and throw it back into the continuum of "life."

The Pageant also avoids another of the traditional signs of fine art, its interpretability. The narrator, during a display of paintings by Degas, simply says, "In dancers, Degas found a favorite subject." Thus, the show avoids the century-long feminist debate over these paintings, an extremely complicated debate in which both men and women have argued both for and against the paintings. The pageant also avoided any complicated interpretation of Copley's *Watson and the Shark*—a right-wing, Tory, proslavery, anti-Revolution propaganda piece—as an exciting eighteenth-century *Jaws*. By treating all this as pop entertainment, the Pageant treats its audience as children.

Any interpretable agenda the Pageant did have could best be described as moral virtue, here the virtue of patriotism as exhibited in a lengthy "Tribute to Lincoln" sequence of images. Morality has been the agenda of tableaux vivants for hundreds of years, along with its opposite, eroticism. I counted the depiction of at least seven nudes (much scrambling for binoculars at those moments!). It is this embodiment of such conflicting tastes—high and low, art and reality, virtue and eroticism, piety and fun—which makes the Pageant so fascinatingly difficult to talk about in any one way.

Issue 26, March 1997

Coagula

#12

FREE **FREE**

Los Angeles ART JOURNAL New York

WOW! THAT ROY LICHTENSTEIN RETROSPECTIVE SURE MADE ME REASSESS THE ENTIRE POP LEGACY...

YEAH, THE SIXTIES SEEM TO BE FADING FASTER THAN A BABY-BOOMER FACELIFT

Illustration: Mike O'Bone

THE LOWDOWN ON HIGH ART #20

COAGULA

ART JOURNAL

ANDY WARHOL

Nine Years Dead Yes, *but* **1996** *could* be his *Biggest* Year **Yet!**

THE LOWDOWN ON HIGH ART

COAGULA

ART JOURNAL

#1
$1.0

Presenting
CLAES
OLDENBURG

IN
POP
FICTIO

The LowDown on High Art
COAGULA
#29

(Ko-WAG-yoo-luh) ART JOURNAL • October, 1997

reconsidering
RAUSCHENBERG

Q&A
(Interviews)

A Tribute to Ray Johnson

On January 13, 1995, **Ray Johnson** *jumped into Sag Harbor Cove on Long Island and backstroked into immortality.*

WBAI-FM art critic **Charlie Finch** *and Artforum Executive Publisher* **Knight Landesman** *assembled a panel to talk about Ray's art and legacy.*

The panel: **Chuck Close***, artist;* **Jill Johnston***, critic;* **Richard Feigen***, dealer;* **Mark Bloch***, Johnson's associate and mail artist.*

Chuck Close: Ray was a much more important artist than was generally recognized by the art world. He was an idiosyncratic figure, inventive, whose collages, whose work, predated the Pop art of Lichtenstein and Warhol. He is best known to the general public as the inventor of mail art.

Ray orchestrated a path for his art through the mail. He would send something to me and say "Add to and send to," but a lot of the times we would keep the work because we liked it so much.

Mark Bloch: Ray started his New York Correspondence School in 1962. But as early as 1943, Ray was sending mail art to his friend Arthur Secuda.

Richard Feigen: I became aware of Ray's work at the end of the fifties. I was immediately aware of his status as a cult figure. I saw his early Shirley Temple pieces and just wanted to own them.

Ray's personality was very much like Joseph Cornell; these two guys were on the same planet, but it wasn't our planet! Not long after I started to represent Ray, he wanted me to hire an airplane and drop a hundred pounds of link sausages over Riker's Island.

I still own my Ray Johnsons, and I don't want to give them up. As weird and poetic as they are, he is a seminal figure. You had to work with Ray on his own terms. Ray recently wanted to have a show with nothing in it! I loved Ray, but it was an all-day, full-time thing.

That's why I was startled when he called me a few days before he died and asked me if I was interested in buying this James Dean collage. Ray never wanted to sell anything! I don't know what he was trying to tell me.

Chuck Close: He didn't need the money, for he had considerable savings.

Richard Feigen: He was just like Joseph Cornell, who had annual reports stacked up on the porch of his home on Utopia Parkway.

Mark Bloch: Ray went out to Cornell's on Utopia

8.17.93

DEAR COAGULA,
I WOULD SUBSCRIBE
TO COAGULA BUT
I DO NOT HAVE
$18.00.

RAY JOHNSON
NEW YORK
CORRESPONDENCE SCHOOL

OO
OO
POP ART 1961

NOTHING
BY RAY
JOHNSON
JULY 30

Parkway and Cornell spent the whole time sitting on the radiator, sobbing!

Jill Johnston: Ray was like an alien. I was at a Fluxus-type performance. It was a small auditorium full of people, and I remember Ray running outside of the audience with Albert Rine, creating his own event. It was disruptive.

I didn't correspond with Ray because he scared me. I heard from him before he died. Many people had various kinds of messages from him before he died.

His message to me was, "Jill, Ronald Feldman sold the *I'd Love to Turn You On* work, which has my hand-lettering of your words in it." I looked up the piece to see what words of mine he had quoted in 1969. My piece was called "Casting for '69," it was in the *Village Voice*, January 9, 1969. The first line of my piece was, "My story begins with some unfamiliar handwriting on an envelope." Of course, Ray copied that. He copied the first 452 words. I found in this piece this line of mine which Ray had appreciated: "Then, for lack of any good reason to go on living, he committed suicide." At the end of the 452 words, I had written, "You've got to have something to be dismembered by."

Mark Bloch: These clues are everywhere.

Richard Feigen: I didn't have any premonitions. But these clues did get more intense. It seems obvious to me that he orchestrated this thing.

Jill Johnston: For what purpose?

Richard Feigen: I don't think his best friends know. I don't think anyone was that close to Ray. By the way, I think Ray was a very gentle, benign personality.

Chuck Close: He looked scarier than he was. He looked like a biker. I have a little trouble with gleaning

clues now in retrospect. I can prove that almost anyone died on purpose. Of course, he was obsessed with Natalie Wood's drowning. Maybe there is something about returning to the water that one could look for.

I spoke to him several days before he died and spoke to Ray regularly on the phone. As a matter of fact, Ray sounded very optimistic about the future and was talking about having shows. He had just put a new roof on his house.

Jill Johnston: Do you disagree with Richard that he orchestrated this?

Chuck Close: I do believe that he committed suicide. I don't think it was planned out as a performance piece.

Richard Feigen: His friend Toby Spiegelman gave me this whole litany of clues after Ray died. It was on his mind.

Chuck Close: I think people who kill themselves are profoundly depressed, not because they want to boost their careers.

Ray had profound ambivalence about everything. He wore his outsider status as a badge of honor, and he was incredibly pissed-off. He made things difficult, and yet he wanted attention desperately. He streaked his own lecture!

Richard Feigen: Ray was at the very top rank of seminal artists of the second half of the twentieth century. His collage works are of an extraordinary high order, aesthetically.

I was at the National Gallery in Washington recently, talking to its contemporary art curator, Mark Rosenthal. Before Ray died, it was like screaming into a wind tunnel trying to get a major museum to acquire a work of Ray Johnson's. Now, all of a sudden, the National Gallery

wants one, and it's not going to be difficult to sell Ray Johnsons to museums.

Jill Johnston: I think Ray's ambivalence could pursue him into his afterlife. He needs a good explicator.

Chuck Close: We don't do too well as a country, as a culture, recognizing idiosyncratic people. It'll take an interpreter to pull things together and teach the public what artists have always known, that Ray made a major contribution.

Charlie Finch: I got Ray's last piece of mail art right before he died, because Ray was a fan of my radio show and left some messages about it. Let's hear Ray's voice on tapes that he made for Mark Bloch.

Voice of Ray Johnson: *Mark, do you have Beatrice Wood's phone number or address? Yes, no?*

I'm looking at the photo in the New York Times *of the collapsed roof on Delancey and Eldridge Streets.*

Hi, Mark, this is Whoopi Goldberg, again . . .

I'm listening to the Charlie Finch Show, *he has a very nice voice . . .*

Can you hear the President talking about recession? They are playing some weird music behind him. Can you hear it? Can you hear it?

Chuck Close: Everybody who knew Ray feels guilty, because everyone was annoyed by him sometimes.

Jill Johnston: Ray sounds incredibly lonely, like he was reaching out all the time.

Chuck Close: When the phone rings, every time, for a split second I think it's Ray.

These excerpts were transcribed from a live radio broadcast on WBAI's Artbreaking, hosted by Charlie Finch.

Issue 18, Fall 1995

Coagula Conversation with MoMA's Robert Storr and Author Francis Naumann

Janet Preston interviewed **Mr. Robert Storr**, *Curator, Department of Painting and Sculpture, The Museum of Modern Art, and* **Mr. Francis Naumann**, *author of* New York DADA: 1915-23 *(1994, Abrams, New York).*

JANET PRESTON: Rob Storr, in your show "Mapping" at MoMA, you posited that there's an omniscient sense of visual place that precedes our literary sense.

ROBERT STORR: The idea for this show was to set up a smaller scale at the Modern, where we could play a little bit more, basically.

JP: Tell me about the Ellsworth Kelly piece called *Fields of Paris*, based on a map of Paris, and made in 1950.

RS: Ellsworth and I are friendly, and I was up in his studio and we were looking at old drawings. He mentioned his map, and we just pulled it out of his drawers. In fact, it had never been assembled. That's the fun thing about being a curator, finding things and having access to find them.

JP: You also have an excellent Yves Klein blue piece in the show.

RS: That came from a dealer in New York who has long represented Klein's work, Carol Janis. The whole show was based on pieces I had seen at one point or another that stuck in my mind. The show was just a mat-

ter of correlating them.

JP: Sol LeWitt's piece satirizes the claustrophobic life of an artist in Manhattan.

RS: That comes from a whole series of drawings where he mapped out his life. It's two of his galleries and his studio at the time, and it comes out a perfect Sol LeWitt shape. To get Suprematist purity out of Manhattan takes some doing!

JP: You also included younger artists like Raymond Pettibon and Kim Dingle.

RS: The Pettibon was something I saw in Cincinnati, at a tiny gallery. It's the best statement of the sublime I've seen in some time. Kim Dingle made a specific map for the show. She's really great. We took it sight unseen. It's a perfect map of the United States in the middle of impressionistic U.S. maps by Las Vegas high school students. The best was a deep brown snowball in the middle, which is sort of an autistic America.

JP: It wouldn't be a mapping show without Richard Long and Hamish Fulton.

RS: My father was always into English watercolor drawing of the eighteenth century and the idea of going out into the land. Fulton and Long have done a conceptual version of this. Conceptual art isn't the same in every country. It has local roots.

JP: Ever since your "Dislocations" show, MoMA has been moving in a different direction. It's popularized itself. There are more intimate gallery-type shows. Are you happy there, Rob?

RS: Well, it's moving. I guess that's the real news. There is a lot of internal dialogue going on at MoMA. And I hope this will mean that people will no longer talk about the Modern and its *Position*, as if it were the Pentagon of Art, but rather the many things that go on there.

JP: Francis Naumann, you've studied Dada since the 1970s.

FRANCIS NAUMANN: For twenty years I've been asked, "What is Dada?" In fact, the people who steal books to sell on the street had my book before I did. One told me he had to take my book off his stand, because people kept asking, "What is Dada?" and it was disrupting his sales.

JP: I love the section where you describe Marcel Duchamp and Man Ray breeding dust in Duchamp's studio. Did Duchamp's studio have more dustballs than the Whitney Museum?

FN: Duchamp's studio was famous for its dust. Georgia O'Keeffe went there with Stieglitz, and the first thing she wanted to do was start tidying. It was actually Duchamp's intention to let the dust breed on *The Large Glass*.

JP: You say that Duchamp would pooh-pooh the readymades when people visited his studio.

FN: Not so much pooh-pooh them as dismiss them. He would say, "If you don't understand them, ignore

Storr.

them." He didn't want to push his ideas on anyone else. Duchamp started a dye company with a French painter, Leon Harteau. Unfortunately, it went bankrupt in six months. Duchamp did it to keep his hand in the art business. I have this theory that he spent the rest of his life seeking alternatives. When John Quinn died and his collection of Brancusis went up for auction, Marcel Duchamp and a woman named Mary Rumsey and Henri-Pierre Roché formed a consortium to buy, ahead of the sale, all the works by Brancusi. They knew it would be a disaster to auction off all the Brancusis at once. Duchamp lived off the proceeds. I've always wanted to do an article called "Money Is No Object" on Duchamp. One wonders what exactly he did for a living.

JP: What is the continued appeal of *The Large Glass*?

ROBERT STORR: What comes to mind is the lateral photographs of Gerhard Richter's paintings. It is very much connected visually to a Duchamp/Man Ray view of retinal painting.

JP: Rob, how did you discover Adrian Piper's work?

RS: I first met her through friends like Arlene Raven.

JP: Last spring, on an *Artforum* panel with Adam Gopnik at the Drawing Center, you delivered a ringing denunciation of the art world's misinterpretation of Adrian Piper's *White Room* in "Dislocations."

RS: Well, I thought that Adam had misinterpreted the piece. The argument I was trying to make is that the best artists who deal with social material are not trying to point fingers or teach a moral lesson. They are more like doubting Thomases, poking at wounds that are there. To engage this work is not to be put on the spot in that you have to agree or disagree.

In the case of Adrian's piece, she put a man in the middle of the room, a black man, shouting racial slurs. A lot of people thought that this was about racial guilt. It wasn't.

JP: It was more of an auto-da-fé?

RS: He could have been engaged in a monologue. It could have been a matter of public speaking. When a group of black guys, ages fourteen or fifteen, was in the room, they did not hear that piece the way Adam Gopnik did.

JP: The magic of "Dislocations" was its extension throughout MoMA. Will there be more of this at the museum?

RS: A museum is a structure that needs to adjust to the incoming work. Works like Sophie Calle's in "Dislocations" may not have been possible in the past. It's a credit to Kirk Varnedoe and the people at the top.

JP: Francis, tell us about the man who fought Jack Johnson.

FRANCIS NAUMANN: Arthur Craven was famous for having fought Jack Johnson, in the Arensberg Salon. It was a prearranged bout, and he was scheduled to go down at a preordained time. But it made Craven famous.

Place Naumann sticker here.

Johnson had to make money. He was in Europe under the Mann Act and did exhibitions. Craven gave a lecture at the Salon des Independents in 1917. It was said that he stripped during the lecture. I did some research and found that he only got as far as taking his shirt off. But it was enough to scatter the room.

ROBERT STORR: Karen Finley before his time!

JP: Are there any plans by the Modern to enter the Information Superhighway?

RS: It might run over us! I'm a computer illiterate. I'm a Luddite, really. I presume there are elaborate plans to do that, to manipulate special designs for exhibitions.

FRANCIS NAUMANN: I noticed in a recent interview with Kirk Varnedoe, after he reinstalled MoMA's permanent collection, he mentioned that Picasso was no longer the great legacy that ran through the museum, but Duchamp was, as he put it, "The recurrent haunting ghost." I once noticed that Hilton Kramer used exactly the same terms.

ROBERT STORR: Hilton's haunted by a great many ghosts.

FN: I wondered whether you see the same kind of legacy.

RS: Definitely. Conceptual painters like Johns have been profoundly influenced by Duchamp. But we are at a point now where the artists most profoundly influenced by Duchamp probably take him the most for granted. He has so permeated the culture that younger artists who work in a Duchampian frame of mind, but without direct reference to Duchamp, are taking the best advantage of what Duchamp had to offer. Conversely, there is an academy of Duchamp producing elegant gestures which is not terribly radical in its thinking and has a tendency to assert authority in case of emergency.

JP: In *New York Dada*, Francis, you show that the needs of artists don't change over time. Indeed, Duchamp's *Fountain* was inspired by an artist's need to relieve himself!

FN: Duchamp said that at an apartment of a wealthy collector in New York someone couldn't find a bathroom, and in the middle of the party, they saw the "water" trickling down the steps. Duchamp thought, "We need a urinal right here." And that's how he got the idea to purchase the urinal as opposed to any other readymade.

There are almost two histories of twentieth-century art, one that really does begin with Picasso and the *Still Life with Chair Caning*. You can't connect it to the readymades as easily as art historians would like to. I understand that in Clement Greenberg's last interview, he explained that Duchamp's *Bicycle Wheel* shouldn't be discussed as some kind of phenomenon because the *Still Life with Chair Caning* preceded it. But one really had nothing to do with the other. In *Still Life with Chair Caning* the rope was used to simulate a frame, and the wallpaper to simulate what it was designed for, the chair caning.

RS: It's visual punning, really, rather than readymade presentation.

FN: It's not the object for what it is. Picasso also made a bicycle seat and handlebars into a bull's head. It's visual punning. When you walk into a room, first you see a bull's head. When you see a Duchamp, first you see a snow shovel, then you make other associations.

RS: The business of art is to exploit ideas. There's no such thing as pure Duchampian gesture that can be made impure. There are dumb ones and smart ones. But I don't think you can start out with the virtual Dada idea that is then subject to decline and corruption.

FN: Duchamp limited his number of readymades for himself.

RS: Then, in another context, you have artists of the 1980s who decided to make multiple multiples that were cheap and accessible. The Sol LeWitt drawing in the "Mapping" show was one of the *Democratic Drawings* designed to sell for $100 originally and also sell for $100 on resale.

The idea of disseminating something like that has a social context. It's the territory that artists play with.

JP: Rob Storr, you are doing a project with the Pace/Roberts Foundation in the Southwest?

RS: I picked four artists, and the first projects are already installed. I picked Felix Gonzalez-Torres, Annette Messager, a local artist named Jessie Amato, and Leonardo Drew. The whole idea behind the foundation is to mix international figures with local artists and create a conversation. Then there is a jury that's going to pick the next round and keep it moving.

JP: Has the world stolen the idea of postmodern art from New York?

RS: I don't believe in the idea of postmodernism, so if they stole it they can keep it. We're dealing with a very internationalized art world in some respects, and in other important respects, not. For example, what Kabakov, Bulatov, and others did was done in isolation and similarly, you cannot understand the Brazilian conceptualists entirely out of context. The discrepancies are most interesting internationally.

JP: So Greenbergian linearity is dead, we hope?

RS: It was pure fiction to begin with.

−Janet Preston
Issue 17, May 1995

Karen Finley: The Coagula Interview

Artist Karen Finley entered the mass media's consciousness when a dialogue over federal funding for the arts exploded into a controversy over the direction of American culture. Without ever seeing her performance piece We Keep Our Victims Ready, *conservative columnists Evans and Novak singled it out as an example of why the National Endowment for the Arts should not be funding "controversial" artworks.*

Hailing from Chicago, where she studied at the Art Institute before earning an MFA at the San Francisco Art Institute, Finley, 40, makes her home in Rockland County, New York. She is married and has a daughter, Violet Marie.

Ms. Finley was interviewed by Coagula *Editor Mat Gleason by telephone in early October. Fans of her work will have the opportunity to see her new one-woman show* An American Chestnut *at UCLA (Freud Playhouse, November 1–3, for more info, call 310.825.2101) as well as her exhibit "X-Rated Pooh," a parody of Winnie the Pooh cartoons, at New Image Art (7906 Santa Monica Blvd., Hollywood, opens Sunday, November 3, reception 5–7 P.M.). New York will get a glimpse of Karen at Fotouhi Cramer Gallery next April.*

New Image Art director Marsea Goldberg says that working with Finley was a great experience, "She is just so open. Someone on that level, you might assume they have a big ego, and she just makes you feel at ease . . . [she] really listens to you and is open to dialogue. She really likes the underdog . . . not just lip service."

Coagula: I just perused your new book (*Living It Up: Adventures in Hyperdomesticity*, Doubleday). How has working so closely with corporate America been?

Karen Finley: Doubleday is great, real easy to work with. The book's original publisher was Crown, part of Random House, but they pulled out because they felt that the book would offend Martha Stewart.

C: The book is so funny, it really is kind of subversive humor.

KF: I think that in American culture, right now, today, that humor is the only acceptable vehicle for radical thought. If some dialogue is funny, then I guess they figure it is somehow "safe," more so, safer, than just a plain discussion of issues.

C: Your X-rated Winnie the Pooh drawings are funny, too. Your show of them in L.A. coincides with your performance at UCLA. How has working with [L.A. gallery] New Image Art been?

KF: I like the challenges of the underground. Marsea's really nice. I think the art world should be about turning things around and not about becoming so hierarchical that someone can't show wherever they want just because they've earned a little success. I'm showing at Fotouhi Cramer in New York in the spring and that is a pretty elegant, you know, higher-up place. But I just can't think in a hierarchy type of way. I like to mix stuff up. I like the fact that people in L.A. saw my stuff at Kim Light [Gallery, in 1993] and now they can go to a different kind of space to see what I'm doing now. A lot of my book was inspired by what was

going on in L.A. when I showed at Kim Light's . . . I mention the Menendez brothers and Michael Jackson's problems.

C: You have gone on to a lot of other things, other projects, but how does your whole battle with the NEA and Congress look in hindsight?

KF: Oh, it's still going on. Look around. Alternative spaces are closing. I'm really concerned for young artists because America does not fund their culture. They leave it to the media, and don't you think all their problems, drugs and crime, all that stuff, might be related to culture being underfunded? The energy is concentrated on stifling freedom of expression. The NEA thing is still going on. We won in Los Angeles over the Bush administration, but the Clinton administration is fighting the verdict on appeal.

C: What most worries you about the political climate?

KF: This idea of protecting the children as a basis to censor free speech is really troublesome... also, look, I'm against big things like Philip Morris, but America has this reputation of going overboard [on issues like smoking]. Instead of things just being about freedom, it's a person's

rights versus what offends a person. Why are people so afraid of being offended, I mean, walk past it, just ignore it, I mean, when did America become so mannered?

C: When you spoke about the political climate's effect on younger artists, don't you think that artists will just find their own way of expressing themselves, that they'll just do something on the Web if they can't find a theater or a gallery for their work?

KF: I remember when video came out, when it got into everyone's hands and everyone was saying that it would be the people's medium and finally we would all have control of television and really democratize society, and well, video did affect things, the way things are done was affected, but it wasn't changed. I see the same thing happening now with the Internet. And they're spending so much time trying to sanction speech on the Internet and they will, just like radio, eventually. It belongs to us but we can't use it to discuss controversial matters. They are trying to censor the Internet and they probably . . . eventually they probably will to some degree. I have a piece that I want to put in the MOCA show ["Uncommon Sense," opening at L.A. MOCA, spring 1997) that uses the Internet. I want to call it *Fear of Offending* and have people link up to a Web site and type in what offends them, whatever they really don't like, and what gets input into the site will be projected onto a fountain in the museum. I'm also putting together a piece called *Go Figure*. It's going to be a life drawing class, a real experience, a traditional class that will have a nude model and an area where people can draw the model and then display their art, their drawings, in the museum.

C: Who is curating the MOCA show?

KF: Julie Lazar. It'll be good. I want to show that artists who deal with the body aren't crazy, that there is

a relationship with the body like a doctor's, that dealing with the body doesn't have to be erotic or deviant, that it can be a natural, professional, maybe even a clinical experience.

C: Is there any difference between how your European audiences react to your performances and the way crowds in America handle it?

KF: Completely different. In Europe, the audiences actually discuss the work, the content of the piece. In Europe, there's no need to justify nudity or other acts, the performance can be appreciated for what it is and not for how offensive it might be. In the United States, the audiences are good, but the people who don't attend seem to affect things more. In Providence we had to get the ACLU just to perform. It's like having hecklers who don't attend the performance but still manage to completely harass you. If they were in the audience, I would just tell them to go back to New Jersey, but it's a much larger situation; there is an atmosphere in America during a performance that there is something going on besides the content of the work.

C: Do you attribute the whole response here to some quintessential aspect of the American character?

KF: No, it's really what America has become. My theory about why *Saturday Night Live* isn't funny anymore is that reality has actually become a much better parody of sitcoms than anything else out there. I mean, have you seen Donna Rice lobbying Congress on behalf of the children? It is scary and funny at the same time. You can't believe it is happening while you watch it. It's too funny. This is what we've become. You can't shock with traditional methods. After Lorena Bobbitt–think about this–after the Bobbitts, the word "penis" is like the word "ear," it's just some thing. Penis, ear, the shock is gone.

Issue 24, Mid-August 1996

Constant Collector

Believe it or not, there are art collectors in Los Angeles!! Really! I am not making this up. Although this is proof that I do not have a life, I decided to phone one of L.A.'s idle rich, just to ask for a report on the L.A. scene from a collector's point of view.

2-01-96 12:50 P.M.

(Preliminary phone conversation omitted so you won't die of boredom)

Me: So who is hot?

CONSTANT COLLECTOR: Well, there isn't one artist who is dominating the scene, but certain ones seem to be as healthy as ever.

Me: You sound jaded, did I catch you between Valiums?

CC: Funny. I really liked Linda Stark's work at Marc Foxx. Didn't you give her a positive review?

Me: Yeah. We like her. I actually met her a few months ago. She's very cute, as good-looking as her art.

CC: Well, boys will be boys. She doesn't fit my aesthetic a hundred percent, but Marc Foxx knows just how to price things. He makes them quite tempting.

Me: Slur your words a little more, I can't tell if that martini you're drinking is a double.

CC: What?

Me: Nothing. Did you see Ross Rudel at Angles?

CC: Yes, actually. I saw you at the opening. Thank you for not approaching me.

Me: I protect my sources.

CC: Yes, Angles certainly seems to be surviving

without Mr. Foxx at the helm. I thought Ross put together a beautiful show. I didn't care for that couch thing on the wall in the back room, but otherwise it was outstanding work, very sensual.

Me: Down the street from Angles was the infamous curation of the Norton Collection by Kim Dingle. What'd ya' think?

CC: She exhibited the art as it exists in storage—marvelous, I say! There have been some serious tizzy-fits over that one. Kim Dingle could teach YOU a thing or two about controversy, let me tell you.

Me: I thought the show was brilliant.

CC: Well, that's not what I hear Lari Pittman thinks about it.

Me: Because his painting was shown covered in storage wrapping?

CC: Yeah.

Me: Ha. Like what the fuck is he gonna do, buy the painting back from the Nortons?

CC: Hello! Maybe he'll tell Jay Gorney to have buyers sign disclaimers that they can never wrap or crate the artworks.

Me: Yeah. "Jay, this is Lari, you took money for my art, you capitalist pig, I'm going back to Rosamund Felsen, at least she never lifted a finger for me!"

CC: Yeah, that's about all the leverage Lari has and Jay knows it.

Me: (laughing at the thought of Lari Pittman walking in the door of Felsen's with a box of chocolates)

CC: Well, I heard a juicy one—I think Roy Dowell and Tom Knechtel may be leaving Rosamund's . . .

Me: Ooh . . . I bet Renée Petropoulos would take the first offer that came around.

CC: It's hard being Rosamund in a Bergamot world.

Me: Yeah, and who would Shoshana Wayne have to copy if Rosie retired?

CC: Maybe Berman. She could probably grow a mustache if she tried.

Me: I saw Roy Dowell in the audience at a Peter Schjeldahl lecture recently. It was the first time I had ever seen him without Lari Pittman. Like, I bet they even go to the men's room together at MOCA openings. I thought only girls did that . . .

CC: In New York?

Me: Naw, girls go to the can together everywhere, you idiot.

CC: I was asking if you saw Peter Schjeldahl lecture in New York, you idiot.

Me: No, here, L.A.

CC: Where did Schjeldahl lecture in L.A.?

Me: At Otis one night.

CC: When?

Me: January.

CC: January what?

Me: I don't fucking know, I haven't even bought a goddamn 1996 calendar yet.

CC: Why was he speaking at Otis?

Me: They paid his ass, I guess.

CC: I mean what event was he there for?

Me: He spoke about Kim Dingle.

CC: Everyone's talking about Kim Dingle.

Me: Talk about something else, she'll kill me if I mention her on every page of the magazine like I did last issue.

CC: If she killed you, Lari Pittman might like her better.

Me: Lari Pittman doesn't even know I exist, and that's the way I like it.

CC: I finally made it over to Gagosian's Beverly Hills space.

Me: Pretty beautiful space, eh?

CC: Richard Meier is so much better than Frank Gehry.

Me: Yeah, and I bet his buildings don't leak like Gehry's do in the rain. Did you go to Gogo's opening? Who was there?

CC: I saw Cheryl Tiegs at the opening there. She was real friendly with Larry.

Me: I always resented her for replacing Farrah Fawcett. . . . They should have made *Charlie's Angels* a duo after Farrah left.

CC: I didn't watch a lot of TV in those years.

Me: Hey, it was television's golden age.

CC: The late seventies?

Me: History will prove me right.

CC: The problem with seeing big celebrities at Gagosian's and Pace is that if all the star power goes to big galleries, the only market for the smaller spaces will be industry wannabes. And if they're just buying art to fit in, it creates a volatile market and rewards galleries that mimic fashionable trendy art . . .

Me: And every dealer in town has their finger in the air, looking for that next big thing, whether it's art or not . . .

CC: Well, if the market crashes big again, you can blame film industry executives who only shop retail.

Me: Spoken with conviction.

CC: If you quote me on that, I *will* show it to my mother.

Me: I gotta go vomit. (hang up)

—**Mat Gleason**
Issue 20, Spring 1996

On the Phone with the Los Angeles Art Watcher

The Editor spoke to the Art Watcher on January 2, during Channel 5's rebroadcast of the Rose Parade.

Mat Gleason: After the "Pure Beauty" show, I just can't relate to MOCA anymore. I want to like MOCA, be proud of it, and I have been in the past. What's your take?

AW: "Pure Beauty" was a comprehensive display of a type of internationally influential art making—the 1301 School, for lack of a better name—and was one of the few shows that has actually engendered debate about what type of art-making is appropriate for our time.

MG: It sucked, end of debate. I see it as the main problem for MOCA for years to come.

AW: I disagree. The main problem for MOCA is: Where is the permanent collection? Anyone not totally *au courant* with the contemporary art world who visited MOCA recently would leave totally bewildered about the state of contemporary art. There's nothing in any of the recent shows that allows anyone outside a very small world to understand or appreciate contemporary art.

MG: Should MOCA have fewer shows so that the permanent collection stays up?

AW: The various institutions in L.A. are going to have to create a way to have the shows MOCA does so well, but also have shows that will allow the culturally educated public access to contemporary art, to educate those with little exposure to art and, equally important, have a permanent collection on view showing the devel-

opment of contemporary art from 1940 to the present. All four goals are important.

MG: That's why New York can still snub L.A. L.A. has these little art-gem showcases, but no diamond-mine art museum.

AW: What L.A. really lacks is a space for the permanent collection, a space for educational shows to help others develop an interest in contemporary art, and places for photography, graphics, clay, film, architecture, design, textiles, and the other contemporary arts to be on permanent display.

MG: All this education shit, dude, you're losing me, and don't ever use the word textiles in my presence again.

AW: Listen. It would also be nice to have a place where a visitor to the city—and the locals—could see an update on what is currently happening in L.A. and what has happened in recent art history to get where we are today.

MG: Yeah, and it would be nice if we lived to be two hundred and Count Panza bought all our art.

AW: I'm serious, I have a concrete proposal.

MG: Hey, I'm all ears.

AW: One strong possibility for a space for MOCA's permanent collection is only a solid line drive away from Grand Avenue—the old Broadway Department Store on Fourth Street. With the pending installation of Angels Flight, it will become an easy stroll down to a 175,000-foot building that could comfortably hold many of the functions MOCA cannot now accommodate.

MG: So where's the tree that all this money's growing on?

AW: The cost could be far less if forgiveness can be arranged on the back property taxes, because it's those taxes that constitute the bulk of purchase price. Utilizing the basement, blowing out the top floor for a double-height ceiling, and tying up the vacant lot on the corner for future development would give MOCA a space second to none. This would also be excellent city planning with museum-goers coming down historic Angels Flight and then walking one block past Ira Yellin's Bradbury Building, the Metropolitan Water Building with the Million Dollar Theater, and the Laughlin Building with Grand Central Market to get to the new building.

MG: Well, it's obvious you've done your thinking, but how do you sell City Hall on what is always gonna be perceived as elitist theme parks?

AW: Aha! That's where the plan is airtight! The ground-floor fronting could be the educational wing of the museum.

MG: What is it with this educational bullshit? Why does a museum have to educate to justify its existence?

AW: Hear me out. Moving part of the museum to the most ethnically dense and diverse street in the city makes a statement, but only if an attempt is made to communicate with that audience. What government calls education is, in art terms, communication.

MG: I don't know if I buy that . . .

AW: That first floor should be curated specifically with the non-art-oriented viewer in mind. It should not be a third-world ghetto, but a noncondescending Art 101 course for all cultures. A museum of contemporary art will always be an elitist institution to an extent, but there is a difference between a closed elite and an open elite. The upper floors would then contain the rest of the permanent collection and all the various curatorial departments.

MG: Okay, who's signing the check?

AW: Who do you think is gonna read this?

MG: To quote a previous generation's philosopher, "You shouldn't let other people get your kicks for you."

AW: To quote a contemporary philosopher, "If you build it, they will come."

MG: Ha-Ha. Enough of your damn proposals. I haven't read an art rag since November. Has anything been happening out there?

AW: The *L.A. Times* finally returned Suzanne Muchnic's essential "Art Notes" column to the Sunday Calendar section. Her column is literally the only city-wide means of communicating what is going on in the art community as a community, and it has been missed.

MG: You read the *L.A. Times*? I mean, I read the sports section and the horoscope, but for arts coverage? Can I ask why you bother?

AW: Are you sure you edit an art magazine?

MG: Journal, dude, journal, and speaking of magazines, there's lots of new galleries out there, any new magazines?

AW: *Vernacular* magazine made its debut at the December Art Fair and has declared war on artspeak. Their goal is an art magazine that examines all the visual arts in the language of the spoken vernacular. The goal is to get a more general audience interested in the visual arts and by covering all the arts getting a larger audience interested in the art world. The pilot issue was well received and monthly publication will start this May.

MG: I saw that one. It's nice to go to bed at night knowing that *Art Issues* finally has some major competition. Who do you think was the best art writer in L.A.

last year?

AW: Best art writing anywhere last year was Christopher Knight in the *L.A. Times*.

MG: Fuck you! (hang up)
Phone rings.

MG: Hello?

AW: Hear me out.

MG: I'm timing you . . .

AW: Look, no other writer in L.A. has written so well on so many subjects affecting the art world. Whether you agree with his views or not, he is never less than interesting, and more often illuminating.

MG: Bye. (hang up)
Phone rings.

MG: Make it quick, dude, I may cut this whole piece.

AW: What do you think of Christopher Knight, honestly? Is he a bad writer?

MG: No, he's not a bad writer, but talent doesn't account for shit when you're just another windbag riding the art-world gravy train.

AW: When do you get on board?

MG: Whether I get on it or not, I'll always be on the derailing committee.

AW: If Christopher wanted to contribute to *Coagula*, maybe write a little commentary or something . . .

MG: *Three strikes, you're out, dude.* (hang up)
Phone rings.

Editor leaves without answering.

–Mat Gleason
Issue 16, January 1995

FREE

Coagula

#10

Los Angeles ART JOURNAL New York

ArtLA/93 CONVENTION COVERAGE

Coagula goes to CHINA with

gilbert and george

in the land that art forgot

I. F. Stone Made me Do It

(Tom Patchett interviews Mat Gleason)

First of all, what possessed you?

You mean what possessed me to start *Coagula*?

Fine. We'll start with that.

Well, the quick history is that I started writing for the school paper when I was at Cal State L.A. At first I was reviewing student art shows, and then I started reviewing the administration. I had a weekly column for about a year and a half called "Mat Gleason's Monkey Wrench," and every week I'd pick an administrator and just rip him to shreds. It got an incredible response. It was a very corrupt bureaucracy; everybody had an agenda. The Manuel Noriega thing was happening at the same time, so I compared the president of the university to Noriega–there *were* similarities, except the Cal State guy had better skin. Well, the guy hated me.

Go figure. Anyway, he wouldn't let me be editor of the school paper, so I started my own paper, *The Student Independent*. The funny thing is they could have just let me be editor and put up with me for a semester and then said, "O.K., your term's over." Instead, they had to put up with *The Student Independent* for two years. And, because I *was* independent, I wasn't bound by their checks and balances. I could attack power. And that's just instinctual in me. I don't know if I got it from being a punker or because I was educated by nuns.

Did you always consider yourself a writer?

I wasn't a writer. I was an art major. A really bad painter.

How bad?

So bad that when Fred Hoffman ripped off

Manuel Ocampo in 1992 or '93, I gave Manuel all my old canvases to paint over. In fact, I just talked to Manuel and he said, "Hey, one of your biggest paintings is now hanging in a museum in the Cayman Islands." I actually did sell some work, though. I used to be in a band called The Starvin' Band, and they would get on stage and play and I would paint. When the show ended, the painting was done. That people bought them shows you how much money was wasted in the eighties.

So, Coagula.

Oh, yeah. So, after publishing *The Student Independent*, I won a big Super Bowl bet. January '92. Redskins over the Bills. I mean, a thousand or so bucks. Sports betting was my life. Anyway, I

Mat's fave band, "Down By Law"

had all this money, and a friend of mine suggested since I'd already published an underground paper, why not an underground paper for the art world? I realized it would give me a way to get out of sports betting before I lost my ass. 'Course I may lose my ass on *Coagula,* but at least it's my thing, you know. I really think it was meant to be. When I was a kid, I'd throw a tantrum in the grocery store if my mom didn't buy me *Mad* magazine and the *National Enquirer*. And I can still remember asking, "How do they get the letters to not look like they came from a typewriter?" I was seven or eight, but conceptually I was interested in the fonts. So years later, when I was doing *The Student Independent*, it all kind of clicked that I had this ability to communicate in a satiric tone, like *Mad* magazine, and in a shocking, sensationalistic tone like the *Enquirer*.

Where did you grow up—not that you're grown up?

La Mirada, California. Big Catholic family. Pope said "no birth control," parents said "fine." Seven kids. Flash forward through a contentious childhood, and when cable TV

came to town I started a TV show on public access. A punk show called *Media Blitz*. All the punk bands could appear on the show and keep a copy of the videotape; there was no money involved. To promote the show I wrote a letter to *Flipside* magazine, which was a little 'zine at the time. Still is. Anyway, I wrote to *Flipside*, saying, "Hey, do you want to review bands on *Media Blitz*?" And they were like, "Yeah." So over comes this guy Al Flipside, that's what we called him, and he shows up with some of the people who work on the magazine and they review records and talk. It was a great time. What was your question?

I forgot.

Oh, yeah, La Mirada. Sorry, I kinda got caught up in the punk thing.

Would you say that *Coagula* has a "punk" aesthetic?

I'm not sure "punk" and "aesthetic" go together, but yeah, *Coagula*'s basically a punk 'zine for the art world, because the art world is stiff and dogma-oriented. Rules, you know. There's "you gotta do this, you gotta do that, you gotta do it this way, you gotta do it that way." But you look at the history of art, and anybody who ever did anything never played by those fuckin' rules. I mean, just imagine if van Gogh went to grad school today. He'd be a freak. "You gotta tighten up those paintings,

Vinnie." And it's all about power. Everybody wants to establish their own hierarchies. The Minimalists were against the established order, but then they became their *own* establishment. Just like punk rock is now corporate America. In its purest form, punk was DIY—do-it-yourself—you know, four kids in a garage, a reaction to the rock-star system. And the fact that it's now the status quo, I mean, it took twenty years, but punk rock went from dog vomit to Nirvana outselling Michael Jackson. And, you know, the whole thing about it was supposed to be "never give in to the power structure, even when it changes." Its like in the art world, there's always "X"—whatever type of art is on top. The prices are high, the artists are popular, and the art schools are teaching students to imitate those styles. Twenty years later that's gone, and it's been replaced by its antithesis. The point is, there are people in power, and there are people who *aren't* in power who are going to try to point out why the people in power are wrong. And I'm not in either camp. The goal of *Coagula* is not to destroy the academy in order to become the next academy.

What is the goal?

I have a quote above my desk, if you can call it a desk—some people call it a kitchen table—it's a quote by I. F. Stone, the journalist. "To tell the truth, exactly as I see it."

That's me, that's the goal.

And after five years, how successful *is* Coagula?

All I know is I print twelve thousand copies, and a lot more than twelve thousand people read it, even if they have to pick it out of the trash. And AT&T is making a killing on the phone calls around the country from people reading it to the people who haven't gotten it yet. I still have drinks thrown in my face, I've been punched out, I've been yelled at, kicked out of galleries, disinvited to parties . . . I'd say we're extremely successful!

Do you have power in the art world?

Like Machiavelli said, "Power is its own reward." I don't use my power for anything other than to attack power. My power is an established integrity—you can rely on me to not be part of a corrupt system. You pick up any other art magazine and they're compromised publications, whether it's the line between advertising and editorial or the line between the people who write for the magazines and the people who run our institutions. They're all basically perpetuating elitism and "group think." They're a complete ass-lick to fashion and institutions. *Coagula* is just me and Charlie against the world. I mean, I have other writers now, too, but the attitude of *Coagula*, when you come right down to it, is "rage against the machine." So in the realm of art magazines, if *Artforum* and *Art in America* are art mag-

azines, we're not an art magazine; if *Art Issues* is an art magazine, we're not an art magazine. We're something else. You know, I was once a seminarian. I was the son in my family who was going to be a priest. I was one of the first infants to survive heart surgery and it was a "miracle," so my whole life I was told "You're going to be the priest." So I went to a college seminary and, of course, got kicked out for asking too many questions. The Catholics, they don't want you to ask questions. They want to say, "This is the way it is, and that's it." And that's the art world, too. It's run like the Catholic Church. You can't ask questions. "Matthew Barney is a great artist, no further questions, please." It's like, "Excuse me, Monsignor, but how does God get that into little host?" "It's a mystery, son, it's a mystery. You gotta have faith." But you look at Judaism, Judaism says we can discuss everything. You know, "We accept that there is God, and we do not question the existence of God. Other than that, everything is up for discussion." So that's my analogy—the art world should be more like Judaism. We should accept the fact that there is value in art. That's not up for discussion. And we should accept that, by and large, people who make art love what they're doing and are not trying to con some status-seeking, nouveau-riche collector into buying something they don't want.

That's the dealer's job.

Yeah, well, dealers get no quarter from me. But artists do if they believe in what they're doing. This book is called "Most Art Sucks," so most people probably think it's a book that's really down on art. We're down on the art world, but not art. There is value in art. That's not on the table for discussion, but everything else is. That's what the art world doesn't want.

Do you feel that you always have enough information to act on? Journalistically speaking?

Coagula is not a journalistic enterprise. It was ruled in the Superior Court of New York that I am not a journalist. When I tried to fight a lawsuit by protecting my sources as a journalist, Judge Elliot Wilke said, "I've looked at *Coagula*. You're not a journalist." I don't think he meant it as a compliment, but the extrapolation was that I'm an artist.

Does that mean you can do or say whatever you want?

That's the way I interpret it, yeah. Some people say that *Coagula* doesn't research and doesn't do the proper journalistic work. Fuck that. This is an attack on power. I don't think the people I write about in a negative manner *deserve* the courtesy of a full investigation. These are people who hold artistic careers in their hands like they're toys. The only thing they worship is power and money and I have no respect for them whatsoever. If someone's lawyer writes me a letter, I'll back off if I have to, to stay in business. But we'll come back at them another day in another way. If they're part of the power structure, I'm going after them, you know, by any means necessary. Because these people have no scruples, and definitely no sense of humor. Well, the art world needs something glib. I mean, fuck the heavy-handed theoretical approach. I think the bullshit benchmark is the Jerry Saltz essay on Matthew Barney in *Art in America* in 1996. Nine pages on a movie about Barney being a sperm cell. And I just look back on that as the most turgid prose, ten thousand words on nothing. And if that's the art world, then fuck you, I'm glib and I'm proud. Again, it's I. F. Stone: "The job of the writer is to comfort the afflicted and afflict the comfortable." So that's definitely what I'm doing in practice. That's what drives me—that and when I go to the printer at Glendale Rotary Offset and hand him a check for, you know, twelve hundred bucks and I owe him forty-two hundred, is he gonna scratch his head and start the presses, or not.

Let's talk about people in the art world who wear more than one hat. The dealer-collector, for example, or . . .

How about the *critic*-collector? Now *there's* a self-serving combination. Take Christopher Knight. Please. Friends of his own the work. His boyfriend owns the work. *He* owns the work. So naturally he's going to write favorable reviews of the work because he has a vested interest. And it's not only a question of ownership, it's a way of insulating "The Club." You know, let's keep the club very limited. There are people who are curator-critics, curator-consultants, curator-collectors. A museum could end up having a show of an artist that the guy in charge collects! Talk about conflict of interest, talk about power! And people don't think the art world needs *Coagula*?

Who's Charlie?

Charlie?

You said it's you and Charlie against the world.

Oh, Charlie Finch. My New York editor. Janet Preston to the world. Janet Preston, "New York Letter Bomb," everything New York.

How did that happen?

One day he called me and said, "Hi, I want to write for your magazine," and I said, "Well, put up or shut up." Then I hung up on him. I got a ton of his stuff in the mail.

Do you and Charlie divide things up?

No, he goes his own way. I mean, every once in a while, I'll suggest, "Hey, why don't you go a year-end 'Best of,'" or "We only trashed Go-Go six times in the last issue, why don't you call and harass him." Sometimes he will, sometimes he won't. You should talk to Charlie.

I have.

What did he say?

Good things about you, bad things about almost everybody else.

That's my man.

I trust you guys didn't receive an invitation to one of the special dinners at the Getty?

Well, we get so much mail, it could be in a stack somewhere. Actually, I'd be worried if we got invited to a Getty dinner.

We'd all be worried, Mat.

Fuck you, Tom.

Keep up the good work . . .

Mat Gleason
and
Charlie "Janet Preston" Finch

ODDS AND ENDS
(MAINLY ODDS)

Etch A Sketch Poodle does doo doo.

"She said she'll fuck you if you'll just stop spinning that chair around."

HUGO BOSS
RAUSCHENBERG TIE COLLECTION

1. THE FAMOUS NAME

Mix up the name - Good for TRADERS, CEOS AND MUSEUM Directors

LIMITED EDITION OF Felt tip pen on clear plastic by COUSIN OF Bobs — WALTER CLEARY

2. THE SIGNATURE

SIGNATURE ON UNSTRETCHED LINEN

Good for ACADEMICS, DOCTORS AND INTROVERTS

3. The GOAT

AFTER MANY SURVEYS IT WAS DISCOVERED That Rauschenberg doesn't Really HAVE A signature piece like WARHOL (campbell soup) Johns (FLAG).

PURPLE BURNT SIENNA

Goat etched IN PAYNES GRAY

AZURE

COPPER

4. ASSEMBLAGE w/ JFK

PROMISES to be a BIG SELLER - IMAGE OF JFK WITH CHICKEN WIRE WITH FOUND STUFF MIXED IN WIRE LIKE BIRDHOUSE, WOOD - PAINTBRUSHES INCLUDES Real LIVE PAINTSPLATTERS FROM ARTISTS STUDIO

The goat piece IS Really ONLY KNOWN IN ACADEMIC CIRCLES OF ARTFORUM SUBSCRIBERS - Therefore HUGO BOSS WILL CREATE A TIE OF IMPORTANCE THAT THE PUBLIC CAN RELATE TO AND NEED TO BUY

Top: Gordy Grundy returns Mike Sie...

Duchamp's First Nine Tries by Vikki Neck

Jessica Fredericks

Dan Bernier looks in on Jack Tilton

Colin De Land

Tim Hunt

OOPS! RETRACTiONS

L.A. Scene

Forget post–Deng China speculation, the real political machinations are at Santa Monica's Bergamot Station! We hear that the Bergamot Boys, Tom Patchett (the money behind the sprawling art-gallery complex) and Wayne Blank (its toilet-scrubbing property manager) are reportedly only speaking to each other through their respective lawyers.

Blamer Blank (or Mister Shoshana Wayne as he is known behind his back) flipped his wig when Patchett installed a gigantic *Miss Saigon* billboard at eye-level on the exterior of his Track 16 gallery, to augment "Street-O-Matic," the excellent Track 16 show of billboard art. This, of course, means that poor Patchett is missing the stimulating chat of Blank, whose favorite negotiating tactic in disputes with Bergamot tenants (most of whom are two years into their five-year leases) is to reportedly utter, "Three years is a very short time."

Touché–one reason for Blank's blood to boil over: Patchett, whose age is hovering around the speed limit, is reportedly shagging a woman under thirty, while we estimate that the Blamer will have to wait at least two years for wife Ivana's next face-lift.

–*Mat Gleason*
Issue 22, Summer 1996

Correction

It has come to the attention of *Coagula* that information in an article in our previous issue (Issue 22, Summer 1996) concerning Mr. Wayne Blank cannot be verified.

Coagula has not been able to validate the information that appeared. Therefore, we regret publication of the article and any damage it may have caused Mr. Blank.

Issue 23, September 1996

OOPS!

I wrote a news item for this column that appeared in our last issue where I replaced the name of an artist with the name of someone who had nothing to do with the article!

Due to an editorial error that was solely my fault, Marilu Knode's name appeared in a negative review of two emerging painters (Laura Owens and Monique Prieto, both of whom still suck). Ms. Prieto's name was accidentally replaced with Ms. Knode's.

Ms. Knode is a well-known and respected curator. I apologize for any inconvenience this inaccuracy may have caused.

Issue 20, Spring 1996

Dedication

This book is dedicated to the memory of Curt Thomas, a friend, an inspiration, a great cynic, an uncompromising artist, and the only painter I know of who consistently got a better finish than Ellsworth Kelly.

Mat Gleason's Acknowledgments

So many people have helped along the way that it would be impossible to mention all of them. The joy of publishing the succinct intellect of Charlie Finch is the only reason I kept to this project through some of the lean times; the love of Barbara got me through some of the others—the lonely nights in downtown L.A. disappeared for good when you came into my town. I learned publishing at the offices of the University Times at Cal State L.A in the summer of 1989. Thanks to Mary Ann Swissler, Steve Robinson, Geoff Fein and Dave Smalley for their patient tutelage and to CSLA President Dr. James M. Rosser for taking all of my editorial abuse. It was great practice. Thanks to Earl Raines and Kim Williams for engineering my first self-publishing venture, The Student Independent newspaper.

A good Catholic boy always thanks his parents, and, even though you've scratched your head at what I do, you raised me to pursue what makes me happy, mom and dad, and I think I may have found it.

Thanks to Joe, Patty and Harry for putting up with piles of newspapers that needed shipping, Bruce for occasional advice, Mary for emergency laser printing and Angela for early lessons in nonconformity.

Thanks to all the editorial contributors, writers and artists. Pseudonymous or not, you've helped greatly.

Thank you to all of our advertisers, past and present and the people who patronize them. Big thanks to my advertising salespeople past and present, Michael Salerno and Kim Kaufman. Stuart Katz was our first advertiser, and thanks to him we became bloodthirsty mongrel capitalists. Thanks Stuart. Thanks to all my lawyers past and present, especially Adam in New York and Wendy in California. Thanks to Tom Patchett, Susan Martin and everyone at Smart Art Press and Track 16 for putting up with this project and the inevitable flak from art-world types who hate Coagula. Thanks to Steve Samiof at Brains for the great design. Brady Westwater was there when nobody else was and kept this journal alive for a crucial month in 1995. Thanks Brady. Ongoing thanks to the folks at Glendale Rotary Offset including Jeff, Jonathan, Sandy and everyone in the camera department, Sal and all his pressmen, Jerry Burr, Mister Bo, and especially Jerry Deal for extending me credit and helping us grow. The generous photographic assistance of Raymond Y. Newton, Gary Leonard, Ed Glendinning, Bob Bertero, Toni Hernandez, Waheed Boctor and Ed Colver have helped Coagula tremendously. Thanks to Murray Schiff, Dez Festiva, Alex & Peekay, Brian Roop, Janet Preston and Spill in New York, and Functional Dave. Thanks also to Adrianna for help with UPS. Thanks to Bibbee Hansen and Sean Carrillo whose Downtown L.A. coffeeshop Troy (R.I.P.) was the first place at which Coagula was distributed. If I forgot to thank you here, forgive me, Susan Martin needed this page yesterday and my computer has already crashed twice. Look at it this way, nobody will give you shit for helping out that damn mean-spirited gossip rag. Special thanks to: Max Estenger, Janet Preston, Freedom X, David Horii, Gordy Grundy, Erika Icon, Llyn Foulkes, Ming, Onyx Sequel, Karen Finley, Kim Dingle, Odie at Models Network, Brett Favre, Irit Krygier, Mary Jones, Bernie Bridges, Connie Monaghan, Dianne Lawrence, John C. Edwards, Abbas Daneshvari, Ed Forde, Sabina Ott, Dan Douke, Joe Soldate, Gene Plan-9, Bryan Styble, Jennifer Faist, George Herms, Rudy & Mirta, Jim Caron, Jeff Gillette, Aida Cynthia DeSantis, Scot Severns (for showing me the edge), Tom Callinan, Lisa Adams, Lavialle Campbell, Joel Bloom, the Fabulous Hortons, Roland Reiss, Don Jones, Sally Trato-Rust-Miller, Jim & Shari, Eloy Torres, Sharon Bell, Rick at CDS, Tara at Traxx, Hope Urban, Arthur Correia, Bill Radawec, Mark Rypien (whose 1992 Superbowl performance financed the first few issues via my wise wager), Robert Stoller, Audra & Brad, The Starvin' Band, Down By Law, Joe Gatto, the Zorthians, Heilman-C, both John Petersons (W3 & O.C.) Kate & Farid, Liz & Val, Brian & Yogi, John Rand, Robbie Conal, Matthew Marks (Coagula's very first subscriber), Brett Goldstone, James Seehafer at coagula.com, the Seemayer family, the Spences, Tom Ryan, Steve Erickson & Lori Precious (for the Halloween photos), Matt Carlin, Skulli Acosta, David DiMichele, James Suelflow, Richard Godfrey, Vito Lorusso, Rick Ankrom, Roberto Quintana, Jay & Mike of Bone, Gary Blitz. Al Roth, Kyle McCulloch, Buddy Roberts, Kerry Kugelman, Wendy Christine, Jennifer Timbre, and the gang at Spanish Kitchen. Apart from the art world, the inspiration for all this comes from a mind set wired by Trader Joe's coffees, and schooled in the art and attitudes of Jello Biafra, John Lydon, Charles Bukowski, Exene Cervenk(ov)a, Brian Downing, Darby Crash, They Might Be Giants, Lyman Bostock, Grant Lewi, Rockie Gardiner, Liz Phair, Robert Allen Zimmerman, Gerald Locklin, Beck, Miles Davis, Leonard Cohen, Steve Richmond, Troy Percival and Anais Nin.

Lastly, a big thanks to my publishing role model, Al Flipside, for his admonition: "Don't sell out, sneak in."

No Bullshit.

Alberto Miyares,
Coagula's Spiritual Advisor

**Far from tame, Most Art Sucks is not the first
quirky tome to tumble off the Smart Art press.
Featured below are four of our more deviant examples.
Perusing our whole list could make you think
we're quite peculiar indeed.**

...ed Tomaselli

...g drugs, bugs, and resins,
...d Tomaselli constructs multi-
...ered paintings that are eye-
...ping and resolute in their
...suit of unabashed beauty.
...ys by Alisa Tager and
...id A. Greene.
...l. 2, no. 12
...tcover, 7 x 9 inches
... pp
... color, 7 b&w
...strations
...N 0-9646426-3-8
...0

Manuel Ocampo: Heridas de la Lengua

This beautifully illustrated
book documents one of the
most important young artists
to have emerged from Los
Angeles in the last decade; his
work updates the tradition of
political allegorists like
Gericault, Goya, Daumier, and
Golub.
Vol. 4, no. 31
Softcover,
10 ¹/₂ x 11 inches
96 pp
64 color, 12 b&w
illustrations
ISBN 1-889195-10-3
$30

Beck & Al Hansen: Playing with Matches

In the late 1980s and early
1990s, the Grammy Award-
winning recording artist Beck
teamed up with his grandfa-
ther, the influential
Happenings artist Al Hansen,
to produce riveting collages.
*Beck & Al Hansen: Playing
with Matches* provides an
overview of the individual and
collaborative mixed-media
works that reflect the shared
values that bridge their respec-
tive generations.
Vol. 4, No. 40
Softcover, 8 x 10 inches
144 pp
90 color, 45 b&w
 illustrations throughout
ISBN 0-921381-13-1
$25
Smart Art Press/Plug-In
Editions

Pinspot #1: Marcel Dzama

Swimming in a sea of blank
space, stripped of all extenuat-
ing circumstances, Marcel
Dzama's quirky ink and water-
color drawings effortlessly
encompass a wide range of
human characters, animals,
and mythic concoctions, medi-
tations on such disparate sub-
jects as Spiderman, Inuit
imagery, film noir, Surrealism,
The Wizard of Oz, Jean-Pierre
Jeunet's *City of Lost Children*,
1950s sci-fi sets, late Victorian
children's book illustrations,
E.T., and zany MTV cartoons.
Softcover, 6 x 8 ⁷/₈ inches
32 pp
8 color, 24 b&w
illustrations
$7

OUGHOUT OUR SHORT PUBLISHING LIFE — TWO QUESTIONS HAVE BEEN ASKED OF US MORE THAN
— WHY ARE YOU SO NEGATIVE — 2 — WHY CAN T YOU BE NICE
THE ANSWERS — SIMPLY
1 — WE RE ONLY NEGATIVE TO COUNTERACT THE PLACATING INCE
OUSNESS WHICH SWAMPS ALL CREDIBLE RELATIONSHIPS IN THE
LD
2 — WE CAN T BE NICE WHEN THE PEOPLE MOST CLOSELY ASSOC
ED WITH CARETAKING THE BEAUTY AND LEGACY OF GREAT CONTEMP
RY ART ABUSE THEIR ROLES FOR PERSONAL GAIN AND OR GLORY
THE WORST REACTIONS TO COAGULA DURING MY TEN ISSUE TEN
FROM PEOPLE WHO AT ONE TIME OR ANOTHER HAD ORIGINALLY SU
RTED THIS JOURNAL — THEY WERE CHEERING US ON UNTIL WE INVE
GATED SOMETHING A LITTLE TOO CLOSE TO THEM — THE ICY STA
D CANCELED INVITATIONS FOLLOWED — I HAVE A WONDERFUL TH
NOTE FROM A PROMINENT LOS ANGELES GALLERISTE — HANDWRIT
EXPENSIVE BOARDING SCHOOL SCRIPT — THANKING US FOR OUR CO
UOUS SUPPORT — AFTER TWO POSITIVE REVIEWS OF THE GALLER
ISTS — YET AFTER ONE SMALL ITEM DISCUSSING THE PERSO
ITS OF ONE OF THE STABLE S MORE OBNOXIOUS JUNIOR AR
ERRATED ASS — JUST BE READY FOR MORE THAN

RE — — WE — — AR

HERE — — TC

STAY